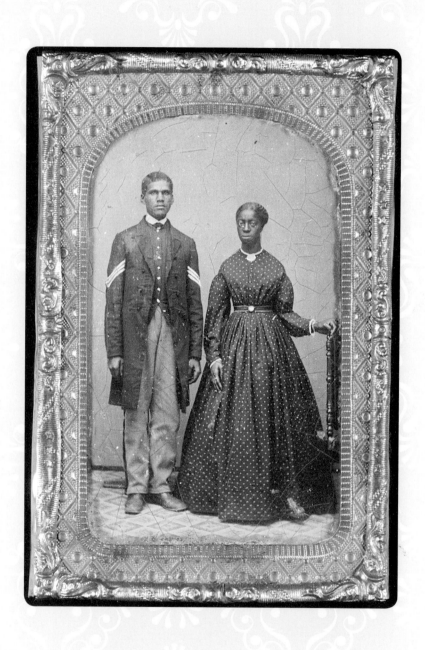

Deborah Willis AND Barbara Krauthamer

ENVISIONING

Black Americans and the End of Slavery

EMANCIPATION

Temple University Press

Frontis: **Edward V. Richardson (b. 1840) and Fannie Sturgis,
former slaves from Maryland**

Photographer unknown • c. 1865 • tintype, sixth plate

(Randolph Linsly Simpson African-American Collection, Yale Collection of American Literature,
Beinecke Rare Book and Manuscript Library, 1032293)

TEMPLE UNIVERSITY PRESS
Philadelphia, Pennsylvania 19122
www.temple.edu/tempress

Copyright © 2013 by Temple University
All rights reserved
Published 2013

TEXT DESIGN BY KATE NICHOLS

Library of Congress Cataloging-in-Publication Data

Willis, Deborah, 1948-
 Envisioning emancipation : Black Americans and the end of slavery /
Deborah Willis and Barbara Krauthamer.
 p. cm.
 Includes bibliographical references and index.
 ISBN 978-1-4399-0985-0 (cloth : alk. paper)
1. African Americans—History—1863–1877—Pictorial
works. 2. African Americans—Portraits. 3. United States—History—Civil
War, 1861–1865—African Americans—Pictorial works. 4. Documentary
photography—United States. 5. Historiography and photography—United
States. I. Krauthamer, Barbara, 1967– II. Title.
 E185.2.W68 2013
 973.7'14—dc23

 2012032600

Printed on acid-free paper for greater strength and durability

Printed in the United States of America

2 4 6 8 9 7 5 3

To my mother, CAROLE KRAUTHAMER,

and my children, ZORA *and* MAX ELKIN

—BK

To my mother, RUTH ELLEN HOLMAN WILLIS,

born in 1922

—DW

Contents

Preface and Acknowledgments

❧

I t all started with a conversation about photography and how the concept of emancipation could be documented through that medium. Then there was another conversation about representation and presentation; and yet another conversation about the archive and the photographic object, about history and memory, personal and collective; and a conversation about photographs of the past and art images today. In over twenty-five years as a curator and professor and over thirty years as a photographer, working in museums, libraries, galleries, and archives, I became increasingly curious about how Americans preserve "memory"—from the Revolutionary War and the horror of slavery to the Civil War and Reconstruction and on to the turn of the twenty-first century—through the art object. Over the years I found myself engrossed in the question, reading literary works, watching documentaries, and listening to the myriad of experiences that defined the twentieth century, from the Great Migration to individual human rights struggles to the Civil Rights movement. I became interested in how each story was visualized at the time through photographs in public and private

collections. I was curious about the past and also about the ways in which "postmemory," to use Marianne Hirsch's terminology, is framed by the photographic record. This collaboration began when Barbara Krauthamer and I discovered the story of "Dolly," an enslaved woman who was photographed by her owner and whose image was pasted on a "Wanted" poster—*after* the Emancipation Proclamation.

I would like to thank Hank Thomas, Hank Willis Thomas, Mary Schmidt Campbell, Kellie Jones, Cheryl Finley, Carla Williams, Jane Lusaka, Irene Cho, Liz Andrews, Sharon Howard, Sharon Harley, Francille Wilson, Robin D. G. Kelley, Khalil Gibran Muhammad, A'Lelila Bundles, Lorie Novak, Melvina Lathan, Sarah Lewis, Pamela Newkirk, Bob Gore, Rachelle Browne, Clement Price, Lonnie Bunch, Claudine Brown, Douglas Mitchell, Nicole Fleetwood, Leslie Willis Lowry, Henry Louis Gates Jr., and Faith Childs for their continued support for my work. I also thank the Humanities Initiative of New York University for awarding me a grant to complete research for this project.—**DW**

Thanks, also, to the University of Massachusetts, Amherst, Center for Teaching and Faculty Development's Mutual Mentoring Initiative, funded by the Andrew W. Mellon Foundation. This grant facilitated our initial conversations about the project and allowed us to continue working closely together as we researched and wrote about the history of photography, slavery, and emancipation. A one-year fellowship at the Institute for Historical Studies at the University of Texas at Austin provided the uninterrupted time and quiet space needed to complete this project. The University of Massachusetts, Amherst, Book Publication Subvention Program and History Department helped defray the cost of reproducing the images included here. Thank you to Joye Bowman and Melinda V. LeLacheur for helping me secure this funding. Daina Ramey Berry, Maria Franklin, Jennifer Fronc, Laura Lovett, Ted Melillo, Chantal Norrgard, Elizabeth Pryor, Dawn Peterson, and Cherise Smith read and commented on portions of this work. Conversations with Daina and Cherise were especially valuable and generated many insightful questions and suggestions that helped me think and write about the visual representation of slavery and freedom. Thank you to Joshua Haynes for his spectacular research on the history of black political and social life in Georgia.—**BK**

We would both like to thank Janet Francendese, editor-in-chief at Temple University Press, for her stimulating and enthusiastic response to our project. Also at Temple, we thank Amanda Steele, Kate Nichols, and Charles Ault.

We benefited from the remarks of the anonymous readers and thank them for taking the time to read this work. We appreciate the close read and detailed attention that book editor Jane Barry gave to this project. We are also grateful to the following institutions, scholars, archivists, librarians, and photographers for their assistance in various aspects of our research and for allowing us to reproduce the photographs in this book: Austin History Center, Austin Public Library; Drew Adan at the Beinecke Rare Book and Manuscript Library, Yale University; Diane Turner and Leslie Willis Lowry at the Charles L. Blockson Afro-American Collection, Temple University Libraries; Patricia M. Boulos at the Boston Athenaeum; Jacklyn Burns at the J. Paul Getty Museum; Candy L. Crayton at the Madison County Historical Society; Nancy Sherbert, Kansas State Historical Society; JoEllen ElBashir at the Moorland-Spingarn Research Center, Howard University; Steve Engerrand and Gail DeLoach at the Georgia Archives; Malcolm Daniel at the Metropolitan Museum of Art; Missouri State Archives; Stacey Sherman at the Nelson-Atkins Museum of Art; Hallie Yundt Silver and Sheila Dennehy at the Hannibal Free Public Library; Autumn Reinhardt Simpson at the Valentine Richmond History Center; Matthew Turi at the Louis Round Wilson Special Collections Library, University of North Carolina at Chapel Hill; Maricia Battle, Verna Curtis, and Beverly Brannan at the Library of Congress Prints and Photographs Division; Frank Goodyear at the Smithsonian's National Portrait Gallery; Michelle Delaney and Shannon Perich, Photographic History Collection, National Museum of American History, Smithsonian Institution; Michele Moresi and Jacqueline Serwer, National Museum of African American History and Culture, Smithsonian Institution; William Copeley at the New Hampshire Historical Society; Sharon Howard and Mary Yearwood, New York Public Library Schomburg Center for Research in Black Culture; Wilson's Creek National Battlefield; Michelle Franco, Richard Avedon Foundation; Mary Jo Fairchild, South Carolina Historical Society; Neal Adam Watson, Florida Memory, Division of Library and Information Services; Brian Wallis and Claartje van Dijk, International Center for Photography; Jessica Desany Ganong, Harvard Peabody Museum of Archaeology and Ethnology; Lory Morrow, Montana Historical Society; British Museum; George Eastman House International Museum of Photography and Film; Tom Rankin at Center for Documentary Studies, Duke University; Berkley Hudson and Elizabeth A. Lance at University of Missouri; and Kroch Library, Division of Rare and Manuscript Collections, Cornell University. For contemporary photographs of Civil War memorials and monuments, we are indebted to David "Oggi" Ogburn, Wendel White, and William Williams. Finally, we are extremely grateful to all who listened to us talk about this project and shared their ideas. —BK/DW

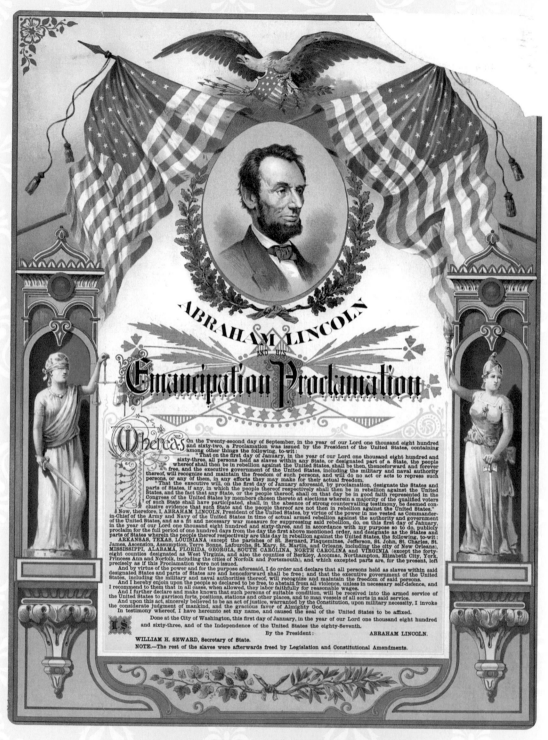

"Abraham Lincoln and His Emancipation Proclamation"

Published by Strobridge Lithography Company, Cincinnati • c. 1888 • chromolithograph

(Library of Congress, Prints and Photographs Division, LC-USZC4-1526)

The Emancipation Proclamation

Whereas, on the twenty-second day of September, in the year of our Lord one thousand eight hundred and sixty-two, a Proclamation was issued by the President of the United States, containing, among other things, the following, to wit:

"That on the first day of January, in the year of our Lord one thousand eight hundred and sixty-three, all persons held as slaves within any State or designated part of a State, the people whereof shall then be in rebellion against the United States, shall be then, thenceforward, and forever free; and the Executive Government of the United States, including the military and naval authority thereof, will recognize and maintain the freedom of such persons, and will do no act or acts to repress such persons, or any of them, in any efforts they may make for their actual freedom.

"That the Executive will, on the first day of January aforesaid, by proclamation, designate the States and parts of States, if any, in which the people thereof respectively shall then be in rebellion against the United States, and the fact that any State, or the people thereof, shall on that day be, in good faith, represented in the Congress of the United States by members chosen thereto at elections wherein a majority of the qualified voters of such State shall have participated, shall, in the absence of strong countervailing testimony, be deemed conclusive evidence that such State, and the people thereof, are not then in rebellion against the United States."

Now, therefore I, ABRAHAM LINCOLN, President of the United States, by virtue of the power in me vested as Commander-in-Chief of the Army and Navy of the United States in time of actual armed rebellion against the authority and government of the United States, and as a fit and necessary war measure for suppressing said

rebellion, do, on this first day of January, in the year of our Lord one thousand eight hundred and sixty-three, and in accordance with my purpose so to do publicly proclaimed for the full period of one hundred days, from the day first above mentioned, order and designate as the States and parts of States wherein the people thereof respectively, are this day in rebellion against the United States, the following, to wit:

ARKANSAS, TEXAS, LOUISIANA, (except the Parishes of St. Bernard, Plaquemines, Jefferson, St. John, St. Charles, St. James, Ascension, Assumption, Terre Bonne, Lafourche, St. Mary, St. Martin, and Orleans, including the City of New Orleans), MISSISSIPPI, ALABAMA, FLORIDA, GEORGIA, SOUTH CAROLINA, NORTH CAROLINA, and VIRGINIA (except the forty-eight counties designated as West Virginia, and also the counties of Berkley, Accomac, Northampton, Elizabeth City, York, Princess Ann and Norfolk, including the cities of Norfolk and Portsmouth), and which excepted parts, are for the present, left precisely as if this proclamation were not issued.

And by virtue of the power, and for the purpose aforesaid, I do order and declare that all persons held as slaves within said designated States, and parts of States, are and henceforward shall be free; and that the Executive government of the United States, including the military and naval authorities thereof, will recognize and maintain the freedom of said persons.

And I hereby enjoin upon the people so declared to be free to abstain from all violence, unless in necessary self-defence; and I recommend to them that, in all cases when allowed, they labor faithfully for reasonable wages.

And I further declare and make known, that such persons of suitable condition, will be received into the armed service of the United States to garrison forts, positions, stations, and other places, and to man vessels of all sorts in said service.

And upon this act, sincerely believed to be an act of justice, warranted by the Constitution, upon military necessity, I invoke the considerate judgment of mankind, and the gracious favor of Almighty God.

In witness whereof, I have hereunto set my hand, and caused the seal of the United States to be affixed.

Done at the City of Washington, this first day of January, in the year of our Lord one thousand eight hundred and sixty three, and of the Independence of the United States of America the eighty-seventh.

By the President: ABRAHAM LINCOLN

WILLIAM H. SEWARD, Secretary of State.

Envisioning Emancipation

$50.00 Reward !!

Ran away from the Yard Corner of Jackson & Broad Streets, Augusta Ga.— on the evening of Tuesday 7ᵗʰ April 1863 a Woman "Dolly", whose likeness is here seen.—

She is thirty years of age, light Complexion— hesitates somewhat when Spoken to, and is not a very healthy woman— but rather good looking, with a fine set of teeth. Never Changed her Owner and has been a house Servant always.—— It is thought she has been enticed off by some White Man, being herself a Stranger to this City, and belonging to a Charleston Family.——

For further particulars apply to Antoine Poullain Esqᵣ Augusta Ga.——!! ﾟ

Augusta Police Station

Louis Manigault Owner of Dolly

Introduction

A Very pleasing feature of our pictorial relations is the very easy terms
upon which all may enjoy them. The servant girl can now see a likeness of
herself, such as noble ladies and even royalty itself could not purchase fifty
years ago. Formerly, the luxury of a likeness was the exclusive privilege of
the rich and great. But now, like education and a thousand other blessings
brought to us by the advancing march of civilization, such pictures, are
placed within easy reach of the humblest members of society.

Frederick Douglass,
"Pictures and Progress," 1863

*E*nvisioning Emancipation explores the ways in which black people's enslavement, emancipation, and freedom were represented, documented, debated, and asserted in a wide range of photographs from the 1850s through the 1930s. We see these images as historically situated representations, created usually by the photographers and subjects, but sometimes by other interested parties as well. We also view them as powerful images with enduring meanings and legacies. To recall the words of Frederick Douglass: "the servant girl can now see a likeness of herself" in the ambrotype of the "washerwoman" on the cover of this book. We can also read this portrait as a symbol of patriotism and beauty. The young woman is believed to have worked for the Union army as a laundress.[1] Perhaps to show her appreciation for the army's help in obtaining her freedom, she has pinned a miniature American flag to her dress.

Photographic likenesses became available in America soon after the Frenchman Louis J. M. Daguerre (1787–1851) announced in January 1839 that he had successfully fixed an image on a silver-coated copper plate. Only a few months later the daguerreotype had arrived, and U.S. newspapers were publishing accounts of experiments with the process. Early photographers, who were from widely varied backgrounds, produced results that were also varied, culturally, commercially, and aesthetically. Low prices—between twenty-five cents and a dollar—made daguerreotype portraits accessible to all classes of American society, unlike the popular but expensive miniature portraits in oil or watercolor. After the mid-1850s, photography studios began experimenting with other technologies. The ambrotype, also known as a "collodion positive" (1852–mid-1870s), replaced the daguerreotype's copper plate with a glass one.[2] The tintype was adapted from this process and remained popular from 1854 to 1900 because of its short exposure time.

The photographs in this book trace the technical developments of the medium and also suggest the multiple ways in which Americans, black and white, engaged the prevailing controversies over slavery and black people's freedom in the nineteenth and early twentieth centuries. At the same time, these images record the presence of black people who have too often been ignored and erased from the historical record. In that context, these photographs are important historical sources that can inform the thinking of readers and scholars about the intertwined histories of slavery, freedom, and photography.

We cannot overlook the cost of these images. Free blacks who could afford to pay for their likenesses posed for ambrotypes and tintypes. Although the cost was beyond the reach of enslaved men, women, and children, they were often photographed by their owners to identify them as human property or by others who categorized them as objects of scientific scrutiny. Taking these differences in circumstance and purpose into account will enhance awareness and appreciation of the complex significance and meanings of these images. By considering the ways in which slavery and freedom were represented in photographs and also the people presented in them, this book contemplates the question, what did freedom look like?

This project emerged from our respective interests in the history of photography, beauty, slavery, and memory. Our earliest conversations centered on a cropped portrait on a "runaway poster" (discussed later in this chapter) of an enslaved woman named Dolly, who freed herself by running away from her master. Dolly's image has been widely reproduced in histories of slavery but has rarely been the subject of analysis or discussion. Why did Dolly's master, a prominent Georgia and South Carolina planter named Louis Manigault, have that picture taken? Why did

he save her picture after she ran away in 1863, a signal year midway through the Civil War? What did we, as scholars and writers, see when we looked at Dolly's image nearly 150 years after the war's end and slavery's demise? Over time, as we each proceeded with our own research projects, we found ourselves repeatedly coming back to conversations about photographic representations of slavery and freedom and the ways in which these photographs functioned simultaneously as historical sources of information, as visual representations of particular ideas and interests, and as sites of memory that sustain a sense of connection to the earliest generations of the black freedom struggle. The images presented in this book span the period from the prewar 1850s through the 1930s, when the Works Progress Administration (WPA) instituted an oral and photographic history project of sorts that focused on the lived experience of slavery through the words of the survivors. All of these images reveal the different ways in which black Americans positioned themselves and were posed by others to address prevailing questions about the meaning of black freedom in America.

Slavery and Photography

We begin with a discussion of images from the 1850s, produced in a time of tremendous, inflammatory, and often violent controversies over slavery and the place of free black people in the United States. Americans, white and black, had long recognized the fundamental contradictions between the nation's professed ideals of individual liberty and equality on one hand and its abiding legal and social commitment to the institution of chattel slavery and the attendant racial ideology of black inferiority and white supremacy on the other. This paradox was embodied most notably by Thomas Jefferson, who owned well over a hundred slaves when he authored the enduring lines of the Declaration of Independence: "We hold these truths to be self-evident, that all men are created equal." Three-quarters of a century later, in 1852, at a public Fourth of July ceremony in Rochester, New York, Frederick Douglass confronted the contradiction head-on with the rhetorical question: "What, to the American slave, is your 4th of July? I answer: a day that reveals to him, more than all other days in the year, the gross injustice and cruelty to which he is the constant victim. To him, your celebration is a sham; your boasted liberty, an unholy license . . . your shouts of liberty and equality, hollow mockery."[3]

The intensifying national conflict over slavery and black freedom played out through competing campaigns of photographic imagery.[4] Slavery's defenders employed visual imagery, especially photography, to illustrate and advance their arguments that blacks were less than human, with limited intellectual ability,

stunted morality, and an overall incapacity for freedom. Proponents of slavery and its bedrock ideology of black inferiority used these images to reinforce existing paradigms of racial difference and legitimate the ownership of black people as property. Photographs of enslaved people defy easy categorization because they are both the record and a relic of the brutal racism and domination at the core of chattel slavery. Images of enslaved women and men provide compelling and haunting documentation of individuals otherwise lost to the written historical record. Yet the history of such photographs is firmly embedded in the dynamics of exploitation and dehumanization that lay at the core of slavery.

Perhaps some of the best-known and most painful images of enslaved women and men are those created under the direction of Louis Agassiz, a Swiss-born and Harvard-trained zoologist. In 1850 Agassiz traveled to Columbia, South Carolina, at the invitation of Robert Wilson Gibbes, a prominent physician who taught at South Carolina College and also treated both elite white patients and the black people they held in slavery. During his time in South Carolina, Agassiz visited colleagues, delivered a series of lectures at the college, and spent his evenings at dinners hosted by families of the slaveholding gentry. He was, however, most excited about the opportunity to examine African-born slaves. Columbia's black population, nearly double the white population, included a small number of African-born women and men, and Gibbes located at least five and made them available for Agassiz to examine. "I took him to several plantations," Gibbes wrote, "where he saw Ebo Foulah, Gullah, Guinea, Coromantee, Mandingo and Congo negroes." After studying their bodies, Agassiz believed he had the physical evidence to support his theories of polygenesis—the separate human origins of Africans and Europeans—and racial hierarchy. He was, Gibbes wrote, satisfied "that they have differences from other races." Gibbes subsequently arranged for Joseph Thomas Zealy, an established daguerreotypist in Columbia, to photograph these enslaved African men and their American-born daughters in order to document Agassiz's findings. Once the images were made, Gibbes carefully wrote a label for each daguerreotype, noting names, specific African ethnic group or country, and American owners. Each photographed subject was thus identified as both a person and a specimen.[5]

One set of the Agassiz images consists of pictures of two women, Delia and Drana, stripped to the waist. Their dresses have been opened and pulled down to reveal their naked breasts. The women's exposed bodies are not presented as objects of sensual desire but as evidence of their debased condition—though, in the context of black women's enslavement, the line between the two motives was never sharply drawn. Stripped bare, their bodies, specifically their breasts, and by implication their health and reproductive history and capacities, were displayed

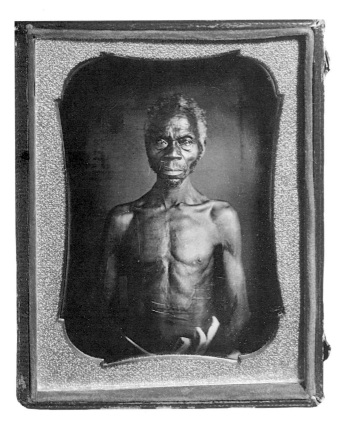

**"Portrait of Renty, Congo,
Plantation of B. F. Taylor, Esq."**

Photographer: Joseph T. Zealy
1850 • daguerreotype

(Courtesy of the Peabody Museum
of Archaeology and Ethnology,
Harvard University, 35-5-10/53037)

**"Portrait of Jack (Driver), Guinea,
Plantation of B. F. Taylor, Esq."**

Photographer: Joseph T. Zealy
1850 • daguerreotype

(Courtesy of the Peabody Museum
of Archaeology and Ethnology,
Harvard University, 35-5-10/53043)

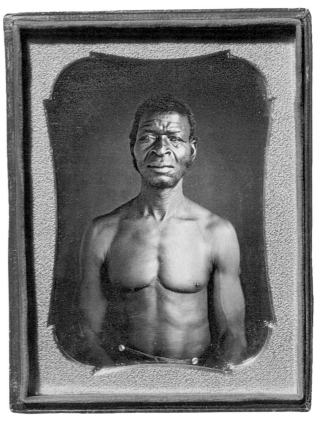

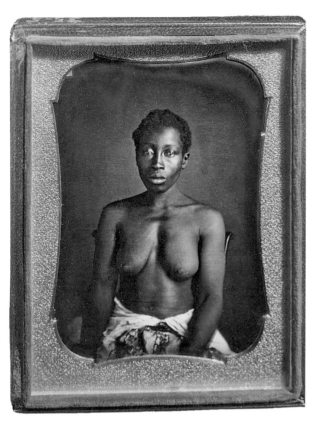

"Portrait of Delia, American born, daughter of Renty, Congo"

Photographer: Joseph T. Zealy
1850 • daguerreotype

(Courtesy of the Peabody Museum of Archaeology and Ethnology, Harvard University, 35-5-10/53040)

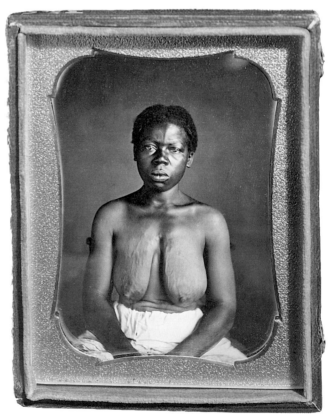

"Portrait of Drana, country born, daughter of Jack"

Photographer: Joseph T. Zealy
1850 • daguerreotype

(Courtesy of the Peabody Museum of Archaeology and Ethnology, Harvard University, 35-5-10/53041)

for scientific scrutiny. Their photographic exposure mimicked the way in which enslaved women were stripped, prodded, probed, and examined in public slave markets. The daguerreotypes of Delia's and Drana's unclothed torsos convey, in the words of Deborah Willis and Carla Williams, "the pornography of their forced labor and of their inability to determine whether or how their bodies would be displayed." [6]

Delia and Drana could not control or openly object to how Zealy posed them and Agassiz viewed their living bodies or photographic representations. Art historian Lisa Gail Collins likens Zealy's studio to the scientist's laboratory and the camera to an "instrument of dissection," suggesting that Delia and Drana were required to stare directly at the camera and thus at Zealy, as well as subsequent viewers, to facilitate their presentation as scientific specimens.[7] The interest in documenting racial types allowed the setting aside of social conventions that forbade an enslaved person to look directly, eye to eye, at a white person. Yet having Delia and Drana meet the eye of the camera and viewer did not in fact place them on an equal footing with white people, because it departed from the standard approach to portrait photography. According to Alan Trachtenberg, mid-century photographers directed their subjects to stare off into the distance rather than directly at the camera, contemplating serious or pleasurable thoughts, depending on the preferred facial expression. Thus the pictures of Delia and Drana present carefully composed images of black women's bodies and faces that were designed to demonstrate their inherent racial difference and inferiority. We cannot know what Delia and Drana saw or thought when they looked at the camera and its operator. To men like Agassiz and Gibbes, taking photographs of Delia and Drana represented the advancing of scientific and technological knowledge. For Delia and Drana, however, having to undress in Zealy's studio and sit in front of his camera was yet another instance of bodily subjugation and exploitation. Today, these images stand out as painful historical relics of slavery's brutal and often sexual degradation and exploitation of black women's bodies. Yet these images are also important historical sources that prompt consideration of the lives of these specific women whose bodies were placed on display, as well as all the women and men whose bodies were controlled by their owners.

While the Agassiz/Zealy images confront the viewer with stark representations of slavery's physical, emotional, and sexual violence, our research also led us to consider another type of image in which enslaved women figure prominently. In the antebellum period, it was not uncommon for slaveholders to have pictures made of an enslaved woman holding the slaveholder's child. In this genre of photography, examples of which can also be found in Brazil and other slave societies, a black woman, or even a young girl, is often pictured with a white child in her arms or on

her lap, functioning as a human brace to hold the child steady. In other examples, such as the image titled "Father, Daughters, and Nurse," a black woman is positioned alongside older children and their father. The inclusion of a slave in these portraits of white children and families signaled the family's wealth and, like fancy clothes or jewelry, was a mark of status.[8] The presence of a black nurse also reflected the sentimentality slaveholders projected onto the black women who worked in their homes: the stereotypical "mammy," the stern but loving caretaker and devoted slave/servant, present as "a favored doll or pet, as a record of a treasured possession."[9] A viewer could see that the black subject was well dressed, suggesting that she was also well cared for—a counterweight to abolitionist arguments.

Unlike the images of Delia and Drana, photographs of female domestic workers did not aim to present an ostensibly objective documentation of racial typology. Yet enslaved women's presence in these images necessarily distinguishes them from other types of portraiture. In the nineteenth century, portraits were meant to highlight the sitter's individuality and confirm his or her personhood in what Alan Sekula describes as a "*private* moment of sentimental individuation."[10] In the so-called mammy photographs, however, black women were presented not as self-defined individuals but as implicitly bound to both the white child and its family as an object of subordination, however beloved. Working together, white photographers and slaveholders produced images that aimed to present slavery as an appropriate, beneficial, and benign institution based on a natural racial hierarchy. Such images create a visual narrative of the romantic myth of mutual obligation and affection, captured in that rhetorical image favored by slaveholders of the "family, white and black."[11] These pictures thus offer what Jacqueline Goldsby describes as "a *subjectively construed* interpretation of reality, one that is imposed upon us *formally*—through composition, framing, lighting, exposure, angle."[12] When we look at these images today, nearly a century and a half after slavery's demise, we see black women's physical presence, but we can also see their vulnerability to exploitation, violence, and sexual abuse, as well as the erasure of enslaved women's and girls' labor and the countless acts of sale, gift, and bequest that ruptured enslaved people's marriages and families.

What about images in which enslaved women sit alone, unaccompanied by white children or adults? At first glance these may appear more like traditional portraiture in which the individual presents herself to the camera and viewers. Although it is possible that some enslaved people had pictures made for their own possession, it is more likely that slaveholders also orchestrated the production of these images. Indeed, having favorite slaves pose for pictures was yet another way to assert control over black people's bodies and lives. Slaveholders sometimes used these images to illustrate their beneficence, as the owner of Louisa Picquet's mother

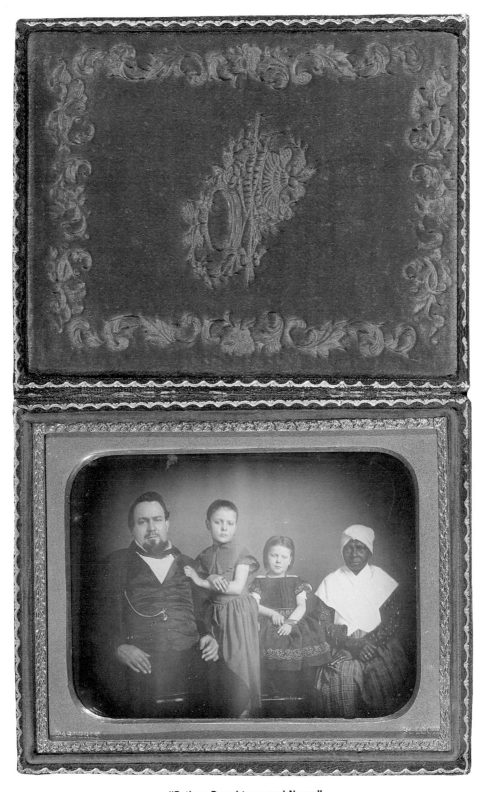

"Father, Daughters, and Nurse"

Photographer: Thomas Martin Easterly • c. 1850 • daguerreotype, hand-colored

(J. Paul Getty Museum, Los Angeles, 84.XT.1569.1)

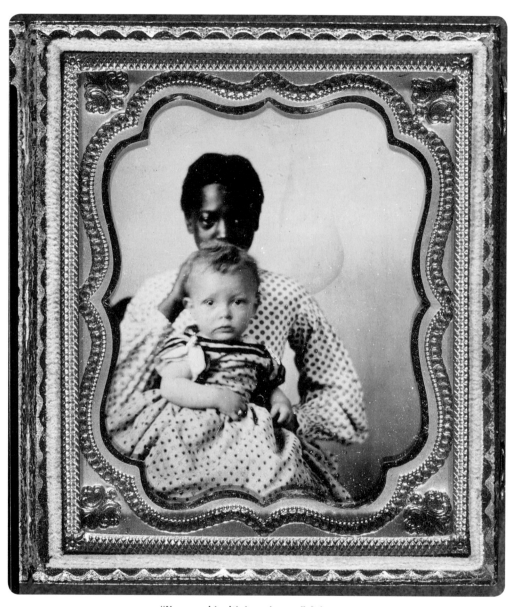

"Nursemaid with her charge," Arkansas

Photographer unknown • c. 1855 • ruby ambrotype, sixth plate, hand-colored

(Library of Congress, Prints and Photographs Division, LC-USZC4-5251)

did in 1859. Louisa Picquet, who was born in Columbia, South Carolina, around 1830, was separated from her mother, Elizabeth Ramsey, and her baby brother and sold to a New Orleans man when she was about thirteen. Picquet eventually obtained her freedom upon her master's death. Her mother and brother wound up in Texas, where they remained in bondage. When Picquet contacted A. C. Horton, her mother's owner, to inquire about purchasing her, he scoffed at the offer, insisting that despite Elizabeth Ramsey's advanced age she remained an able-bodied laundress and cook. To prove his point, Horton had Ramsey and her son dress in "their best possible gear" and pose together for a photographer to produce a picture that would "impress [the viewer] with the superior condition of the slave."[13] This picture has unfortunately either not survived or not yet been located and identified. Like the images of Delia and Drana, it was designed to supply visual evidence of the natural order and orderliness of slavery.

If mastery included the power to create and command images, we are left with the question of what these pictures meant to the women they represented. As archaeologist Maria Franklin reminds us, photographs would have been shared and available for viewing in slaveholders' homes.[14] The enslaved subjects of these images—who would not have commissioned the photographic session or posed in clothing of their own choice—would certainly have encountered the images and thought about them while living and working in their masters' households. In one carte-de-visite,[15] a young woman sits in a simple chair against a plain backdrop. Her hair is covered with a scarf, in a manner customary among enslaved women in the Southeast and possibly reflective of African traditions. Her hands are folded in the lap of her voluminous skirt, and she stares directly and stonily at the photographer and viewer. Hers is not a contemplative or reflective pose. Rather, she appears uncomfortable, possibly resigned, masking her inner self. A notation on the back of the image (which could have been made by the photographer at the time of processing the photograph or at a later date) identifies her simply as "A southern slave, Va. 1861."

Another carte-de-visite of an enslaved woman appears on a handwritten "Wanted" notice composed by Louis Manigault, a wealthy and prominent slaveholder, about a woman named Dolly, who freed herself by running away from his home in Augusta, Georgia, in April 1863, a few months after Lincoln signed the Emancipation Proclamation. At the top of the page, we see a carte-de-visite image of Dolly. She sits in an ornate chair against a plain backdrop, and, as is common in photographs of enslaved women, her head is wrapped in a white kerchief. The image is cropped just below her shoulders. Was she sitting alone or holding one of the young Manigault children in her lap? She looks directly ahead and returns the viewer's gaze with her own stern look.

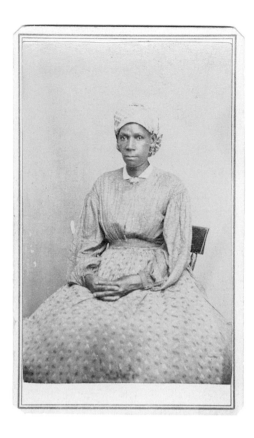

Woman wearing a headwrap

Photographer unknown
1861 · carte-de-visite

(Randolph Linsly Simpson African-American
Collection, Yale Collection of American
Literature, Beinecke Rare Book and Manuscript
Library, JWJ MSS 54)

As part of Manigault's account of Dolly's escape, the image functions as a component of his narrative of mastery, identifying her as stolen property that should be located and returned. Like the neatly hand-printed labels that Zealy affixed to his daguerreotypes of Renty, Jack, and Delia, Manigault's written notice classified both Dolly and her photograph as property. Dolly's face appears at the top of the notice as a form of documentation, displaying the missing item. The photograph is not a portrait of a young woman but visual confirmation of Manigault's ownership.[16]

Dolly was, in Manigault's estimation, "rather good looking"; she possessed a "fine set of teeth" and "hesitates somewhat when spoken to," making her, depending on one's interpretation, either shy or appropriately subservient. This detailed written assessment of her body and demeanor reinscribed Manigault's claims to Dolly's physical body by making clear his power to look at and inspect her and also make her available for public display and scrutiny in writing and visual imagery. It is also indicative of his own fixation with her body and beauty. Manigault explained that he had owned Dolly since her birth; she had "never changed owner" and had always worked as a house servant.[17] By suggesting her physical fragility and limited geographic knowledge of the surrounding area, Manigault's version of Dolly's life securely anchored her in his patriarchal household, both as property and as an

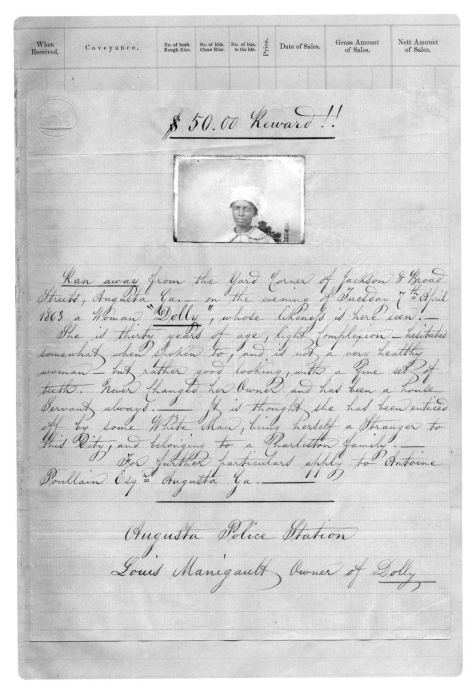

When Received.	Coveyance.	No. of bush. Rough Rice.	No. of bbls. Clean Rice.	No. of bus. to the bbl.	Price.	Date of Sales.	Gross Amount of Sales.	Nett Amount of Sales.

$ 50.00 Reward!!

Ran away from the Yard Corner of Jackson & Broad Streets, Augusta Ga. — on the evening of Tuesday 7ᵗʰ April 1863 a Woman "Dolly", whose likeness is here seen. —

She is thirty years of age, light Complexion — hesitates somewhat when spoken to, and is not a very healthy woman — but rather good looking, with a fine set of teeth. Never changed her Owner and has been a house Servant always. — It is thought she has been enticed off by some White Man, being herself a Stranger to this City, and belonging to a Charleston Family. —

For further particulars apply to Antoine Poullain Esqᵣ Augusta Ga. —

Augusta Police Station

Louis Manigault, Owner of Dolly

"Dolly"

Photographer unknown • c. 1863 • carte-de-visite and manuscript page

(University of North Carolina Library, Chapel Hill, Manigault Papers, no. 484, vol. 4)

*Reward notice for a runaway female slave from the
plantation journal of Louis Manigault.*

enslaved woman who lived and worked in close proximity to her master. Unable to believe or unwilling to acknowledge publicly that Dolly could have imagined herself free from his control, Manigault surmised that she had been "enticed off by some White Man."[18] Other documentation raises the possibility that she had in fact fled with a free black man who had been courting her.[19] Louis Manigault offered fifty dollars to the person who captured and returned her, but Manigault never saw Dolly again.

From her perch on the top of the page, Dolly haunts the archives, her photographic presence always reminding us of her bodily absence from Manigault's plantation and possession. Like so many other images of enslaved and freed black people, the picture of Dolly confirms her existence but reveals precious little about her life. What did she envision when she planned her escape? What did she see around her when she stepped outside her master's yard and closed the gate behind her? When we look at her picture, we see her life in slavery, but we also recognize that the picture is a testament to her liberation. Dolly's picture, with its mysteries and unanswered questions, is one image of what freedom looked like.

Representing the Appeal

Slaveholders' and scientists' images of enslaved women and men stand in stark contrast to the ways in which black people represented themselves in the 1850s. Portraits commissioned by free black men and women, as well as images created by sympathetic white abolitionists, convey self-worth, dignity, beauty, intellectual achievement, and leadership.

In the decade before the Civil War, free black men and women lived on dangerous ground. In a society that had long equated blackness with lifelong and heritable servitude, to be free and black was to be a social and legal anomaly. The dangers free black people faced became even greater in 1850 with congressional approval of the Fugitive Slave Law. The law reinvigorated the Fourth Article of the U.S. Constitution and also a 1793 law governing the return of fugitive slaves, as property, to their owners. Placing the weight of the national government behind slaveholders' efforts to capture runaway slaves, the 1850 law held the state governments responsible for seizing and restoring runaways to their owners. It also criminalized and imposed stiff penalties for assisting fugitives or impeding their capture and arrest.[20] For free black people in the northern states, especially those, like Douglass, who had liberated themselves by escaping from slavery, freedom was ever more precarious.

It was during this period that many free black Americans set their sights

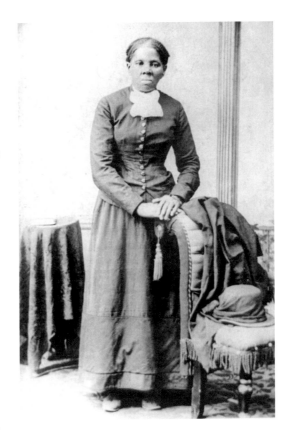

**Portrait of Harriet Tubman
(c. 1820–1913)**

Photographer: H. B. Lindsley
c. 1864 • photograph

(Charles L. Blockson Afro-American
Collection, Temple University Libraries)

on Canada and Liberia as places where they could safely distance themselves
from the threat of kidnapping and (re)enslavement. Images of black Americans
who emigrated to Liberia thus add another dimension to the picture of black
freedom. Photographic portraits depict men and women as refined and prosperous
entrepreneurs and political leaders. Comfortable settings and reflective, thoughtful
gazes, however, coexist with the understanding that freedom might be assured only
through voluntary exile.

Photographic portraits commissioned by noted orators, activists, and leaders
like Frederick Douglass, Harriet Tubman, and Sojourner Truth advanced their
antislavery campaigns in multiple ways. Photographs of Sojourner Truth are perhaps
the best-known nineteenth-century photographic images of a black woman. Truth,
born in 1797 in upstate New York, gained her freedom in the late 1820s when the
laws of New York State finally abolished slavery. Historians Margaret Washington,
Carla Peterson, and Nell Irvin Painter have written magnificently detailed histories
of Truth's life and career as an antislavery and women's rights orator and activist.[21]
As these scholars note, Truth's personal history of enslavement in New York stands
as a powerful reminder that slavery was always a national issue.

Truth understood very well the economic and political power of creating and circulating her photograph. Having initially supported her abolitionist activities by selling the narrative of her life story, Truth later sold carte-de-visite and cabinet card portraits for thirty-three and fifty cents each.[22] "I am living on my shadow," she wrote, and eventually the images were distributed with the caption "I Sell the Shadow to Support the Substance."[23] She posed in a number of photographic studios. One Randall Studio portrait taken in Detroit, Michigan, around 1870 is a cabinet card of a seated Truth, her hands crossed in her lap as she gazes directly at the camera. As historian Nell Painter notes, "Sometimes she is dressed in the Quaker-style clothing that feminists and antislavery lecturers wore to distinguish themselves from showily dressed actresses, their less reputable colleagues in female public performance."[24] Truth posed in front of various backgrounds and with different props, such as books, flowers, and knitting, that identified her as middle-class, sophisticated, and respectable. She, like Douglass, appreciated the potential of photography, and because a receptive audience was eager to buy her pictures, she posed for at least fourteen.[25]

Like Douglass and other abolitionists, white and black, Truth crafted an image of herself that suggested her visions of the future—specifically, a future in which slavery and racism did not stigmatize and constrain all black Americans. She had, of course, engaged in the ultimate act of self-fashioning by changing her name from Isabella to Sojourner Truth when she embarked on her vocation as an itinerant preacher and orator.

Reflecting on that name, art historian Gwendolyn DuBois Shaw wrote:

Africans that arrived on slave ships in the eighteenth and nineteenth centuries were given new names as they were sold into slavery. It was not until a slave was freed that he/she was able to name him/her-self. This practice of self-naming may be found in the case of Isabella Dumont, who as a free woman became Sojourner Truth. . . . Truth was able to sell a reproduction of her body in order to sustain its source. In this manner the formerly enslaved woman was able to achieve an ironic sort of control over the sale of the representation of her selfhood.[26]

Truth's image has been engraved on the public mind since the 1860s. She used photography to construct a new image of herself as a free woman and as a woman in control of her image. Similar modes of self-representation are found within many of the portraits in this book.

Frederick Douglass, too, used images of himself to enhance his arguments

against slavery and racism. Douglass's enthusiasm for photography stemmed in large measure from his frustration with widespread racist imagery and caricature. Indeed, he decried the prevailing depictions of black people by white artists: "Negroes can never have impartial portraits at the hands of white artists. It seems to us next to impossible for white men to take likenesses of black men, without most grossly exaggerating their distinctive features."[27] Literary studies scholar John Stauffer observes that abolitionists, black and white, especially prized photography because it allowed them to translate their aspirations into material reality: "Their desire to transform themselves and their world fueled their interest in images, which helped to make visible the contrast between their dreams of reform and the sinful present."[28] Photography, Douglass maintained, offered black people of all backgrounds, including the "servant girl," the opportunity to craft their own versions of themselves.

During the early years of the Civil War, abolitionists continued to employ photography to help force the question of slavery to the center of attention in the North. When the fighting began in 1861, many northerners, including President Abraham Lincoln, maintained that the principal aim of the war was to restore the Union, not to end slavery. Though the Emancipation Proclamation of 1863 signaled a clear shift in the meanings and consequences of the war, many white northerners remained skeptical at best about the prospect of recognizing some four million enslaved black people as citizens of the United States. In New York City, white working-class antipathy toward the war and the Emancipation Proclamation was stoked by rigid federal draft regulations. Federal law required all eligible men to enter a draft lottery but exempted those white men who could either hire a substitute or pay a $300 fee. Free black men, who were not considered citizens of the United States, were also exempt. Shortly after the July 1863 lottery began in New York, white workers unleashed a wave of bloodshed and destruction, first taking aim at military and government buildings but then quickly setting their sights on black people and symbols of black freedom. Draft rioters assaulted a black fruit vendor and a young boy on the city streets and then advanced on the Colored Orphan Asylum, located on Fifth Avenue between Forty-Third and Forty-Fourth streets. On that July day, 233 children were in the building's classrooms, nursery, and infirmary when a mob of white men, women, and children, wielding clubs and bats, looted and burned the orphanage.[29]

Middle-class northerners, too, worried about what emancipation and black freedom might mean. They feared that newly freed black southerners would refuse to remain in agricultural labor, sparking a national economic upheaval; and they speculated that freed black people would seek bloody revenge against whites.

Prominent white abolitionists hoped to temper such anxieties by hiring photographers to reimagine the lives of those men, women, and children after bondage, and specifically by circulating images of young children who had been freed by the Union army in 1863. In photographic studios in Boston, New York, Philadelphia, and New Orleans, the children were usually posed in formal Victorian dress, though some appeared in tattered work clothes. These photographs were intended to show the detrimental effects of slavery and promote the education of freed children and adults. Regarding these cartes-de-visite, historian Mary Niall Mitchell says, "As members of the first generation of African Americans to grow up in the former slaveholding republic, the black child—freedom's child—represented the possibility of a future dramatically different from the past, a future in which black Americans might have access to the same privileges as whites: landownership, equality, autonomy."[30]

These mesmerizing photographs of freed children still have resonance—and so do their captions: "Isaac and Rosa, emancipated slave children from the free schools of Louisiana," "Rebecca, a slave girl from New Orleans," and "Virginia slave children rescued by Colored Troops—as we found them and as they are now." Mitchell's impressive research on these photographs offers the most comprehensive study of their effect on both southern and northern audiences. The images evoked a new and emerging class of freed blacks through such studio props as an American flag, furniture, and clothing. Public sentiment was stirred by the juxtaposition of children posed without shoes, wearing ragged clothes, and images of the same children wearing neatly pressed, undamaged jackets, dresses, shoes, and pants. These before-and-after photographs represented the formerly enslaved children as worthy of being liberated and made them appear attractive to a northern audience.

Mitchell's argument also connects the sale of these photographs to the sale of the black human form on the auction block. This reading is persuasive when one looks at the images of the light-skinned children and reflects on their "desirability" as presented there.[31] Northern viewers' fascination with these images is evidenced in the large number of them in private and public collections today. These "neatly dressed 'emancipated slave children' who were attending school . . . presented education as the means to transform young former slaves into models of discipline and propriety [and, furthermore,] eradicate slavery's effects, producing instead industrious young people with the desires of free market consumers."[32] One wonders if the children in these images had any inkling of the complex ideas behind their poses and the use of props such as the flag to depict an idealized vision of American freedom constructed primarily by white reformers and photographers.

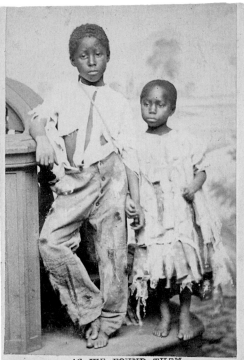

"As we found them"
("Virginia slave children rescued")

Photographer: Peregrine F. Cooper
1864 • carte-de-visite

(Courtesy of George Eastman House, International
Museum of Photography and Film, 1982:1347:0001)

*These before-and-after photographs
"civilized" the emancipated children and made
them appear worthy of sympathy
to a northern audience.*

"As they are now"
("Virginia slave children rescued")

Photographer: Peregrine F. Cooper
1864 • carte-de-visite

(Courtesy of George Eastman House,
International Museum of Photography and Film,
1982:1347:0002)

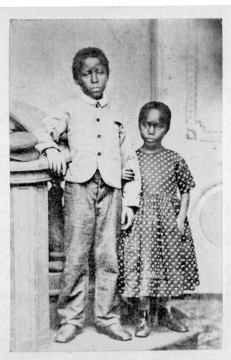

A Collective Portrait of the Civil War

Photographs recorded the presence of the black soldier and the black worker in the American South and now help a twenty-first-century reader to reimagine the landscape of black people's desire to be active in their own emancipation. Even if many white northerners and politicians repeated that the war's principal aim was to save the Union, free and enslaved black people insisted otherwise. In the earliest weeks of the war, enslaved people expressed a keen understanding of the war's potential to advance their quest for freedom. On May 23, 1861, barely one month after the war began, three enslaved men in Virginia ran away from their master, Confederate colonel Charles K. Mallory. They fled to Fortress Monroe in Hampton, Virginia, and presented themselves to Union general Benjamin Butler. The following day, a Confederate officer arrived and demanded that Butler return the three slaves under the provisions of both the U.S. Constitution and the Fugitive Slave Law of 1850. Butler, a Massachusetts lawyer, refused, claiming that the men were "contraband of war" because they had been used as laborers to build enemy (Confederate) fortifications. He then hired the men to work as laborers for the Union. During the summer of 1863, self-liberated slaves flocked to Union camps, hoping for similar protection. By the end of the summer, Congress endorsed Butler's policy of harboring and hiring fugitive slaves rather than returning them to their Confederate owners.[33]

Photography documented the quest for freedom among free and enslaved black Americans. By the 1860s photography had become a booming business; some 3000 Americans worked as photographers, capturing a wide range of black and white sitters in portraits that emphasized racial features, class attitudes, gender roles, and personal achievement. Many of these photographed subjects were soldiers; others were enslaved men, women, and children and newly freed blacks who worked as teamsters, chimney sweeps, carpenters, blacksmiths, artisans, bricklayers, seamstresses, shoemakers, washerwomen, cooks, gardeners, and midwives. White and black Americans worked as studio and itinerant photographers during the war in Washington, D.C., New York City, Baltimore, Philadelphia, Boston, Salem, Concord, and New Bern, North Carolina, among other cities. They included Henry P. Moore, Peregrine F. Cooper, Charles Paxson, E. H. & T. Anthony, Timothy O'Sullivan, Mathew Brady & Company, Alexander Gardner, Samuel A. Cooley, Ball & Thomas Studios, and the many others whose work appears in this book.

Some traveled great distances to photograph soldiers in military camps, while others preserved the memories of the war through souvenir photographs and other

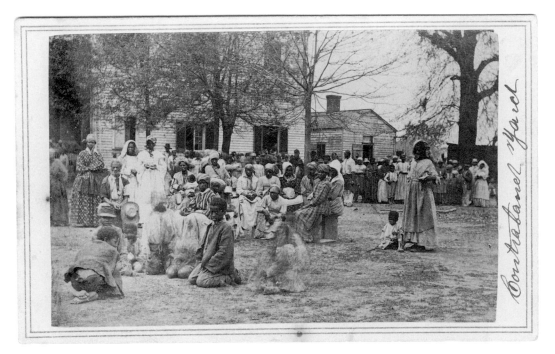

"Contraband Yard"

Photographer: J. W. Taft, Oak Gallery • no date • carte-de-visite

(Randolph Linsly Simpson African-American Collection, Yale Collection of American Literature,
Beinecke Rare Book and Manuscript Library, JWJ MSS 54, folder 498)

———

*A large group of people in various styles of dress are shown under trees
and behind houses. The tag "Contraband Yard" is written in ink on the side.*

———

types of visual memorabilia in their home studios. They provided a curious public
with full-length and three-quarter-length portraits of black soldiers standing in
front of flags, holding their weapons and gear. Several images show white soldiers
posing with their black cooks and servants. Still others depict black soldiers
and white officers in campsites, guarding weapons, sitting in front of tents and
bunkers, and laboring in the fields. These souvenirs offered loved ones hope and
an awareness of the plight of the soldiers, highlighting their bravery and service to
a nation that had not yet recognized them as full citizens. The images speak to the
depth of black soldiers' commitment to their enslaved brothers and sisters and to
their country.

Henry P. Moore's "Contrabands aboard the U.S. Ship *Vermont,* Port Royal,
South Carolina, 1862–63," is an especially engaging image precisely because

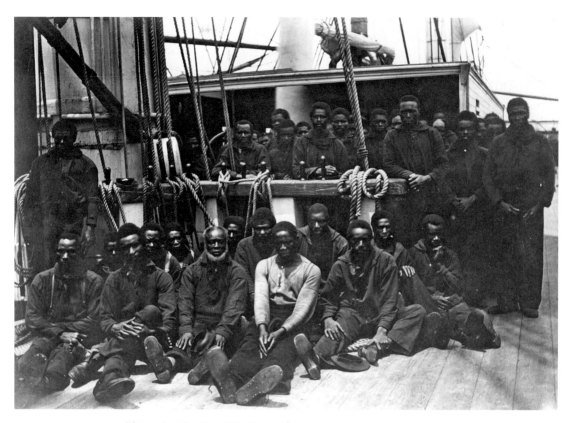

"Contrabands aboard the U.S. Ship _Vermont_, Port Royal, South Carolina"

Photographer: Henry P. Moore • c. 1862–1863 • albumen print

(Boston Athenaeum, AB54S M00.h. [no. 2])

of the ways in which it reflects a particular moment in the history of black freedom during the Civil War and also evokes the longer history of the African diaspora. In this image some thirty-four black men are gathered on the deck of a Union warship. The men, identified collectively as "contrabands," had liberated themselves by running away from their masters and gaining refuge with Union forces. Dressed in Navy-issued clothing, they sit around the ship's mainmast, looking at Moore and his camera. The image highlights both enslaved men's engagement with the war and the prevailing political debates over slavery and Union war policy. And yet it does not present a picture of black empowerment in freedom. Instead, like many Civil War–era photographs of black refugees, it renders their transition from slavery to freedom as an orderly and peaceful change rather than a monumental reordering of society. The men in this image are seated on the ship's deck; they do not assume positions of authority or control in relation

to the vessel and its weapons, its white crew and officers (who are not pictured), or the viewer. In this regard, the image is suggestive of the Middle Passage and the 12 to 14 million African captives forced into the holds and onto the decks of slaving vessels. Black men's freedom is figured against a back story of captivity, dislocation, and death.

Legacies of Emancipation

Freedom did not occur instantaneously with the implementation of the Emancipation Proclamation on January 1, 1863, or with the war's end and the subsequent ratification of the Thirteenth Amendment. Rather, freedom unfolded over time and space and was informed as much by memories of the past as by expectations and visions for the future. Portraits of former slaves interviewed for the Slave Narratives collection of the WPA and pictures of "slave reunions," for example, remind us that only the institution of slavery died in 1865. The people who had been enslaved survived through the end of the nineteenth century and well into the twentieth. Images of slaves and their freeborn descendants suggest the durability of cultural traditions across the generations, such as the patterns of quilts made by black women and girls in Gee's Bend, Alabama.

Photographs also documented the work of black men and women in turpentine and logging camps and laying tracks for the railroads. Called "convict laborers," they had in effect been forced into another form of slavery.

Even with the rise of new forms of legalized exploitation, oppression, and segregation, the medium of photography galvanized African Americans into documenting their own existence and celebrating their freedom. Across the country black people visited photographic studios or the makeshift tents of itinerant photographers. African American photographers helped to re-image and reimagine their black sitters. The photographs range from Buffalo soldiers posing outside a campsite, family portraits, and newly built schools to leaders of the Reconstruction era and campaigners for higher education, such as Booker T. Washington and Mary McLeod Bethune. Photographs of students on the campuses of Howard University, Hampton, Tuskegee, and Bethune-Cookman exemplify the promise of the future for freed blacks.

Photography documented the promise and hope of emancipation through the subjects' framing, poses, and dress. Their clothing and gazes highlighted their sense of racial pride. Props such as the American flag—whether draped inside the home or over a horse—called attention to the patriotism of this new class. Mirrors and books encouraged viewers to speculate about the sitters' beauty and access to

knowledge. Images of parades and Emancipation Day celebrations throughout the South chronicled liberation and raised political awareness among the current generation and those that followed.

The photographic images collected in this book are compelling in large measure not only because they offer us a visual record of the history of slavery and emancipation but because they also foster an affective sense of connection to the past. Scholars and theorists of photography have discussed the medium's power to elicit and shape viewers' emotional responses by evoking milestones from birth to death. Photographs of enslaved and free black people allow us to contemplate not only the history of slavery and emancipation but also our continued ties to that history and its legacies. As literary scholar Marianne Hirsch notes in her work on photography, family, and memory, photographs can provide an especially meaningful sense of connection over time and place for people whose lives were "shaped by exile, emigration and relocation."[34] In the African American context, the commodification of people and the dehumanization and degradation implicit in chattel slavery worked to exclude and erase countless black women, men, and children from the written historical record. Photographs of enslaved and emancipated black people, therefore, stand out, not only as critical historical records and relics that help us understand the past but also as vital images that confirm our ties to forebears whose names and lives we do not know. This photographic archive thus serves as a type of "family album," allowing contemporary readers to envision a collective history that recognizes the range and complexity of the black experience in slavery and freedom.

This reading of photographs made during the latter part of the nineteenth century, and from the dawn of the twentieth century through the early thirties, investigates how black pride and identity were posed and reconsidered by photographers and their subjects. In the following chapters we construct a narrative that exposes a broader visual history of America, from the mid-1840s to the mid-1930s, through photographs, letters, newspaper accounts, and legal documents. Fashioning this history through the eyes of a photo historian and an African Americanist forced us to leave our comfort zones and explore new territories, which resulted in expanding our research and finding new ways to tell this story to a wider audience. The photographs represent the range of processes available to image-makers over this period, from daguerreotypes and ambrotypes to cartes-de-visite and cabinet cards to stereographs and larger albumen and silver gelatin prints. Some have been published in other volumes on the black experience in America, but many have not; taken together, these selected images open up a new discussion of how celebrations are formed, monuments are experienced, memory is preserved, and work, family, and friendships are honored.

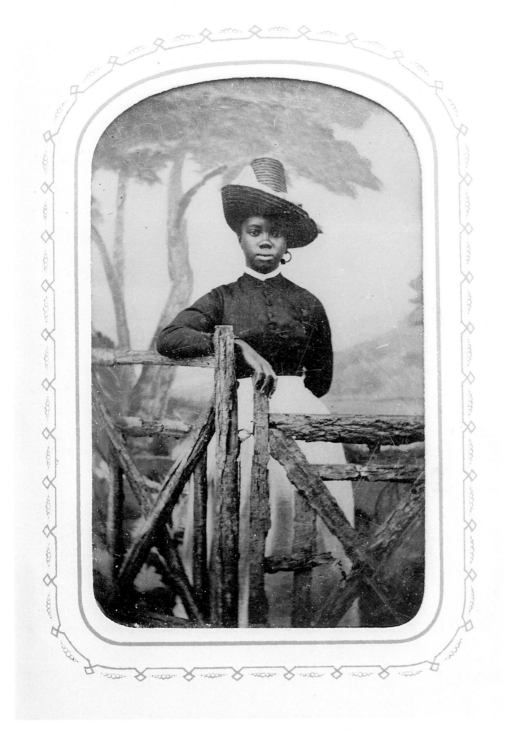

Studio portrait of young woman with hat, standing at a gate

Photographer unknown • no date • tintype

(Cheryl Finley, private collection, Ithaca, New York)

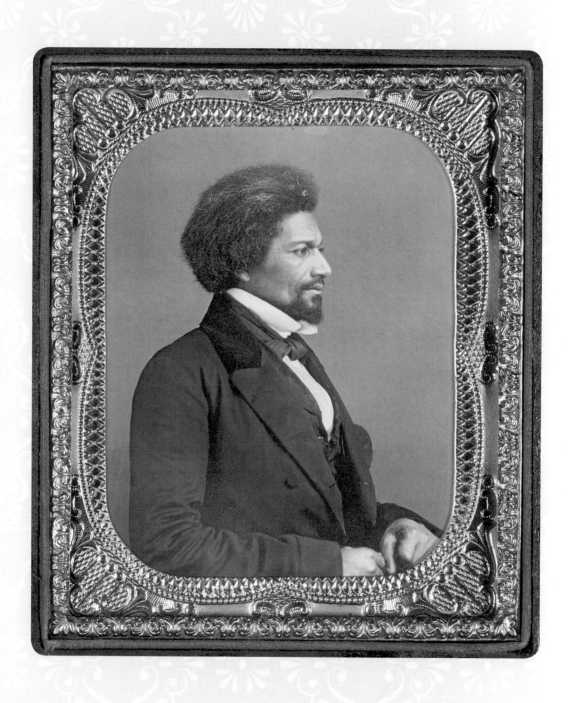

1

Representing the Appeal

With the conviction of a purpose so noble, and an end so beneficient,
I cannot notice the misrepresentations, slander and anathemas, which I
must for a while endure, even from those whose approbation and good will
I would gladly retain. It was no difficult task to have seen, that unless they
could force emancipation, and then the perfect social and political equality
of the races, human nature, human pride and passions would not allow the
Americans to acknowledge the equality and inalienable rights of those who
had been their slaves.

Augustus Washington, 1851

I send you by the mail a daguerreotype of a child about seven years old,
who only a few months ago was a slave in Virginia, but who is now happily
free by means sent on from Boston. . . . I send this picture, thinking that
you will be glad to exhibit it among the members of the Legislature, as an
illustration of Slavery. Let a hardhearted Hunker look at it and be softened.

Senator Charles Sumner, 1855

The 1850s were years of profound uncertainty for many free African Americans, accompanied by a national crisis over slavery and the place of free black people in America. The images presented in this chapter reflect the varied ways in which black Americans protested against slavery and struggled to achieve and protect their freedom.

The Fugitive Slave Law of 1850 and the 1857 Supreme Court decision in *Dred Scott v. Sandford* threatened free black people's security and underscored their civic marginality throughout the country. The Fugitive Slave Law placed all free black people, especially those who had liberated themselves,

on dangerous ground. It effectively required the arrest of suspected and known fugitives, even those who were living in free states. White and black abolitionists decried the law, protesting that it effectively forced antislavery northerners into complicity with slavery. Harriet Jacobs, who had fled her North Carolina master in 1842 and made her way to Brooklyn, New York, wrote: "What a disgrace to a city calling itself free, that inhabitants, guiltless of offence, and seeking to perform their duties conscientiously, should be condemned to live in such incessant fear, and have nowhere to turn for protection. This state of things, of course, gave rise to many impromptu vigilance committees. Every colored person, and every friend of their persecuted race, kept their eyes wide open."[1]

Dred Scott was an enslaved man from Missouri whose master had taken him to live for extended periods in free territories of the United States. Scott eventually sued his master, arguing that his residency in free territories entitled him to legal freedom. In the infamous *Dred Scott* decision, Chief Justice Roger B. Taney denied Scott's claim, writing that free and enslaved black people were not and could never become citizens of the United States, because black people had "no rights which the white man was bound to respect."[2]

Photography played a key role in abolitionists' framing of antislavery arguments, as well as the broader campaign for social and civic equality in which many free black men and women were active. Portraits of prominent black writers and orators, for example, had public and private value as reflections of black accomplishments, pride, and dignity. Publicly circulated images served to document abolitionists' gatherings, providing hope and inspiration to supporters of the cause. Images of former slaves, similarly, revealed slavery's violence but also suggested black people's endurance and resiliency. Photographs mapped the sites of black freedom and reflected the personal and political meanings of freedom in black communities and the larger society. Black Americans viewed photography as both a sign and a tool of reform and social change. Prominent figures such as Sojourner Truth, Charlotte Forten, and Frederick Douglass embraced photography as an important means of representing themselves and participating in national political debates.

Photographic portraits of these noted individuals were collected and widely circulated and thus preserved for future generations to view. Historian Michael Bieze describes the collections found in some African American homes in North Carolina in the late nineteenth century:

When a sociologist from Trinity College (now Duke University) took a random sampling of the art in black homes in a black working class section of Durham, North Carolina, known as Hayti, he and his colleagues found

a great deal of art. Found on the walls were portraits of famous Americans like Frederick Douglass, William McKinley and Booker Washington. They also found the homes filled with books, including the works of John Ruskin. But the big surprise was the number of photographs: "Besides these [portraits of famous Americans] there were many crayon portraits [chalk drawings based on photographs] representing individuals of the several families occupying homes. Quite numerous photographs were seen in albums and on tables, mantels and bureaus."[3]

Prior to the development of photomechanical reproduction in the latter half of the nineteenth century, consumers purchased, collected, and coveted original photographic prints as a way of showing their social, cultural, and political sophistication. Frederick Douglass's daguerreotype from about 1858 offers a sense of how he viewed himself— confident, handsome, and vigorous, with an expressive gaze and stylish dress. He is immortalized in this image as a striking young man looking away from the camera and toward the future. His hair is well coiffed; his suit jacket, glossy vest, and wide black bowtie suggest his status as a highly regarded orator and prominent public intellectual. Art historian Richard J. Powell describes Douglass in terms of the persona of the black activist dandy of the antebellum period: "A man of imposing height (over six feet), strong, masculine features, and wavy, mane-like black hair, Douglass often wore the most elegant suits, vests and neckties. His impressive attire, combined with his handsome features, deep, rousing voice, and dramatic delivery, converted the susceptible and startled the unassuming."[4]

Prominent women, likewise, presented themselves as sophisticated, thoughtful, and insightful. Historian Martha S. Jones interprets this dynamic period for black women's activism in abolitionist and women's rights campaigns: "To be a young African American woman in the 1850s was to glimpse an opening into public culture and perhaps to wonder what one might make of it."[5] Charlotte Forten, for example, came of age in this time of new and exciting opportunities to participate in the black public political culture; during the Civil War she would travel to the Sea Islands to work as a teacher in a community of newly freed people. As a young woman Forten was one of the daring few to purchase and wear bloomers, loose-fitting pants for women. In the summer of 1854, she put on her bloomers and "ascended the highest cherry tree. . . . Obtained some fine fruit, and felt for the first time 'monarch of all I surveyed.'"[6] A small number of black and white women experimented with this new attire in the early 1850s. Their shedding of traditional women's clothing in exchange for pants, however, proved too radical and ultimately detrimental to their respectability and legitimacy as female

activists, and the new clothing was quickly abandoned. Jones writes that Forten "represented a cross-generational history of northern free black public culture and, coming of age in the 1850s, was raised navigating the turbulent waters of women's rights, responsibility, and respectability."[7]

The image of Forten included in this volume presents her as elegant and thoughtful, holding a book in her lap. Forten wrote in her journal about the experience of having a photograph taken at Samuel Broadbent's studio on Chestnut Street in Philadelphia on July 5, 1857: "Mr. C. came and insisted on taking me to Broadbent's where I had an excellent likeness taken" (this is not the equally fine portrait presented here). Like so many other black activists, Forten understood the place and power of photography in the antislavery movement: "Miss J. was there and showed me a daguerreotype of a young slave girl who escaped in a box. My heart was full as I gazed at it; full of admiration for the heroic girl, who risked *all* for freedom; full of indignation that in this boasted land of liberty such a thing *could* occur."[8] Black women in the northern states had their pictures made and shared them with each other as gifts that provoked thought and emotion and inspired action. As we have seen, Sojourner Truth posed for pictures that she sold to earn money. Women who purchased her picture treasured the sense of connection they gained from owning her likeness. Mrs. Josephine Franklin, a young woman from Brooklyn, wrote to Truth: "You asked me if I was of your race, I am proud to say I am of the same race that you are, I am colored thank God for that." She had purchased Truth's photograph for herself and the other women in her family—as many copies as she could afford.[9]

Photography offered Truth much more than a vehicle for crafting a public and marketable image that could help support her political activism. Just as Truth's likeness provided inspiration, she too derived comfort and a sense of connection from meaningful images. In the image included here, she is pictured wearing a polka-dot dress and leather apron. An open daguerreotype rests in her lap—a picture of her grandson, James Caldwell, the son of Truth's daughter, Diana Dumont. Caldwell enlisted in the legendary Fifty-Fourth Massachusetts Regiment during the Civil War. With one hand on her hip and the other arm resting on the table next to her chair, Truth looks toward the camera with an aura of gravitas. As historian Margaret Washington writes: "Gazing past the camera in earnest, straight-faced solemnity, reflecting the perilous times and enormity of her mission, she also smiled slightly in some photos, exuding warmth, sagacity, strength, and intelligence. Her face, her bearing, and her powers of communication gave this African woman a certain star quality and appeal."[10]

An 1850 daguerreotype of an abolitionist convention in Cazenovia, New York, is one of the most remarkable images from this period. Made by local

daguerreotypist Ezra Greenleaf Weld, it presents a multilayered history of black people's efforts to free themselves from slavery and organize opposition to the newly enacted Fugitive Slave Law. It is a picture that tells us about the complexity of the abolitionist movement and the relationships among the black and white women and men engaged in antislavery activism.

In the summer of 1850, Frederick Douglass and his white ally Gerrit Smith organized a convention to protest against the Fugitive Slave Bill, which the Senate had just approved and which would soon be signed into law by President Millard Fillmore. They placed a notice in a Boston antislavery paper, describing the upcoming event as

> a meeting of the persons who have escaped from Slavery, and those who
> are determined to stand by them. . . . The object aimed at on the occasion
> will not be simply an exchange of congratulations and an expression of
> sympathy, but an earnest consideration of such subjects as are pertinent
> to the present condition and prospects of the Slave and Free Colored
> population of the country.[11]

The meeting began on August 21, 1850, with Douglass presiding. He and Smith had initially planned to hold their gathering in a local church that could accommodate several hundred. When approximately two thousand people arrived for the event, it was moved to a nearby apple orchard.

Gerrit Smith delivered one of the convention's featured speeches, "A Letter to the American Slaves from those who have fled from American Slavery." In this speech he assumes the role of a fugitive slave and calls for direct resistance and rebellion against slaveholders and the institution of slavery. Douglass later predicted: "That address will cause a howl to go up from all the bloodhounds of our land. It will be denounced as immoral, cruel and monstrous. . . . The escaping slave is told to escape from his bondage, and take possession of any and everything belonging to his master which he may need for his journey." Because of slavery's fundamental inhumanity, Douglas insisted that

> slave laws should be held in perfect contempt; that it is the duty of the slave
> to escape when he can; and that it is equally the duty of every freeman
> to help the slave in his flight to freedom when he can. For our part, We
> rejoice in every successful escape from slavery; not more because it leaves
> one less to be redeemed from bondage, and is one more added to the ranks
> of freedom, but because it serves to weaken the whole system of slavery, by
> rendering slave property insecure.[12]

Douglass believed strongly that the fugitives from slavery who attended the convention should have a chance to speak for themselves. On the first day Douglass, himself a fugitive, delivered a rousing ninety-minute speech, but he was not the only well-known self-liberated person to speak at the event. The next day two young women, Mary and Emily Edmonson, spoke briefly about their own experiences fleeing slavery and paid tribute to William Chaplin, a white abolitionist who had helped them gain their freedom.[13]

The Edmonson sisters had been born into slavery, along with their siblings and mother, in Washington, D.C. On the night of April 15, 1848, white residents of the nation's capital turned out in the streets to celebrate the news that the revolution in France had yielded a new democratic republic. Elected officials paid tribute to the revolutionaries and lauded the end of tyranny in France, untroubled by the irony of celebrating liberty while also vigorously defending their right to own slaves. Members of Washington's black community gathered on the crowd's edge and plotted to seize their own liberty. Word passed among the black men and women that a schooner called *Pearl* was waiting on the Potomac River, and its captain was willing to ferry black people to the North. Samuel Edmonson, Mary and Emily's older brother, persuaded five of his brothers and sisters to make their bid for freedom. Seventy-seven people boarded the *Pearl* that night with the intention of liberating themselves. The ship set sail at midnight, but by the following morning slaveholders had discovered the escape and organized search parties. The ship was soon overtaken. Irate slaveholders sold the fugitives to Bruin and Hill, a slave-trafficking business based in Alexandria, Virginia. The firm paid $4,500 for the six Edmonsons and refused to sell Mary to a sympathetic local white buyer for $1,000. The traders wanted to sell the Edmonson girls at the slave market in New Orleans, where buyers paid high prices for the young women they intended to use as concubines and breeders.

In the autumn of 1848, Paul Edmonson, father of the Edmonson children and a free man, negotiated with Bruin and Hill and persuaded them to sell his daughters to him for $2,250 if he could raise half of the purchase price before they left for New Orleans. Friends and supporters in Washington donated money, but more was needed. With the aid of white abolitionists, he headed to New York, hoping to appeal to the well-established abolitionist community there. He met with the Reverend Henry Ward Beecher, who was stunned by Edmonson's recounting of the slave traders' explicit discussion of selling the girls for sex. On October 24, 1848, Beecher spoke to a full house at a fundraising event in the Broadway Tabernacle and railed against slavery, and especially the sexual violence and exploitation inflicted on enslaved women. He stirred the audience into a frenzy by appealing to their emotions, asking them to place themselves

in the position of Paul Edmonson: "How would you feel if your daughter were kidnapped and sold to a man who would rape her, sell her children for a profit, and whip her if she put up resistance?" That evening the crowd contributed over six hundred dollars for the Edmonsons.[14]

Donations from black and white abolitionists enabled Paul Edmonson, with the aid of William Chaplin, to purchase his daughters' freedom. (Chaplin actually purchased the two young women and then relinquished his property rights to their father.) Mary and Emily Edmonson then traveled north, where Chaplin helped them locate a school that would educate black women. They soon established themselves as antislavery speakers.

Beecher was not alone among abolitionists in speaking of the ways in which slavery sanctioned and indeed promoted the sexual abuse of black women, the desecration of the bonds between mother and child, and the destruction of family relationships. Indeed, by the 1850s much abolitionist rhetoric invoked images of shackled slave women pleading for sympathy and intervention. In her autobiographical account of slavery, Harriet Jacobs repeatedly alluded to the sexual violence endured by enslaved women, writing in one instance: "Slavery is terrible for men; but it is far more terrible for women."[15] While the imagery of abused and exploited enslaved women and mothers was an especially effective means of arousing sympathy and support for the antislavery cause, black women activists, including former slaves, did not present themselves as helpless and vulnerable. Rather, activists like the Edmonson sisters and Jacobs portrayed themselves as intelligent, empowered, sensitive, and dignified women.

In the picture of the Cazenovia convention, we can see how the Edmonson sisters presented themselves. They are not objects of pity or sympathy. Dressed in the style of their day, they stand in the center of the image on either side of Gerrit Smith, who may be delivering his keynote speech. Frederick Douglass sits at a table in front of them. Next to him is Theodosia Gilbert, who was engaged to William Chaplin; in this picture she is wearing bloomers.[16] The sisters share center stage with Douglass and Smith, full participants in the convention and the ongoing campaign for black freedom. Newspaper accounts of the convention noted that they spoke movingly about Chaplin, the man who had facilitated their purchase and freedom. Chaplin had been arrested in 1850 for helping slaves owned by two Georgia congressmen escape. His arrest and imprisonment were among the central topics addressed at Cazenovia, and the Edmonson sisters testified before the crowd about Chaplin's dedication to the cause.[17] A few years later Emily Edmonson would speak in Rochester to raise money to purchase her brother's freedom.[18] This picture documents enslaved women's efforts to free themselves and also helps us consider how they imagined their lives in freedom.

Photographers' archives depict the various paths to emancipation. Perhaps more than that of any other photographer of this period, Augustus Washington's work represents the complex, shifting, and multiple meanings of freedom for black people in antebellum America. Washington's portrait of white abolitionist John Brown, coupled with his portraits of black emigrants to Liberia, points to the different avenues black people considered as viable means for pursuing freedom during the age of chattel slavery.

Augustus Washington was born free in Trenton, New Jersey, around 1820. He worked as a teacher and distinguished himself as an activist, not only for the abolition of slavery but also for the recognition of free black people's rights as citizens, especially black men's right to vote. From 1842 through 1844 he attended Dartmouth College in Hanover, New Hampshire, where he learned to make daguerreotypes. Later, in Hartford, Connecticut, he opened a daguerreotype studio and became well known for his artistry. Alan Trachtenberg explains that in the mid-nineteenth century people expected photographs to offer more than a straightforward likeness of the subject; they wanted the images to indicate the subject's inner self: "It was in the practice of portraiture that photographers first came to think of themselves as 'artists,' trained in perception as well as technique, equipped with intuitive as well as mechanical means."[19]

Black Americans' interest in photography and black photographers' command of the technical and artistic aspects of their work support our contention that black Americans embraced photography not simply for its novelty or aesthetic value but for its recognized potential to present powerful social and political arguments. For many white Americans, the belief that the physical body could be scrutinized and inspected for evidence of supposedly natural traits was associated with racist myths and ideologies. Black photographers like Washington also participated in the national and transnational debates over slavery and black freedom through their work and the images they produced. He made his portrait of militant abolitionist John Brown in Connecticut in 1846 or 1847, around the time Brown first met Frederick Douglass. Though Brown would not enter the national stage for another decade, Washington's portrait depicts his sitter's unwavering commitment. With his right hand raised, Brown appears to be making an oath or pledge. In his left hand he holds what is believed to be the flag of the Subterranean Pass Way, his militant version of the Underground Railroad.[20] Washington's image of Brown suggests their shared work in the abolitionist movement and endures as a prescient vision of what Douglass and so many others regarded as Brown's martyrdom for the "righteous cause" of black freedom.[21]

Washington's work offers a unique window onto the transnational scope of black Americans' thinking about slavery and freedom during the antebellum period. His portraits of men and women who emigrated from the United States to Liberia offer compelling visual evidence of the history of African colonization. These portraits remind us that black Americans had differing, changing, and conflicting ideas and attitudes about where they could live and thrive individually and collectively.

In December 1816 a small group of prominent white men founded the American Colonization Society (ACS) in the belief that racism in the United States was an insurmountable obstacle to black freedom and citizenship. As an alternative to having a population of free black Americans who were not recognized as citizens and whose social and economic conditions were severely constrained by racist attitudes and laws, colonizationists proposed deporting free black people and creating a free black colony in West Africa. They expected their plan to encourage slaveholders to manumit their slaves over time and send them to Africa. The ACS established the colony of Liberia, which became an independent nation in 1847, with the goal of supporting manumission and relocation. Free black people bristled at the notion that they should be removed from the country of their birth; nor did they like the idea that their antislavery work should be cut short by deportation. From 1820 through the end of the Civil War, only approximately twelve thousand free black people and manumitted slaves emigrated to Liberia.

Washington was among the critics of colonization until Congress enacted the Fugitive Slave Law in 1850. In an 1851 letter to ACS leaders, he wrote that he had changed his stance because he was now convinced that the black man could not enjoy "those inalienable rights to which he, with other oppressed nations, is entitled." Acknowledging black opponents' charge that the plan actually supported and encouraged racism, he still could not see any other viable option: "Seven years ago, while a student, I advocated the plan of a separate State for colored Americans—not as a choice, but as a necessity, believing it would be better for our manhood and intellect to be freemen by ourselves, than political slaves with our oppressors."[22]

Washington emigrated to Liberia with his wife and their two young children in 1853, bringing with him $500 worth of "daguerrean materials." He worked as a teacher in Monrovia, the capital, and also as a daguerreotypist; he ran a store as well, but it was not very profitable. Eventually Washington gave up the photography business and established himself as a farmer and merchant. He was elected to the Liberian National Legislature in the 1850s and was appointed a judge.[23]

Washington's portraits thus offer us an opportunity to contemplate the lives of those black Americans for whom freedom and exile were coeval. The images

depict well-dressed, refined men and women and suggest their social, political, and economic accomplishments. They can be seen as strong endorsements of colonization, while leaving open the possibility that one might also view them as reminders of the dire conditions, including enslavement, that drove some black Americans from their country.[24]

The story of the McGill family allows us to consider some of the factors that informed the decision to leave the United States for Liberia. George McGill was born into slavery in Maryland in 1787. He eventually gained his freedom by purchasing himself, and he also bought the freedom of his father and siblings. A teacher and businessman in Baltimore, McGill was dismayed by the political, social, and economic constraints imposed on free black people. The Haitian Revolution sparked his interest in leaving the United States; one of his sons later recalled his father's pride in "the final triumph of the blacks" in Haiti.[25]

McGill emigrated to Liberia in 1827, where he worked as a teacher and Methodist preacher; his wife and four children joined him there in 1830. His sons became prosperous businessmen in Liberia; Urias (whose picture we include in this book) also captained a trans-Atlantic ship. McGill's only daughter, Sarah, married John B. Russwurm, who was co-founder in 1827 of *Freedom's Journal*, the first black-owned and -operated newspaper in the United States. Russwurm, like Augustus Washington, had initially opposed colonization but later shifted his views; he eventually served fifteen years as governor in Liberia. In his biography of Russwurm, historian Winston James asserts that the unidentified woman in the 1854 photograph included here is "almost certainly Sarah McGill Russwurm."[26] In this portrait we see a young woman in fashionable attire. The seaming on the bodice of her dress is embellished, and she wears a delicate lace collar, adornments consistent with 1850s women's fashion. Black lace gloves and large earrings convey sophistication and suggest financial comfort, if not wealth.[27] She holds a closed daguerreotype case in her hand, another marker of her engagement with the contemporary culture of sentiment associated with photography. Photographed two years after her husband's death, she seems to look past the camera, with perhaps an air of resignation or quiet dignity.

Civil War–era images of freed slaves, like the ones discussed above, were intended by abolitionists to arouse the viewer's sympathy and support for the antislavery cause while pointing toward black people's future in freedom. Images of newly freed children, especially, created narratives in which well-educated young people moved easily from slavery to freedom, assuring northern viewers that the abolition of slavery would be tranquil and would not result in social and economic upheaval.

The widely circulated carte-de-visite of the self-emancipated Gordon presented a different narrative. The original photograph of the "runaway" Gordon was taken by McPherson & Oliver of New Orleans, possibly in that city. Private Gordon is seated sideways on a wooden chair, with his hand placed delicately on his hip. His shirtless body shows the evidence of beatings and whippings in the form of keloid scars. Having escaped from his Mississippi master by rubbing himself with onions to throw off the bloodhounds, Gordon found refuge with the Union army at Baton Rouge. In 1863 *Harper's Weekly* published three engraved portraits showing him "as he underwent the surgical examination previous to being mustered into the service—his back furrowed and scarred with the traces of a whipping administered on Christmas Day last."[28] The back of the carte-de-visite includes the comments of S. K. Towle, the surgeon with the Thirtieth Regiment of the Massachusetts Volunteers, who examined Gordon's scarred body: "Few sensation writers ever depicted worse punishments than this man must have received, though nothing in his appearance indicates any unusual viciousness—but on the contrary, he seems intelligent and well behaved." To the abolitionists who sold the Gordon image, the horrific scars on his body served as evidence of the cruelties of slavery. Indeed, the modern viewer, too, is struck by the spectacle of violence imprinted on the tortured body. Another text printed on the verso of each carte reads: "The nett proceeds from the sale of these Photographs will be devoted to the education of colored people in the department of the Gulf now under the command of Maj. Gen. Banks." Private Gordon's image was also titled "The Scourged Back" and was circulated by medical doctors as well as abolitionists.

The photograph offered two opposing interpretations of Private Gordon. Nicholas Mirzoeff suggests that, to abolitionists, "it was intended to highlight the evils of enforced labor and human bondage, made visible as the scars of whipping(s) inflicted by a cruel slave-owner. In the plantation world-view, *The Scourged Back* was simply evidence of a crime committed and properly punished." A contemporary newspaper, the *New York Independent,* commented: "This Card Photograph should be multiplied by 100,000 and scattered over the states. It tells the story in a way that even Mrs. Stowe can not approach, because it tells the story to the eye."[29]

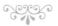

Profile portrait of Frederick Douglass (c. 1818–1895)

Photographer unknown • c. 1858 • daguerreotype, sixth plate

(Nelson-Atkins Museum of Art, Kansas City, MO, Nelson Gallery Foundation,
Gift of Hallmark Cards, Inc., #2005.27.42)

———

By the time this photograph was taken, Frederick Douglass was widely known for his abolitionist and humanitarian crusade. Having been born into bondage, in his early writing and oratory he took on the persona of a fugitive. By the late 1850s, however, he had developed a confident, fluid, graceful, and dignified manner that is captured in this portrait. The stark lines of Douglass's silhouette reflect the sharp and pointed demeanor that he presented to the public, while his focused gaze suggests the intensity with which he carried out his mission against human bondage.

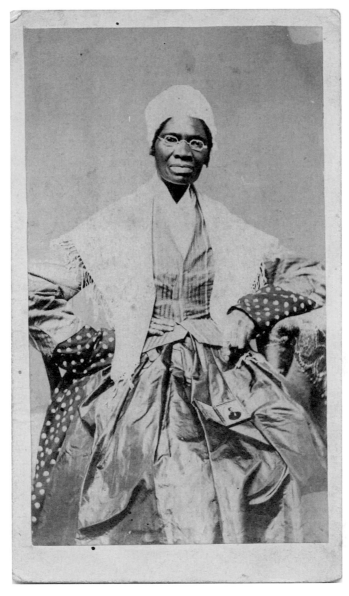

Sojourner Truth (1797–1883), abolitionist and women's rights advocate

Photographer unknown • c. 1863–1870 • carte-de-visite

(Smithsonian Institution, National Museum of African American History and Culture)

Sojourner Truth was probably the first black woman to use photography to construct and record a self-image, deliberately disseminating her likeness to raise money for a political end. This photograph was taken in Battle Creek, Michigan. (Note also the daguerreotype of her grandson on her lap.) The popularity of the carte-de-visite format allowed Truth to use the medium to further her abolitionist cause. She supported herself through the sale of these photographs, which were eventually distributed with the now-famous caption, "I sell the Shadow to Support the Substance. Sojourner Truth."

**Jigsaw puzzle: "America; or, The Emancipation of Slaves
(*Amerika; oder Die Sklaven-Emancipation;
L'Amerique; ou L'Emancipation des Esclaves*)"**

c. 1860s • colored lithograph mounted on wood panel, cut into 132 jigsaw pieces

This jigsaw puzzle offers a narrative of "freedom" through the voice of the abolitionist movement in America. It was used by the antislavery movement to educate and entertain sympathizers about the experience of slavery through metaphors and symbols. The artist's rendering included idealized figures referring to liberation as well as bondage: the loss of family, the inhumanity of the slave auction block, and the arrival of a Union soldier holding the Emancipation Proclamation.

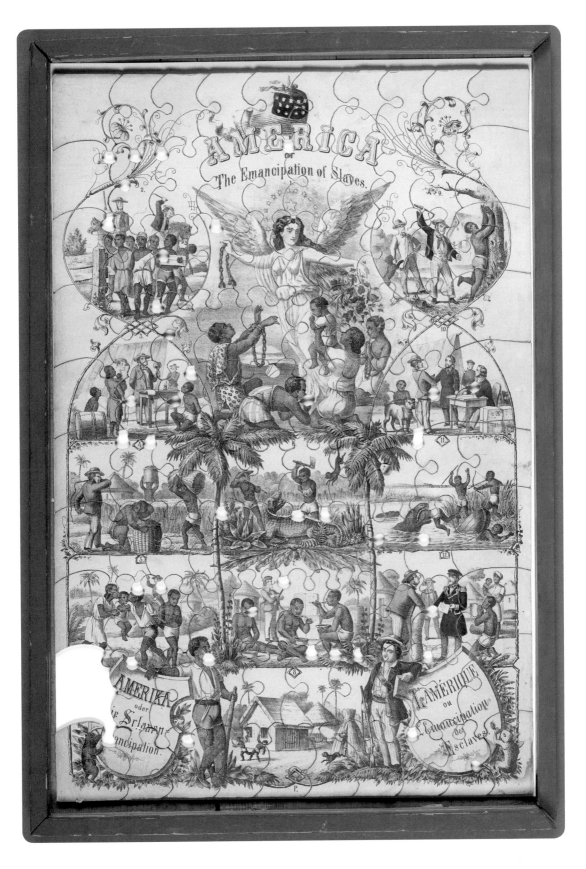

**Frederick Douglass, the Edmonson sisters, Gerrit Smith, and Abby Kelley Foster
at Fugitive Slave Law Convention, Cazenovia, New York**

Photographer: Ezra Greenleaf Weld • 1850 • daguerreotype

(Madison County Historical Society, Oneida, NY)

The Edmonson sisters stand, wearing bonnets and shawls, in the row behind the seated speakers. These two formerly enslaved young women are not appealing for pity or sympathy; rather, they are full participants in the convention and in the ongoing campaign for black freedom. They appear in the center of the image, prominently positioned on either side of the speaker, Gerrit Smith. Frederick Douglass sits at a table in front of them. The dynamism in this image comes from the photographer's vantage point. He has captured the crowd, the dress of the period, and Douglass's magnetism in this outdoor scene.

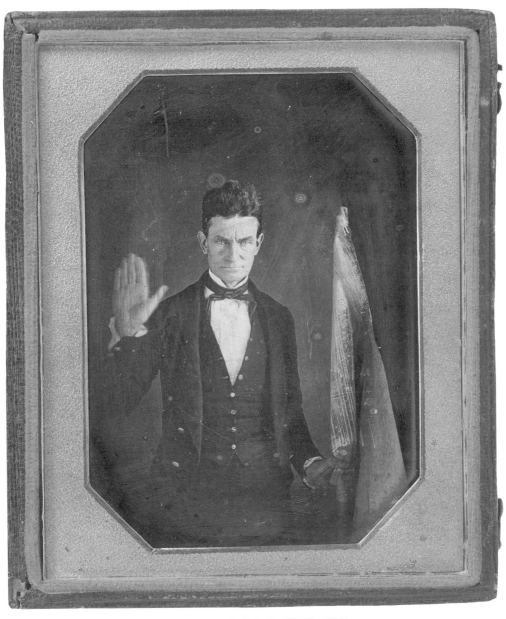

John Brown, abolitionist (1800–1859)

Photographer: Augustus Washington · c. 1846–1847

daguerreotype, quarter plate

(Smithsonian Institution, National Portrait Gallery, Washington, D.C.)

The black photographer Augustus Washington made this portrait of militant abolitionist John Brown in Connecticut in 1846 or 1847. The photographer has captured Brown's unwavering commitment. A decade later, on October 16, 1859, Brown would lead twenty-one men in the assault on Harpers Ferry that shook the nation.

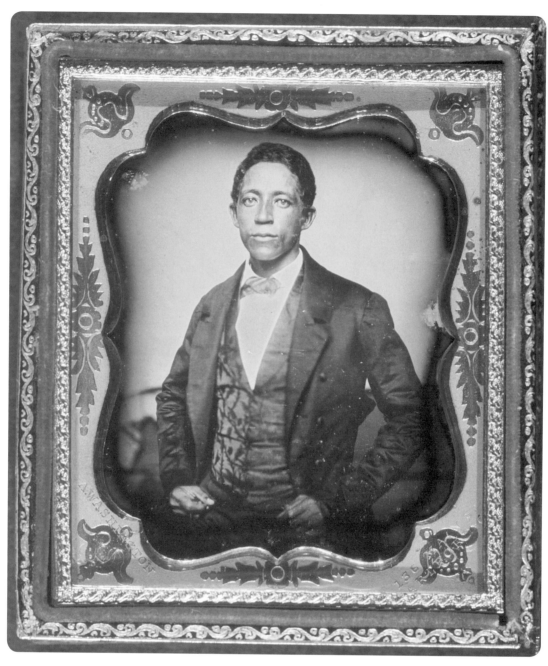

**Urias Africanus McGill (c. 1823–1866), merchant in Liberia,
born in Baltimore, Maryland**

Photographer: Augustus Washington · 1854 · daguerreotype, sixth plate, hand-colored

(Library of Congress, Prints and Photographs Division, LC-USZ6-1948)

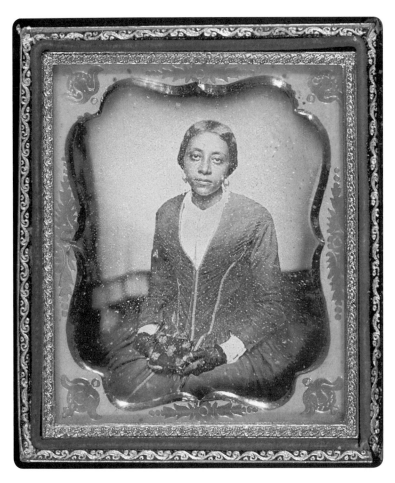

**Unidentified woman, believed to be Sarah McGill Russwurm,
sister of Urias A. McGill and widow of John Russwurm**

Photographer: Augustus Washington · 1854 · daguerreotype, sixth plate, hand-colored

(Library of Congress, Prints and Photographs Division, LC-USZ6-1949)

*In this three-quarter-length portrait we see a young woman in fashionable attire. The
seaming on the bodice of her dress is embellished, and she wears a delicate lace collar,
black lace gloves, and large earrings. If this is in fact Sarah Russwurm, this photograph
was made two years after her husband's death, possibly for a mourning portrait. She seems
to look past the camera, with perhaps an air of resignation.*

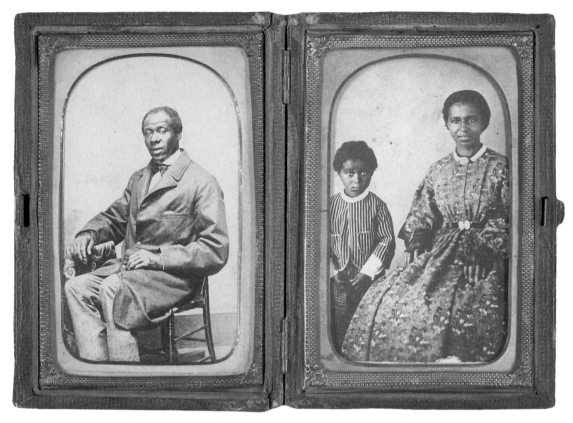

Double portrait of African American man and woman with child

Photographer unknown • 1860–1870 • carte-de-visite

(Library of Congress, Prints and Photographs Division, LC-USZ62-132215, LC-USZ62-132210)

These portraits are mounted in a hinged,
leather-bound dual display case.

Abolitionist button: two hands, one black, one white, resting together on a book (presumably the Bible)

c. 1840s–1850s • miniature daguerreotype and pin

———————

The photograph (5/8" in diameter) is set in a gold-washed brass frame with a loop on the reverse. The design is similar to the gilt-metal buttons mass-produced from 1830 to 1850 in New England factories; one of these, Scovill Manufacturing Company in Waterbury, Connecticut, also manufactured daguerreotype plates. "This button may have been produced to raise money for the abolitionist cause and sold at one of the popular antislavery fairs organized by women," photography curator Malcolm Daniel suggests (www.metmuseum.org/Collections/search-the-collections/190036369). "The first such fair took place in 1834 in Boston, the center of the abolitionist movement. Although the fairs accepted 'all well-made, useful, and ornamental products,' the organizers preferred textiles and other items that incorporated political texts, such as a needlebook inscribed 'May the point of our needles prick the slave owner's conscience.'"

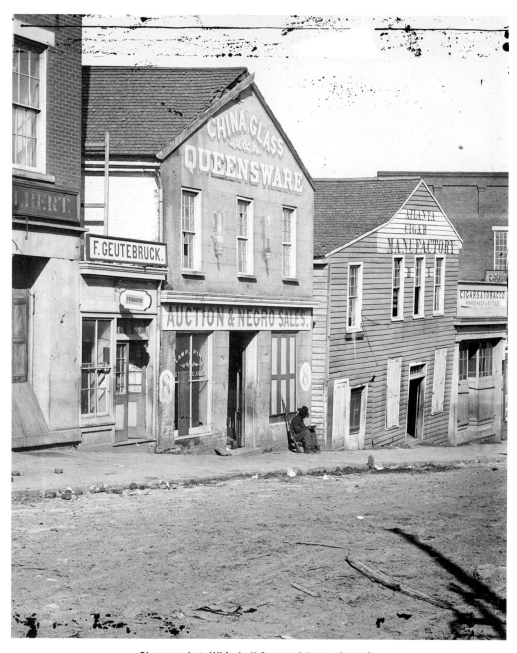

Slave market, Whitehall Street, Atlanta, Georgia

Photographer: George Barnard • 1864 • photograph

(Library of Congress, Prints and Photographs Division, LC-B8171-3608 DLC)

———

A man whose race cannot be determined sits below a sign
reading "Auction & Negro Sales."

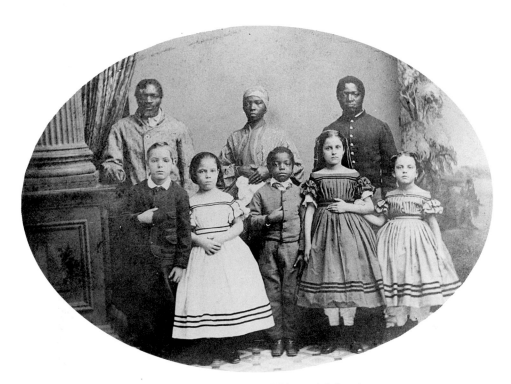

Emancipated Slaves—White and Colored:
Wilson Chinn, Charles Taylor, Augusta Boujey, Mary Johnson, Isaac White,
Rebecca Huger, Robert Whitehead, Rosina Downs

Photographer: Myron H. Kimball • 1863 • albumen print

(Charles L. Blockson Afro-American Collection, Temple University Libraries)

*The children are from schools established in New Orleans by order of Major General
Nathaniel Banks. In December 1863 Colonel George Hanks of the Eighteenth Infantry,
Corps d'Afrique (a Union corps composed entirely of African Americans), accompanied
eight emancipated slaves from New Orleans to New York and Philadelphia expressly to visit
photographic studios. A publicity campaign promoted by Banks and by the Freedman's
Relief Association of New York, its sole purpose was to raise money to educate former
slaves in Louisiana, a state still partially held by the Confederacy. The photographer
retouched the negative before printing to enhance the brand on Chinn's forehead and make
the initials "VBM" more visible. A woodcut of the image appeared in* Harper's Weekly
(January 30, 1864, unpaginated).

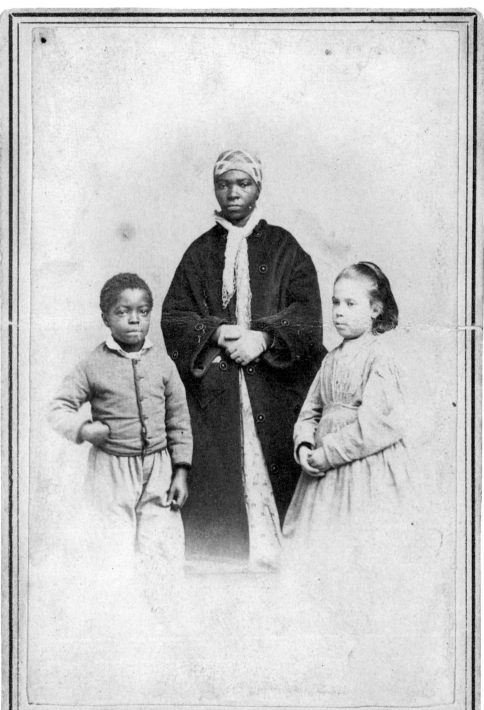

WHITE AND BLACK SLAVES
FROM NEW ORLEANS.
Photographed by KIMBALL, 477 Broadway, N. Y.
Entered according to act of Congress, in the year 1863, by P.
Bacon, in the Clerk's Office of the United States, for the
Southern District of New York.

White and black slaves from New Orleans

Photographer: M. H. Kimball • c. 1863 • carte-de-visite

(Library of Congress, Prints and Photographs Division, LC-DIG-ppmsca-11244)

———————

A group portrait: Isaac White and Augusta Boujey with a woman,
possibly the freed slave Mary Johnson.

"*Isaac White is a black boy of eight years; but none the less intelligent than his whiter companions. He has been in school about seven months, and I venture to say that not one boy in fifty would have made as much improvement in that space of time. Augusta Boujey is nine years old. Her mother, who is almost white, was owned by her half-brother, named Solamon, who still retains two of her children.*

"*Mary Johnson was cook in her master's family in New Orleans. On her left arm are scars of three cuts given to her by her mistress with a rawhide. On her back are scars of more than fifty cuts given by her master. The occasion was that one morning she was half an hour behind time in bringing up his five o'clock cup of coffee. As the Union army approached she ran away from her master, and has since been employed by Colonel Hanks as cook"* (Harper's Weekly, *January 30, 1864, unpaginated).*

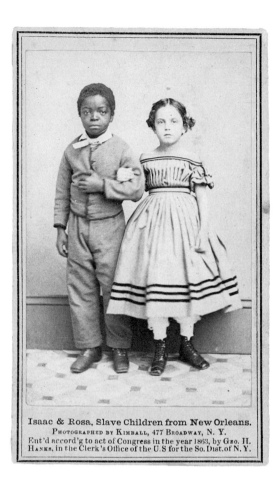

Isaac & Rosa, Slave Children from New Orleans.
Photographed by Kimball, 477 Broadway, N. Y.
Ent'd accord'g to act of Congress in the year 1863, by Geo. H.
Hanks, in the Clerk's Office of the U.S for the So. Dist. of N. Y.

**Isaac and Rosa, slave children
from New Orleans**

Photographer: M. H. Kimball • c. 1863
carte-de-visite

(Library of Congress, Prints and Photographs Division,
LC-DIG-ppmsca-11092)

**"Learning is wealth: Wilson, Charley, Rebecca,
and Rosa, slaves from New Orleans"**

Photographer: Charles Paxson
c. 1864 • carte-de-visite

(Library of Congress, Prints and Photographs Division,
LC-DIG-ppmsca-11128)

———

*Wilson Chinn, Charles Taylor, Rebecca Huger,
and Rosina Downs.*

———

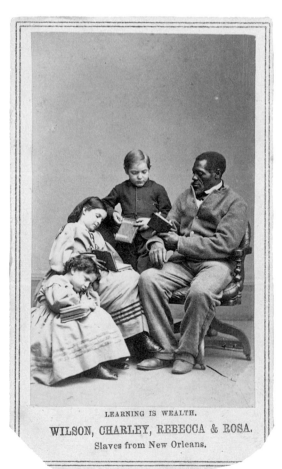

LEARNING IS WEALTH.
WILSON, CHARLEY, REBECCA & ROSA.
Slaves from New Orleans.

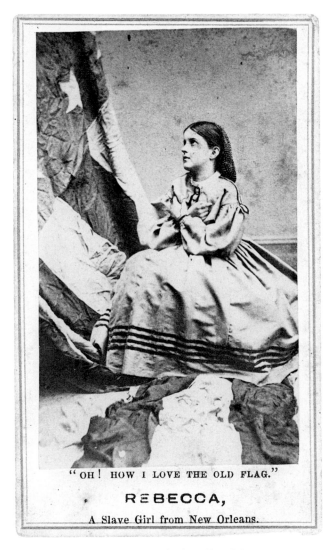

"OH! HOW I LOVE THE OLD FLAG."

REBECCA,

A Slave Girl from New Orleans.

**"Rebecca, a slave girl from New Orleans:
'Oh how I love the old flag'"**

Photographer: Charles Paxson • c. 1864 • carte-de-visite

(Library of Congress, Prints and Photographs Division, LC-DIG-ppmsca-11238)

———

"Rebecca, an emancipated slave from New Orleans. Rebecca Huger is eleven years old, and was a slave in her father's house, the special attendant of a girl a little older than herself. To all appearance she is perfectly white. Her complexion, hair, and features show not the slightest trace of negro blood. In the few months during which she has been at school she has learned to read well, and writes as neatly as most children of her age. Her mother and grandmother live in New Orleans, where they support themselves comfortably by their own labor. The grandmother, an intelligent mulatto, told Mr. Bacon that she had 'raised' a large family of children, but these are all that are left to her" (Harper's Weekly, *January 30, 1864, unpaginated*).

Private Gordon: "The Scourged Back"

Photographer: Mathew Brady, after William D. McPherson and Mr. Oliver
1863 • albumen silver print

(Charles L. Blockson Afro-American Collection, Temple University Libraries)

The thick keloid scars on Private Gordon's back were a result of frequent whippings. Medical professionals and abolitionists circulated this politically charged carte-de-visite, which was reproduced frequently in 1863 by commercial photographic agencies, such as McAllister & Brothers, of Philadelphia, and McPherson & Oliver. It may have been taken in New Orleans. Private Gordon sits sideways on a wooden chair, one hand placed delicately on his hip. His partially nude body makes visible the memory of those bloody whippings. The scarification, for the abolitionists who sold the image, served as evidence of slavery's inhumanity. Other, slightly larger albumen prints of Private Gordon were also used to foment resistance to slavery.

Printed on the back of the photograph: "The nett proceeds from the sale of these Photographs will be devoted to the education of colored people in the department of the Gulf now under the command of Maj. Gen. Banks." A contemporary newspaper, the New York Independent, *commented: "This Card Photograph should be multiplied by 100,000 and scattered over the states. It tells the story in a way that even Mrs. Stowe can not approach, because it tells the story to the eye."*

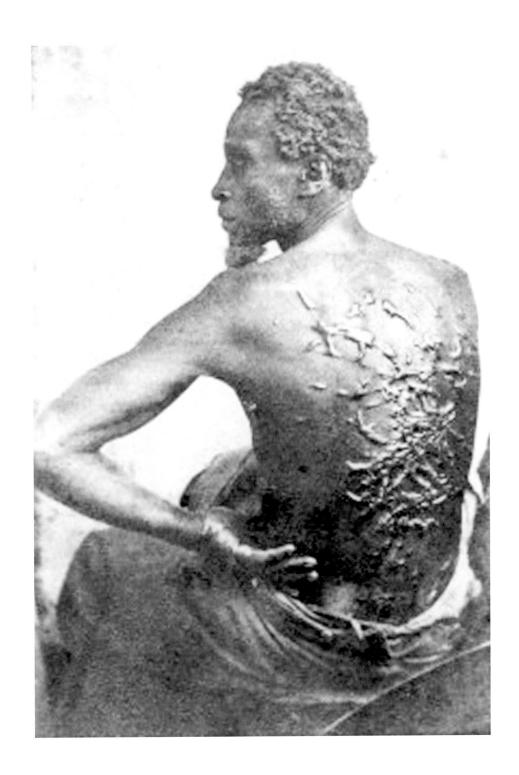

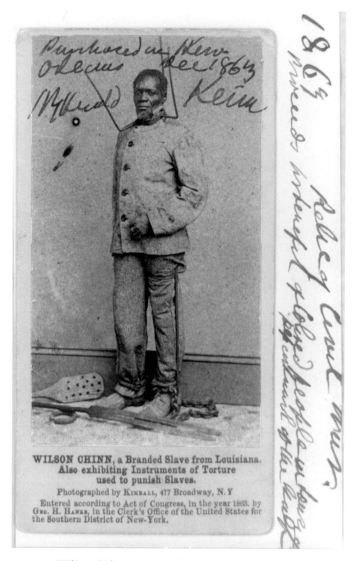

"Wilson Chinn, a branded slave from Louisiana—
also exhibiting instruments of torture used to punish slaves"

Photographer: M. H. Kimball • c. 1863 • carte-de-visite

(Library of Congress Prints and Photographs Division, LC-USZ62-90345)

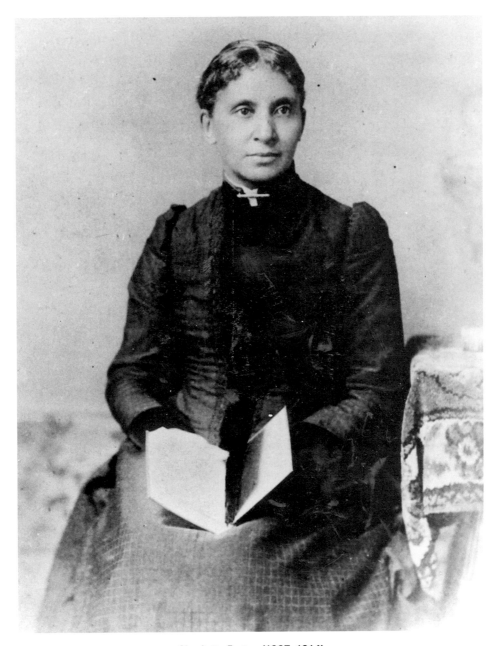

Charlotte Forten (1837–1914)

Photographer: Estabrook • c. 1860 • albumen print, cabinet card

(Howard University, Moorland-Springarn Research Center)

This image of Charlotte Forten presents her as elegant, educated, and thoughtful but also dynamic and energetic. She holds a book in her lap and casts her gaze somewhat to the side, avoiding direct eye contact with the camera and perhaps smiling slightly. During the Civil War, Forten became the first black teacher on South Carolina's Sea Islands and published an account of her mission, "Life on the Sea Islands," in the May and June 1864 editions of the Atlantic Monthly.

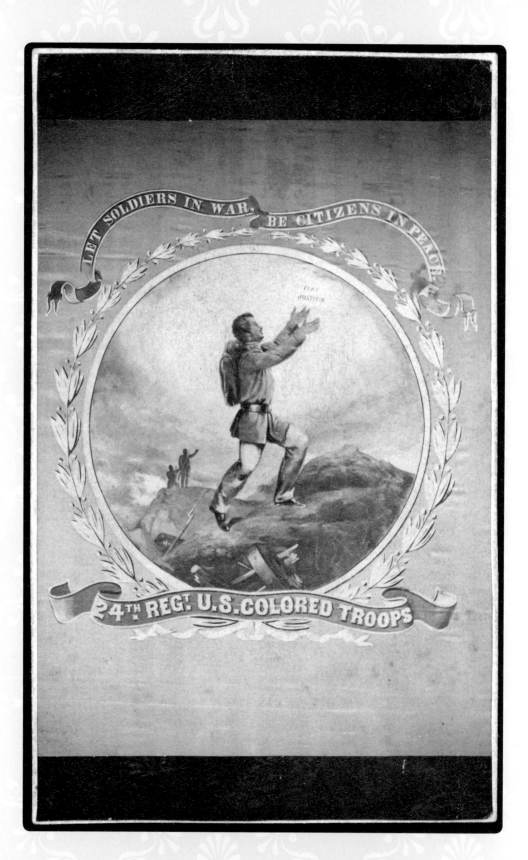

2

A Collective Portrait
of the Civil War

Once [you] let the black man get upon his person the brass letters U.S., let him get an eagle on his button, and a musket on his shoulder, and bullets in his pocket, and there is no power on the earth . . . which can deny that he has earned the right of citizenship.

Frederick Douglass,
"Should the Negro Enlist in the Union Army?" 1863

Photography is following the army south, and very many good operators are finding employment in portraiture in the camp, while at the same time occasionally very interesting camp scenes reach us. One of the camp photographers tells me that his dark box folds up so as to be readily carried on horseback, and he finds no trouble in managing his various solutions in the field.

Coleman Sellers, photographer

Much of what we imagine today about the Civil War (1861–1865), and especially about free and enslaved black people's place and participation in it, comes from photographs and other pictures of soldiers, laborers, families, battlefields, and memorials. Photographs recorded the presence of black soldiers and workers in the Union army, freed slaves on southern plantations, and "contraband" women, men, and children on the road to freedom. Civil War–era photographs add an important dimension to the archive of African American history because they offer documentation of people whose names and life stories went unrecorded in written sources.

Yet more than simply documenting black people's presence in army camps, on the battlefield, and in the cotton fields, these wartime images help a twenty-first-century viewer discern the landscape of black people's desire to be active in their own emancipation. The photographs represent the people who lived to celebrate their emancipation, but in looking at these images we can also envision those who are absent. Pictures of freed people's families and extended communities prompt us to wonder about kin, loved ones, and acquaintances who were sold away during slavery. The images also call to mind the generations of women, men, and children who lived and died in slavery. Thus wartime images of newly freed black people are especially compelling because they can be seen as memorials to those who survived slavery as well as those who did not.

When Confederate forces attacked Fort Sumter in April 1861, President Lincoln issued a call for 75,000 male volunteers to join the Union military and put down what many people anticipated would be a short-lived conflict. White and black northerners rallied to the cause, but many white people in the Union and Confederacy anticipated that the war would be quickly resolved with slavery remaining intact. Black people as well as many white abolitionists in the northern states, however, held decidedly different expectations. Since the late 1840s Frederick Douglass had believed that force rather than moral argument would bring slavery to an end. In his 1850 address to the Cazenovia convention, abolitionist Gerrit Smith declared, "When the insurrection of the Southern slaves shall take place, as take place it will, unless speedily prevented by voluntary emancipation, the great mass of the colored men of the North . . . will be found by your side, with deep-stored and long accumulated revenge in their hearts."[1] In the spring and summer of 1861, Douglass railed against slavery and southern slaveholders, determined to keep the issue of slavery foremost in the minds of northerners.

Enslaved people quickly seized the opportunity to disrupt slavery in the southern states, liberate themselves, and pursue their own visions of freedom. Union general Benjamin Butler's May 1861 "contraband" policy acknowledged the extent to which enslaved people, like free black northerners, viewed the war as a fight to end slavery and redefine black people's place in the United States. By the late summer of 1862, Lincoln had set the stage for the Emancipation Proclamation of January 1, 1863. Historians have long debated the meaning and consequences of the proclamation, as it was indeed limited in scope. It addressed only the liberation of slaves in Confederate states not yet under Union control and thus excluded areas already under Union command as well as the four loyal slave states of Kentucky, Maryland, Delaware, and Missouri; and it did not immediately grant freedom to any enslaved person but linked it to Union

victory. Still, as many scholars have noted, the Emancipation Proclamation held tremendous symbolic meaning for free and enslaved Americans, clearly linking the cause of freedom to the Union war effort.

Capturing the diverse ways in which people experienced and understood the Civil War, photography evokes also the respective vantages of the subject and the photographer. In the early 1850s photography studios, owned by white and black Americans, recorded the social and political lives of the people in their communities. By the 1860s the photography business was booming, with more than three thousand Americans across the country working as photographers and catering to a wide clientele. The war quickly expanded opportunities for photographers and created lucrative new ones. Photographers jumped at the chance to make and sell pictures of the places, people, and topics that were on the minds of all Americans.

Throughout the war they had little difficulty finding purchasers for carte-de-visite images. The federal government capitalized on the popularity of photographs and placed a tax on them to raise money for the war.[2] During the war some 1,500 photographers created tens of thousands of war-related pictures, either in their studios or on battlefields, in army camps, on warships, and on southern plantations. Commercial photography studios hired camera operators and photographers to capture life and death on the battlefield as well as activities in the camps. Photography curator and historian Keith Davis asserts that "Civil War photography is, to a large extent, the result of the complex web of personal and commercial relationships between businessmen such as Mathew Brady, Edward Anthony, and Alexander Gardner; influential politicians and military figures; and the individuals who actually made the photographs."[3]

Photographers documented the war for distant audiences across the country, but they also created visual narratives or interpretations that shaped how it was seen and understood. In his study of New Hampshire photographer Henry P. Moore, historian Jeffrey Bolster finds that Moore composed many of his images to resonate with northern, middle-class ideals of domesticity. Moore created what Bolster describes as "homey scenes of camp life" that emphasized "domestic tranquility" and likely assuaged viewers' fears about the dangers that awaited young Union soldiers. Moore's scenes of life in Union camps routinely included "familiar props, such as a floral arrangement, playing cards, or parlor furniture, all of which contributed to the air of relaxation and ease." Visual cues such as conch shells and palmetto fronds gave Moore's pictures "a touch of southern mystique."[4] One Union officer recalled Moore's arrival in the Sea Islands of South Carolina: "He comes with

the intention of taking views of the camps and plantations, and has had over one hundred applications for large sized pictures. He is just the man we want, for it has been impossible to obtain pictures of any kind worth having, or durable enough to retain their color even a month."[5]

Moore arrived on the South Carolina island Hilton Head (renamed Port Royal by Union commanders) in February 1862, barely four months after a Union naval fleet had defeated the Confederate forces in the Port Royal Sound. Wealthy rice and cotton plantation owners evacuated the coastal islands, leaving behind their possessions, including some ten thousand enslaved people. Union officers seized the land and claimed the slaves as "contrabands." In July 1862 Congress declared that enslaved people who were owned by Confederates but were within Union lines were free. Newly freed men, women, and children worked for Union officers and other government agents. Moore's scenes of life in Union camps sometimes included newly freed young black men, depicted primarily in their role as servants to white officers. An image labeled "3rd N.H. Band," for example, portrays the New Hampshire regiment's band in the camp on Hilton Head Island. The picture includes a young boy, a former slave named Billy Seabrook, who had been hired as the band's drum-carrier and servant. He stands to the right of the twenty-three seated band members, who are posed with their instruments. Seabrook is slightly out of focus, perhaps an indication that he moved, stepping toward the center of the frame while Moore was making the picture. He stands with one hand on his hip and the other holding his band cap, and his gaze is direct and confident. Though he is unmistakably positioned as a subordinate on the margins of this picture and at least one other, the image also suggests a youthful energy and unwillingness to remain on the sidelines.[6]

Union commanders and other government officials sought to demonstrate black people's ability to live and work as productive citizens and members of free society. Northern missionaries and teachers, white and black women and men, created organizations to establish schools and inculcate the values of the northern free-labor economy among the newly freed black people of the Sea Islands. A cornerstone of the "Port Royal experiment" was hiring former slaves to remain on island and coastal plantations as agricultural laborers, cultivating cotton under the direction of black and white northern supervisors.[7]

Charlotte Forten left New York by boat for Port Royal on October 22, 1862, and worked there as a teacher for a year and a half. She was one among hundreds of northern teachers and clergy who went to the South to help emancipated slaves make the transition to freedom. Northern black men and women, like Forten, saw their work among South Carolina's "contraband" population as an important service to their race. Yet, as historian Brenda Stevenson writes in her introduction to

Forten's journals, "like the other teachers and missionaries who came to instruct the contraband, Charlotte sometimes was both amused and repulsed by the social and religious practices of the Sea Island blacks."[8] Photographs of freedmen's schools and churches have preserved this convergence of northern and southern, free and freed black people. After the war ended, one South Carolina newspaper would criticize northern "teachers of freedmen" who sold photographs of themselves to their students for one dollar, decrying the practice as economically exploitative.[9]

A number of Moore's photographs from 1862 and 1863 reflect this distinctive and regional chapter in the history of emancipation and freedom and this photographer's efforts to envision black people's future in the United States. The photograph of former slaves on Confederate general Thomas Drayton's plantation, for example, depicts just over forty women, men, and children posed in front of outbuildings used for ginning, sorting, and storing cotton. In the foreground of this image, one child and fourteen women, some holding babies, are seated on some sort of tarpaulin covered with cotton bolls, creating the impression that the ground itself is covered with cotton. A group of men and one woman stand behind them. The woman balances on her head a tub that appears to be overflowing with cotton. From one vantage, this picture firmly links black people to cotton plantations and seems to indicate that little has changed with the dawning of freedom. Another photograph depicts a group of fourteen in a field on an Edisto Island plantation. Three men and a woman stand in the foreground, hoeing the ground. In her study of enslaved Africans' agricultural work in South Carolina, geographer Judith Ann Carney points to the significance of this pose: "Several colonial-period engravings and paintings of American rice plantations depict slaves, often females, carrying or working with the long-handled hoe. Its significance in field preparation continued after emancipation."[10]

Moore's "Sweet Potato Planting, James Hopkinson's Plantation" thus fits into a long tradition of representing black people at work in the fields. In the background one man drives a wagon while another, further in the distance, guides a plow along the furrowed ground. A group of women sit on the ground, surrounded by small piles of sweet potatoes that they are evidently placing into a basket. The depiction of black women as agricultural workers is an important reminder that during slavery black women performed heavy labor and skilled labor alongside men, and that many white Americans, northerners and southerners, expected them to remain in the workforce after emancipation. In these photographs black men and women are depicted as competent and compliant agricultural laborers.

These images do not simply allow us to see how northerners imagined an orderly and uneventful transition from slavery to freedom; they are noteworthy also for the wealth of detail they reveal about the complexity of black people's lives and history.

Carney's compelling study highlights the central importance of enslaved African women's knowledge, skill, and labor as rice producers in the colonial South Carolina plantation economy. She notes, for example, that the long-handled hoe was a primary agricultural implement in eighteenth-century West African societies but had "actually played a minor role in eighteenth-century European farming systems."[11] The trans-Atlantic slave trade transferred not just people but also African knowledge and skills to the Americas, including women's ability to cultivate rice and other crops using hoes.

Moore's image of freed slaves working a sweet potato field in this way evokes historical, personal, and cultural connections to African antecedents even while it anchors black people in plantation labor. Historian Charles Joyner and other scholars have likewise demonstrated that the black-majority population of the Sea Islands developed and maintained a distinctive culture infused with African social customs, linguistic patterns, and spiritual beliefs. In both Moore images, the women wear kerchiefs wrapped around their heads in various styles. In his study of enslaved people's culture on the Sea Islands, Joyner writes that "the custom of wearing headkerchiefs in the slave community reflected continuity with African tradition and expressed a high degree of personal pride."[12] Historian Stephanie Camp has written about enslaved women's efforts to create "fancy clothing" and jewelry to wear on special occasions. Women adorned their clothing with buttons, beads, and fancy needlework; used berries and plants to manufacture yellow, red, brown, and black dyes; and made earrings and necklaces out of shells, beads, and dried berries: "Women's style allowed them to take pleasure in their bodies, to deny that they were only (or mainly) worth the prices their owners placed on them."[13] We can see in the photograph taken on Drayton's cotton plantation that many of the women are wearing necklaces. Thus Moore's photographs present multiple and decidedly different visual narratives of black people's lives during the early days of freedom on the Sea Islands. Viewers can recognize a white northern photographer's effort to create an image of freedom as an almost unremarkable shift in black people's economic and social roles, but the images also invite us to think carefully about the range of experiences, knowledge, and expectations black people brought with them as they moved from slavery to freedom.

Pictures of "contraband" groups, large families, and plantation-based communities add nuance and complexity to our understandings of what freedom looked like in the Civil War South. Images of "contrabands" convey a physical mobility and vibrant energy that are largely absent from Moore's images. Pictures of self-liberated people leading loaded wagons and moving en masse toward Union camps present black people in motion—enslaved people creating their own freedom and influencing Union war policy and ultimately the meanings and consequences of

the war itself. Timothy O'Sullivan's picture of J. J. Smith's plantation near Beaufort, South Carolina, like the image titled "Contraband Yard," depicts freedom as a collective experience, pursued and embraced by women, men, and children together.

A close look at the pictures reveals a range of individual clothing styles and physical poses that work in concert to create a composite image of a large community linked through relations of family, gender, age, and work. In "Contraband Yard" we see a group of children kneeling in the foreground, possibly paying more attention to their game than to the photographer. Gathered and posed in front of slaveholders' homes and in their yards, black people transformed slavery's physical landscape by making those homes, buildings, fields, and yards sites where freedom was displayed and documented. Pictures of extended families, such as the Whole family, also suggest the strength, durability, and resiliency of family and kinship ties during and after slavery. (See image on page 178.) What did it mean to them to call themselves the "Whole family" in freedom? These images stand as testament to black people's survival as individuals, families, and communities. At the same time, however, the images call to mind those who were not photographed—people who had been sold away as well as those who had run away. What did freedom mean to those who found themselves without family or loved ones? What did it mean to those who felt alone in the middle of the crowded yard? What did freedom mean to those who wanted to create new family and community ties distant from the people and places they had known in bondage?

During the summer of 1862, as Moore, O'Sullivan, and countless other photographers produced images of enslaved people's steps to destroy slavery from within and create freedom for themselves, Lincoln was drafting the text that would become the Emancipation Proclamation and making it clear that he would end slavery in order to win the war. One important component of both the preliminary proclamation of September 1862 and the final Emancipation Proclamation of January 1, 1863, was the provision authorizing the enlistment of black troops. From the beginning of the war, free black men and women of the North had pressed for the men's right to enlist in the Union military, and they welcomed the opportunity once it finally arrived. In his March 1863 call to arms, Frederick Douglass declared, "There is no time to delay. The tide is at its flood that leads on to fortune. From East to West, from North to South, the sky is written all over, 'Now or never.' Liberty won by white men would lose half its luster. 'Who would be free themselves must strike the blow.' 'Better even die free than to live slaves.' This is the sentiment of every brave colored man amongst us." He specifically encouraged men to enlist

with the new Massachusetts regiment: "Go quickly and help fill up the first colored regiment from the north."[14]

Portraits of northern black soldiers record their participation in the war and reflect the gravity of their mission. They served a nation that too often marginalized and constrained them, and they fought with the goal of reforming and expanding the meanings of citizenship and freedom. Their pictures—in their uniforms and often bearing arms—can be seen as one component of their campaign to declare their rights as free men and redefine freedom to include black people. Like the images of "contrabands" and other freed slaves, portraits of black soldiers help a twenty-first-century viewer understand the scope and significance of black people's desire to be active in their own emancipation.

The photograph of Nick Biddle of Pottsville, Pennsylvania, gave public notice of his activity as one of the "First Defenders of the Union." Biddle worked as a servant of Captain James Wren and accompanied Pennsylvania troops when they were called to defend Washington, D.C. Days after the start of the Civil War, Biddle was attacked by a mob in Baltimore and hit in the head with a brick. It was reported that when he reached Washington and shook Lincoln's hand, the blood from his wound was still wet. The solemn portrait includes a caption: "the first man wounded in the Great American Rebellion, Baltimore, April 18, 1861."[15] Later this portrait became a source of income for Biddle: "Nick himself sold thousands of these photographs," remembered one veteran; "to this day a photographic album is not considered complete in Pottsville without the picture of the man whose blood was first spilled in the beginning of the war."[16]

Christian Fleetwood, a free black man from Baltimore, served with the Fourth U.S. Colored Troops and was awarded a Medal of Honor by Congress for his heroism in the September 1864 Battle of Chaffin's Farm, near Richmond, Virginia. Fleetwood had visited Liberia as a young man, but having decided that his future lay in the United States, he dedicated himself to the fight for black freedom.[17] His diary offers a glimpse of Fleetwood's wartime view of President Lincoln:

Tuesday, June 21, 1864.
Up early took down tents and packed everything self. Handy sick. Division moved towards Pburg. Stopped in woods Slept like a Dormouse. Woke and snacked. President Lincoln & Gen. Grant passed our bivouac and were cheered.[18]

Some black soldiers in the Union army voiced their discontent about their menial roles and inferior treatment. James Henry Gooding, a corporal in the Fifty-

Fourth Massachusetts Volunteer Infantry, wrote a complaint to the president from Morris Island on September 28, 1863:

> Are we Soldiers, or are we LABOURERS. We are fully armed, and equipped, have done all the various Duties, pertaining to a Soldiers life, have conducted ourselves, to the complete satisfaction of General Officers, who, were if any, prejudiced against us, but who now accord us all the encouragement, and honor due us: have shared the perils, and Labour, of Reducing the first stronghold, that flaunted a Traitor Flag: and more, Mr. President. Today, the Anglo Saxon Mother, Wife, or Sister, are not alone, in tears for departed Sons, Husbands, and Brothers. The patient Trusting Descendants of Afric's Clime, have dyed the ground with blood, in defense of the Union, and Democracy. Men too your Excellency, who know in a measure, the cruelties of the Iron heel of oppression, which in years gone by, the very Power, their blood is now being spilled to maintain, ever ground them to the dust. . . .
>
> Please give this a moments attention
> James Henry Gooding[19]

Portraits of Frederick Douglass's sons, Lewis and Charles, highlight the intersection of Douglass's political activism and personal life. Both sons joined the Massachusetts Fifty-Fourth, which was commanded by Robert Gould Shaw, a white colonel from an elite Boston family. The regiment's approximately 600 volunteers, mostly free blacks, fought a bitter battle at Fort Wagner, South Carolina, in July 1863 and lost 281, including Shaw.[20] Charlotte Forten had met Shaw in the summer of 1863 and felt "affectionate admiration for him." She saved an autographed picture of Shaw among her cherished possessions and personal papers.[21] Lewis Douglass wrote to his fiancée on July 20, 1863, two days after the Fort Wagner attack:

> My Dear Amelia
> I have been in two fights, and am unhurt. I am about to go in another I believe to-night. Our men fought well on both occasions. The last was desperate we charged that terrible battery on Morris Island known as Fort Wagoner, and were repulsed with a loss of 3 killed and wounded. I escaped unhurt from amidst that perfect hail of shot and shell. It was terrible. I need not particularize the papers will give a better than I have time to give. My thoughts are with you often, you are as dear as ever, be good enough to remember it as I no doubt you will. As I said before we are on the eve of another fight and I am very busy and have just snatched a moment to write

you. I must necessarily be brief. Should I fall in the next fight killed or wounded I hope to fall with my face to the foe.

If I survive I shall write you a long letter. DeForrest of your city is wounded, George Washington is missing, Jacob Carter is missing, Chas Reason wounded Chas Whiting, Chas Creamer all wounded. The above are in hospital.

This regiment has established its reputation as a fighting regiment not a man flinched, though it was a trying time. Men fell all around me. A shell would explode and clear a space of twenty feet, our men would close up again, but it was no use we had to retreat, which was a very hazardous undertaking. How I got out of that fight alive I cannot tell, but I am here. My Dear girl I hope again to see you. I must bid you farewell should I be killed. Remember if I die I die in a good cause. I wish we had a hundred thousand colored troops we would put an end to this war.

Good Bye to all Write soon

Your own loving Lewis[22]

This letter adds another dimension to Lewis Douglass's portrait. In the picture he stands with his arms folded across his chest, and his youthful face is overlaid with a serious expression. His is a portrait of manly determination and bravery. His letter allows us to view his picture with a more nuanced understanding of black soldiers' experiences on the battlefield. He assures his fiancée of his own safety but also lists the names of the men she knows who have been killed or wounded. Even in his private correspondence, Douglass depicts his commitment to the "good cause" of black freedom. As the image of Sojourner Truth holding the daguerreotype of her grandson and the wedding portrait of a young black woman and her soldier husband suggest, photographs and letters like Lewis Douglass's offered loved ones comfort and inspiration even in the face of the war's brutal uncertainties.

As we thought about this history of northern, free black men and women fighting and working to end slavery, we turned to first-person testimonials found in letters, journals, and memory books. A letter written by Hannah Johnson, whose son had also joined the Massachusetts Fifty-Fourth, amplifies what is implicit in Douglass's letter—black women's complete involvement in matters related to men's military service and the larger fight to end slavery.

Buffalo [N.Y.] July 31 1863

Excellent Sir

My good friend says I must write to you and she will send it My son went in the 54th regiment. I am a colored woman and my son was strong and able

as any to fight for his country and the colored people have as much to fight for as any. My father was a Slave and escaped from Louisiana before I was born morn forty years agone I have but poor edication but I never went to schol, but I know just as well as any what is right between man and man. Now I know it is right that a colored man should go and fight for his country, and so ought to a white man. I know that a colored man ought to run no greater risques than a white, his pay is no greater his obligation to fight is the same. So why should not our enemies be compelled to treat him the same, Made to do it.

My son fought at Fort Wagoner but thank God he was not taken prisoner, as many were I thought of this thing before I let my boy go but then they said Mr Lincoln will never let them sell our colored soldiers for slaves, if they do he will get them back quck he will rettallyate and stop it. Now Mr Lincoln dont you think you oght to stop this thing and make them do the same by the colored men they have lived in idleness all their lives on stolen labor and made savages of the colored people, but they now are so furious because they are proving themselves to be men, such as have come away and got some edication. It must not be so. You must put the rebels to work in State prisons to making shoes and things, if they sell our colored soldiers, till they let them all go. And give their wounded the same treatment. it would seem cruel, but their no other way, and a just man must do hard things sometimes, that shew him to be a great man. They tell me some do you will take back the Proclamation, don't do it. When you are dead and in Heaven, in a thousand years that action of yours will make the Angels sing your praises I know it. Ought one man to own another, law for or not, who made the law, surely the poor slave did not. so it is wicked, and a horrible Outrage, there is no sense in it, because a man has lived by robbing all his life and his father before him, should he complain because the stolen things found on him are taken. Robbing the colored people of their labor is but a small part of the robbery their souls are almost taken, they are made bruits of often. You know all about this

Will you see that the colored men fighting now, are fairly treated. You ought to do this, and do it at once, Not let the thing run along meet it quickly and manfully, and stop this, mean cowardly cruelty. We poor oppressed ones, appeal to you, and ask fair play.

Yours for Christs sake

Hannah Johnson[23]

These compelling testimonies and letters from soldiers and family members, along with the soldiers' photographs, suggest the engagement of black people with

the war and pay homage to their bravery and their commitment to the ideals of American liberty and family life. Their complaints convey the obstacles black men and their families continued to face even after the Union sanctioned the enlistment of black soldiers. Barred from the highest ranks and often confined to menial labor, black soldiers served under discriminatory and degraded conditions that reflected the larger society's racist exclusions. Yet despite poor treatment, unequal pay, and inferior conditions, northern black men and women devoted themselves to the war effort and the higher cause of ending slavery. Indeed, black soldiers insisted on serving without pay rather than accept lower wages than their white counterparts.

Women are rarely discussed in scholarship about black people's emancipation during the Civil War, although, as we argue, they played a central role. Our research uncovered photographs that emphasize women's wartime liberation, their ideas about freedom, and their service to the military as nurses, seamstresses, washerwomen, and cooks. Images, as well as diaries and letters, help shape our understanding of the ways in which women envisioned and pursued their freedom. In her work on gender, emancipation, and the Civil War, historian Stephanie McCurry discusses the Union's "contraband" policy in terms of women's place in army camps and the minds of policymakers. Federal policy, she explains, justified the retention of self-liberated men on the grounds that Confederates had used enslaved men as laborers for their war effort—but what about self-liberated women and children? General Butler wrote to his superiors, "As a military question and a question of humanity can I receive the services of a Father and a Mother and not take the children?" In the spring of 1863, a commander in the Mississippi Valley complained about the newly freed slaves under his command, "two thirds to three fourths of whom are women and children incapable of army labor, a weight and incumbrance."[24]

Images of "contraband" women along with the written sources suggest a more complicated picture. In Susie King Taylor's portrait, her fixed gaze bears visual testimony to her determination to be an active participant in the Civil War as a nurse, cook, teacher, and laundress for the all-black unit of the First South Carolina Volunteers.[25] She had been enslaved as a child on an island off the coast of Georgia. During the war, she also routinely cleaned guns and taught soldiers to read.[26] She was never paid for any of her work. Her diary records her observations and experiences:

> The first colored troops did not receive any pay for eighteen months, and the men had to depend wholly on what they received from the commissary . . . their wives were obliged to support themselves and

children by washing for the officers, and making cakes and pies which they sold to the boys in camp. Finally, in 1863, the government decided to give them half pay, but the men would accept none of this. . . . They preferred rather to give their services to the state, which they did until 1864, when the government granted them full pay, with all back due pay.

I was very happy to know my efforts were successful in camp, and also felt grateful for the appreciation of my service. I gave my services willingly for four years and three months without receiving a dollar. I was glad, however, to be allowed to go with the regiment, to care for the sick and afflicted comrades.[27]

An image of an unnamed washerwoman is an especially intriguing picture of black women's freedom. In this ambrotype we see a woman sitting tall, with her right arm resting on a table positioned next to her seat. She wears a neatly pressed dress, and tucked into the bodice is a small American flag, which was accentuated with hand tinting. She stares at the camera with an inscrutable or placid gaze. Notations on the back of her picture indicate that she worked as a washerwoman for the Union army in Richmond, Virginia. We do not know who commissioned, designed, and owned this picture. In some respects it stands as a fitting counterpart to the portraits of black soldiers, emphasizing the woman's proud service and dignified bearing. It is a stark contrast to the images of "contrabands" that locate black people as plantation residents and workers. Similarly, this image does not fit easily with the wartime photographs of freed children or the image of Gordon's scarred back. In those pictures, black bodies are presented to evoke sympathy with slavery's victims and horror at the ways in which slavery ravaged black women's sexuality and black men's humanity. In this image, however, the unnamed woman appears more as a certain and confident person than an object of scrutiny or pity.

According to historian and curator Keith F. Davis, Civil War images were a highly sought after commodity. He notes that photographers, working in studios and in the field, profited especially from the demand for portraits of soldiers. Early in 1862 photographer Coleman Sellers observed that "with the professional operators the war has been quite a profit."[28] The Anthony photography studio, for example, boasted that it had available carte-de-visite-sized prints for twenty-five cents each, including "scenes in Washington, Manassas, and Bull Run; camp scenes and groups near Yorktown; the Antietam battlefields and numerous portraits of leading officers."[29] Families and clients interested in war photography paid up to five dollars for a dozen cartes-de-visite. Historian Jeffrey Bolster argues that Henry Moore "recognized that slaves were objects of curiosity in the North. . . .

He sold [photographs] from his studio in Concord at a price of one dollar each, or five dollars for six photographs and nine dollars for twelve."[30] This commerce in photographs, especially images of the enslaved and newly freed black population, raises questions about the continued commodification and scrutiny of black bodies.

During the Civil War era, northern and southern white and black viewers desired photographs of slaves and freed black people for a wide variety of reasons. Images were created and obtained as sources of information, inspiration, sympathy, horror, tribute, and entertainment. Accordingly, photographic images present complex and usually contradictory views of emancipation and the transition from slavery to freedom. Though their commodification and circulation may seem to mirror the commodification of black bodies and the sale of enslaved people, we find that these images cannot be easily dismissed as racist hopes or fantasies that black people would remain in servile status.

Even those images that were designed to depict emancipation as uneventful, such as Moore's images of black agricultural workers and army servants, allow us to see the cultural expressions and social relations that sustained enslaved communities. Images of large, newly freed black communities, furthermore, suggest the collective energy and determination that would fuel black people's post–Civil War efforts to achieve economic independence, exercise their civil rights as citizens, and assume control over their bodies, labor, and lives. Black Americans, as well as white Americans, desired, created, purchased, circulated, and preserved these images. The range of Civil War–era photographs constitutes an important archive that depicts the scope of black Americans' experiences. The images can be seen not just as documentation or representation of black people's presence and participation in the war but also as a type of memorial to the free and enslaved black women, men, and children whose individual and collective actions made black people's freedom central to the Civil War from the outset.

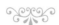

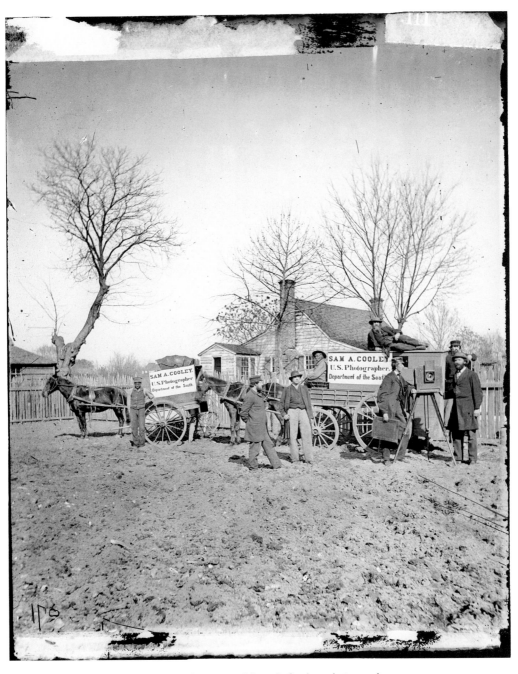

Wagons and camera of Sam A. Cooley, photographer

Photographer unknown • 1860–1865 • albumen print

(Library of Congress, Prints and Photographs Division, LC-DIG-cwpb-03518)

———

A black driver guides the wagons and equipment of Sam A. Cooley,
employed by the Department of the South to document the Civil War.

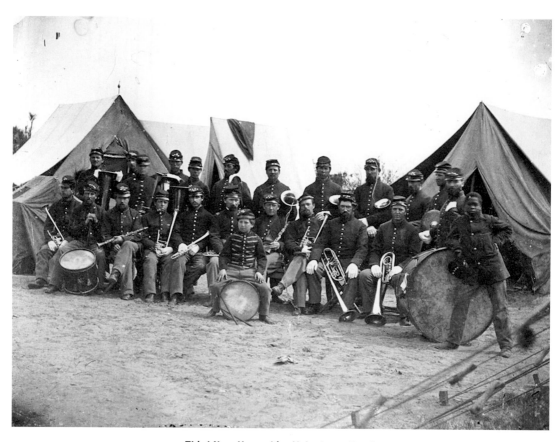

Third New Hampshire Volunteers Band

Photographer: Henry P. Moore • March–April 1862 • albumen print

(New Hampshire Historical Society Collection, Concord, NH, 306)

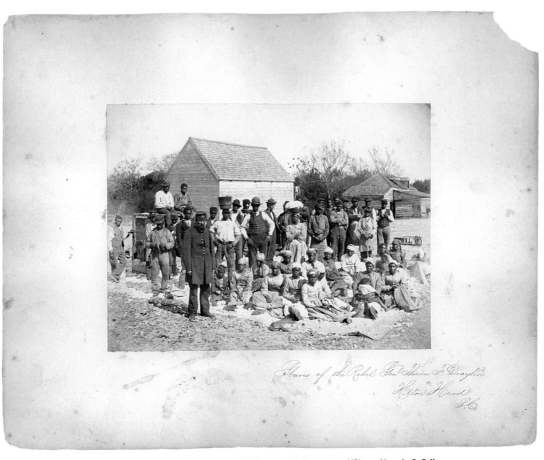

"Slaves of the Rebel General Thomas F. Drayton, Hilton Head, S.C."

Photographer: Henry P. Moore • 1862 • albumen print

(Library of Congress, Prints and Photographs Division, LC-DIG-ppmsca-04324)

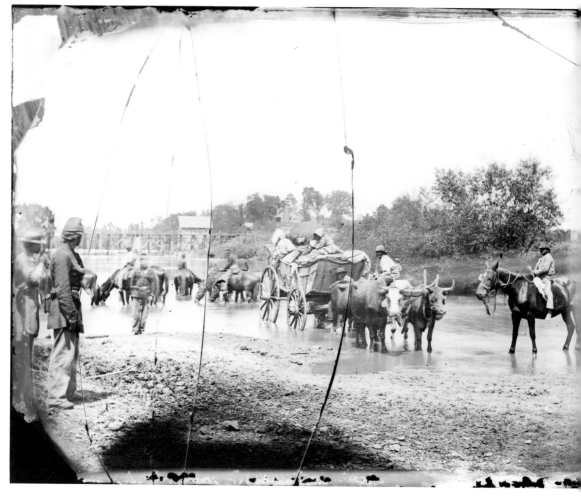

Fugitive African Americans fording the Rappahannock River, Virginia

Photographer: Timothy O'Sullivan

1862 • photograph (stereographic format)

(Library of Congress, Prints and Photographs Division, LC-DIG-cwpb-00218)

———

This photograph comes from the main eastern theater of the war.
In August 1862, following the second Battle of Bull Run, fugitives sought to join other
recently self-liberated African Americans, eventually becoming "contrabands."

———

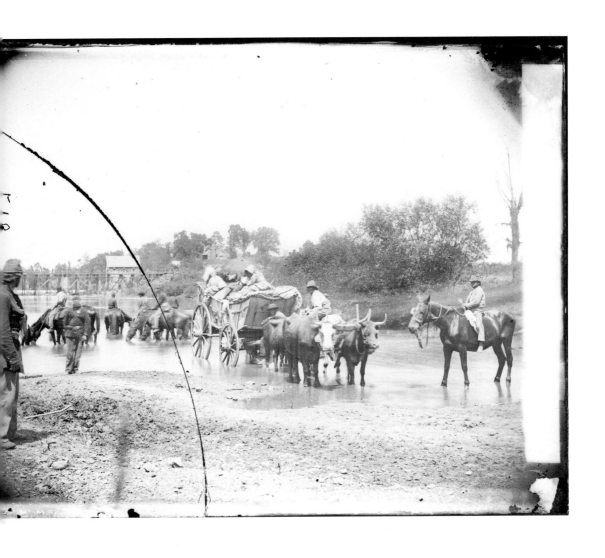

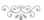

"Sweet Potato Planting, James Hopkinson's Plantation"

Photographer: Henry P. Moore • 1862 • albumen print

(Library of Congress, Prints and Photographs Division, LC-DIG-ppmsca-11398)

✿

Facing page: **"Contraband Yard"**

Photographer: J. W. Taft, Oak Gallery • no date • carte-de-visite

(Randolph Linsly Simpson African-American Collection, Yale Collection of American Literature,
Beinecke Rare Book and Manuscript Library, JWJ MSS 54, folder 498)

———

*A large group of people in various styles of dress are shown
under trees and behind houses.*

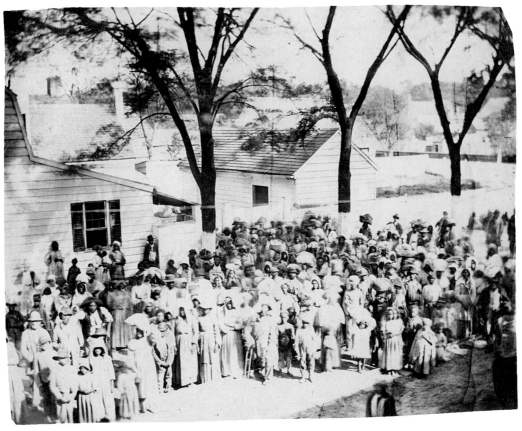

Slaves on J. J. Smith plantation, near Beaufort, South Carolina

Photographer: Timothy H. O'Sullivan • 1864 • carte-de-visite

(The J. Paul Getty Museum, Los Angeles, 84.XM.484.39)

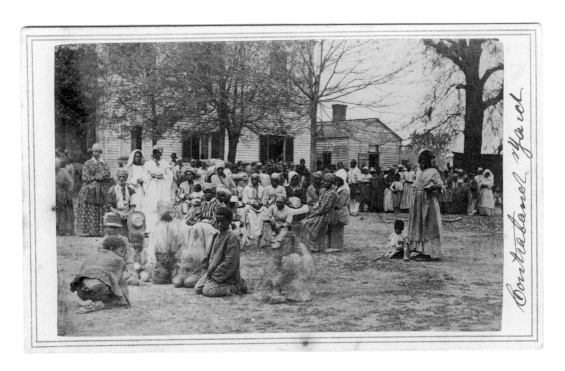

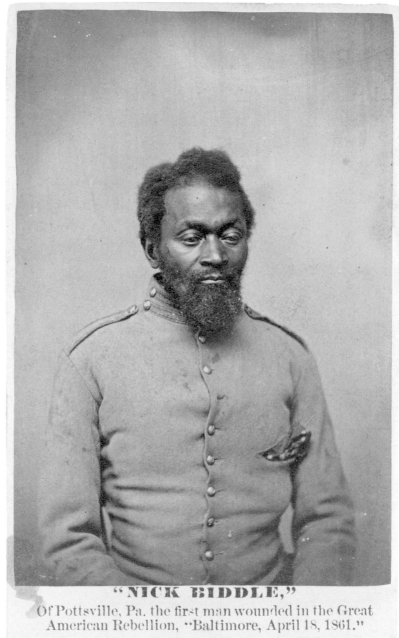

"NICK BIDDLE,"
Of Pottsville, Pa. the first man wounded in the Great
American Rebellion, "Baltimore, April 18, 1861."
Published by W. R. Mortimer, Pottsville, Schuylkill Co., Pa.

**Nicholas Biddle, Union soldier of Pottsville, Pa.,
"the first man wounded in the Great American Rebellion, Baltimore, April 18, 1861"**

Photographer: W. R. Mortimer • 1861 • carte-de-visite

(Charles L. Blockson Afro-American Collection, Temple University Libraries)

———

*Biddle was the servant of Captain James Wren, who oversaw a company of about 100
Pennsylvania militiamen. When they arrived in Baltimore, on their way to defend the
capital, Biddle was injured by townsmen rioting against the war.*

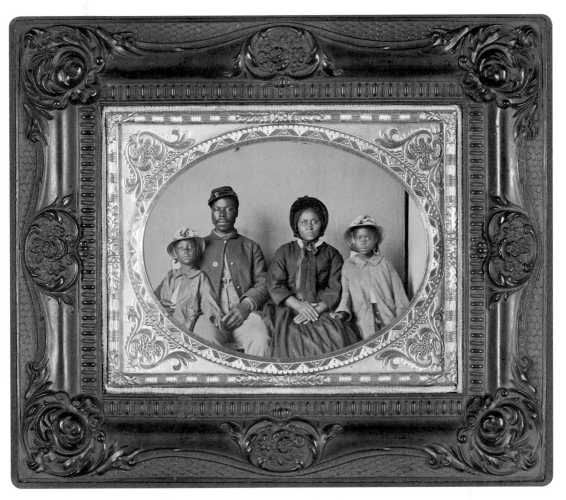

African American soldier in Union uniform with wife and two daughters

Photographer unknown · 1863–1865 · ambrotype, quarter plate

(Library of Congress Prints and Photographs Division, Liljenquist Family Collection
of Civil War Photographs, LC-DIG-ppmsca-36454)

A soldier in uniform, with his wife in dress and hat and two daughters wearing matching coats and hats. General Order 143 issued in May 1863 by Secretary of War Edwin Stanton created the Bureau of U.S. Colored Troops. According to the Library of Congress this image was found in Cecil County, Maryland; it is likely, therefore, that the soldier belonged to one of the seven U.S.C.T. regiments raised in that state.

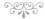

"Free Military School for Applicants for the Command of Colored Troops"

Photographer unknown • c. 1864 • modern print

(Charles L. Blockson Afro-American Collection, Temple University Libraries)

———

Following the Emancipation Proclamation and Lincoln's decision to find regiments of African American troops to serve in the war, the Philadelphia Supervisory Committee for Recruiting Colored Regiments opened this school in the heart of Philadelphia (1210 Chestnut Street) in December 1863. Students attended classes in military tactics, math, and history; some also trained at Camp William Penn in nearby Montgomery County, the first training grounds for African American soldiers in the Philadelphia area. Graduates who were judged to be prepared for duty were commissioned and sent into the field with an African American regiment. Philadelphia businessman Thomas Webster served as chairman of the school and advocated for proper compensation for African American soldiers, who were then paid about half as much as white soldiers.

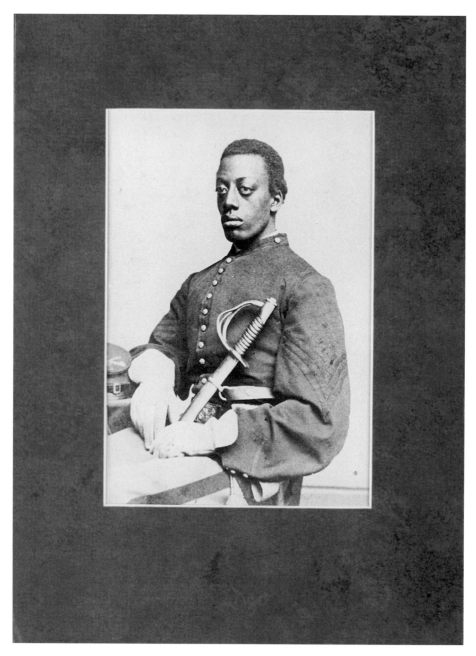

Charles Remond Douglass

Photographer unknown • 1864 • photograph

(Randolph Linsly Simpson African-American Collection, Yale Collection of American Literature,
Beinecke Rare Book and Manuscript Library, 1032321)

The son of Frederick Douglass is pictured here in Union army uniform with his sword. He was the first African American in the state of New York to enlist to fight in the Civil War. Afterward he had numerous government positions, including his appointment by President Ulysses S. Grant as consul to Santo Domingo.

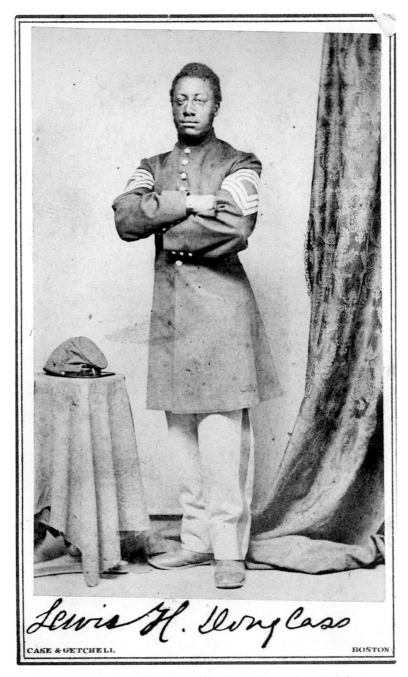

Sergeant Major Lewis Douglass, Fifty-Fourth Massachusetts Infantry

Photographers: Case & Getchell, Boston • 1863 • carte-de-visite

(Moorland-Spingarn Research Center, Howard University)

———

"Let the slaves and free colored people be called into service, and formed into a liberating army, to march into the South and raise the banner of emancipation among the slaves," said Frederick Douglass. "Men of color, to arms!" Both of his sons, Charles and Lewis, enlisted. Here Lewis Douglass stands firmly in his Union army uniform.

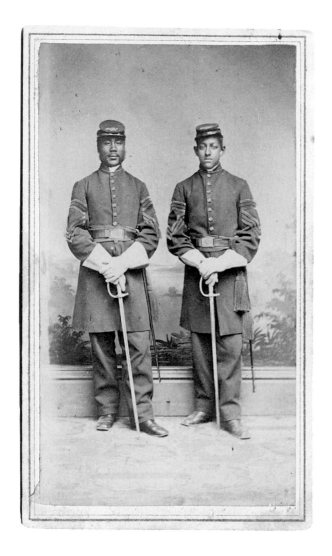

Two sergeants

Photographer: Wells & Collins

c. 1865 • carte-de-visite

(Randolph Linsly Simpson African-American Collection, Yale Collection of American Literature, Beinecke Rare Book and Manuscript Library, 1030383)

Facing page: **Sergeant Major Christian Abraham Fleetwood (1840–1914)**

Photographer unknown • no date • photograph

(Library of Congress, Prints and Photographs Division, LC-USZ62-48685)

Fleetwood was awarded the Congressional Medal of Honor for heroism on the field of battle at Chaffin's Farm in Virginia on September 29, 1864. He was twenty-three. Born a free man in Baltimore, he traveled to Liberia as a youth and graduated from Ashmun Institute (later Lincoln University) in Oxford, Pennsylvania.

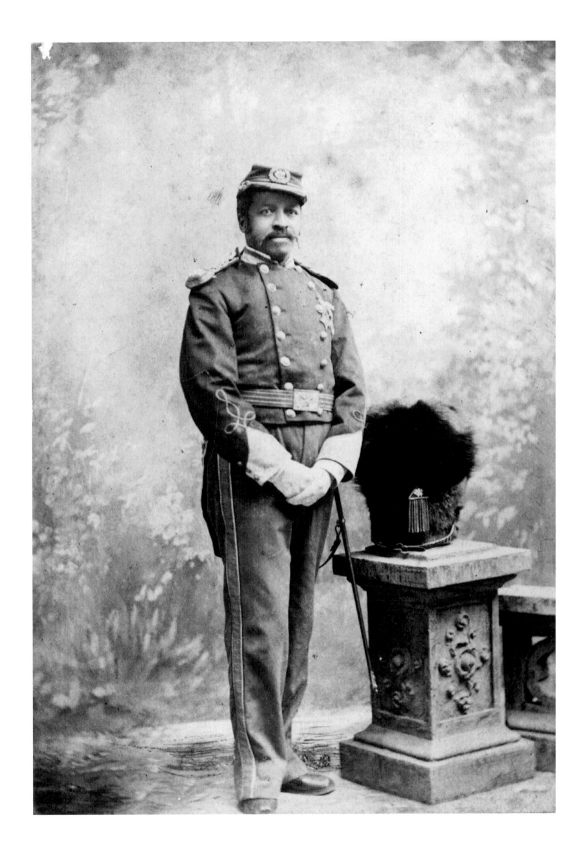

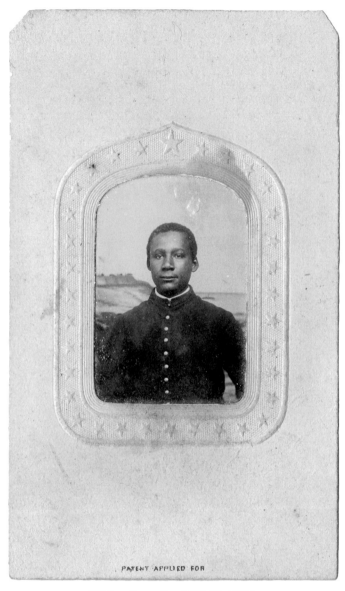

William Henry Scott (1848–1910)

Photographer unknown • c. 1862–1865 • carte-de-visite

(Emory University, MARBL, Research Services, William H. Scott Papers)

Scott was born enslaved in Virginia in his master's house. He escaped to Union troops when they moved near his home and joined the Twelfth Massachusetts Regiment in 1862. Scott spent three and a half years as aide-de-camp to Major Loring W. Muzzey, witnessing some of the severest fighting of the Civil War at Antietam, Fredericksburg, and Gettysburg.

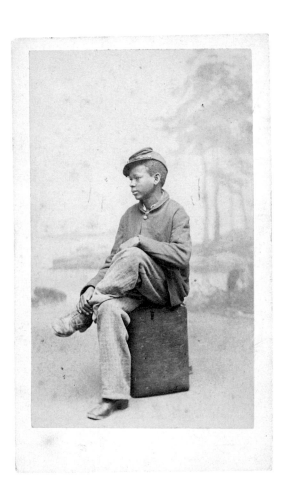

**Studio portrait of a servant boy
sitting on a travel case**

Photographer: B. Black of J. E. Tilton & Co.
1860–1870 • carte-de-visite

(Library of Congress, Prints and Photographs
Division, LC-DIG-ppmsca-10864)

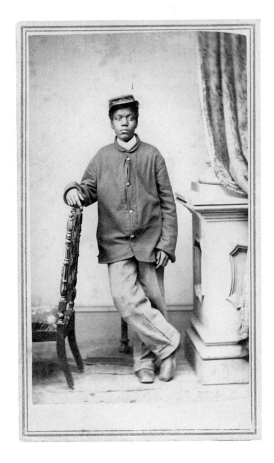

**Studio portrait of a teenaged Henry
Wright, private servant**

Photographer: Gayford & Speidel
1860–1870 • carte-de-visite

(Library of Congress, Prints and Photographs
Division, LC-DIG-ppmsca-10868)

Self-liberated teenaged woman with two Union soldiers, Jesse L. Berch, quartermaster sergeant, and Frank M. Rockwell, postmaster

Photographer: J. P. Ball • 1862 • carte-de-visite

(Library of Congress, Prints and Photographs Division, LC-DIG-ppmsca-10940)

———————

J. P. Ball, a black photographer and active abolitionist in Cincinnati, posed these two soldiers holding their pistols high, possibly to represent their bravery in protecting their young charge. The website of the Oxford African American Studies Center gives the story behind this image (http://www.oxfordaasc.com/public/features/archive/0810/photo_essay. jsp?page=4):

> *In the fall of 1862, two soldiers from Wisconsin's 22nd Infantry Regiment escorted an escaped teenage slave from Nicholasville, Kentucky, to the home of famed Underground Railroad operator Levi Coffin in Cincinnati. The regiment, composed of numerous sympathizers to the abolitionist cause, had been stationed in Nicholasville to fend off a rumored attack from Confederate General Edmund Kirby Smith. The soldiers were Frank M. Rockwell (left), a twenty-two-year-old postmaster from the town of Geneva, and Jesse L. Berch, a twenty-five-year-old quartermaster sergeant from Racine. With the young fugitive disguised as a "mulatto soldier boy," Rockwell and Berch traveled the one hundred miles to Coffin's house at a rapid pace. The party arrived safely and spent two days at the Coffin residence. Before sending the girl off to Racine (where the soldiers had friends ready to take the girl in), however, they posed with her for the above daguerreotype [actually a carte-de-visite].*

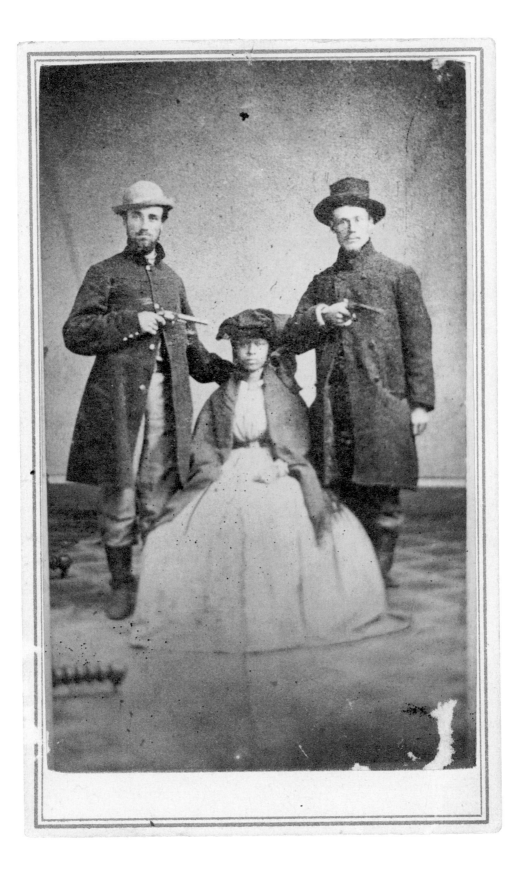

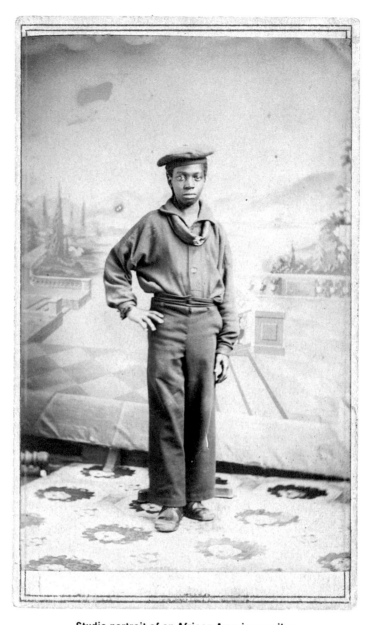

Studio portrait of an African American sailor

Photographer: Ball and Thomas Photographic Art Gallery

c. 1861–1865 • carte-de-visite

(Library of Congress, Prints and Photographs Division, LC-DIG-ppmsca-11280)

———

This unidentified young sailor stands in front of a painted backdrop. It is estimated that over 18,000 African Americans enlisted as sailors during the Civil War, serving in segregated units that consisted of formerly enslaved blacks from the South and black Unionists from the North.

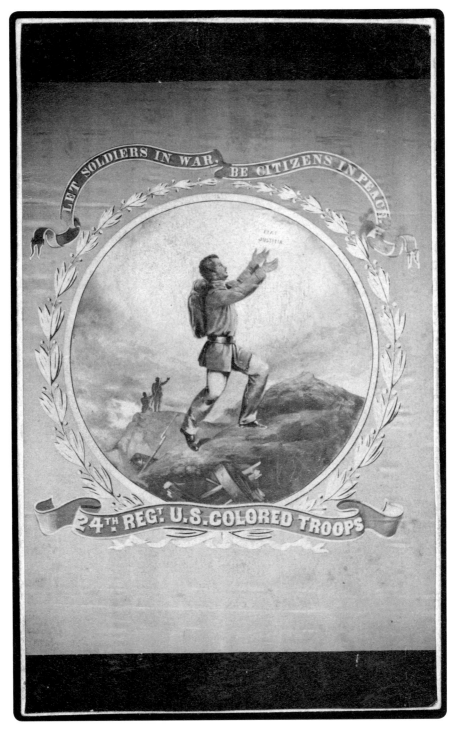

"24th Regt. U.S. Colored Troops: Let Soldiers in War, Be Citizens in Peace"

c. 1865 • carte-de-visite

———

The regimental flag and motto of the Twenty-Fourth Infantry Regiment,
U.S. Colored Troops.

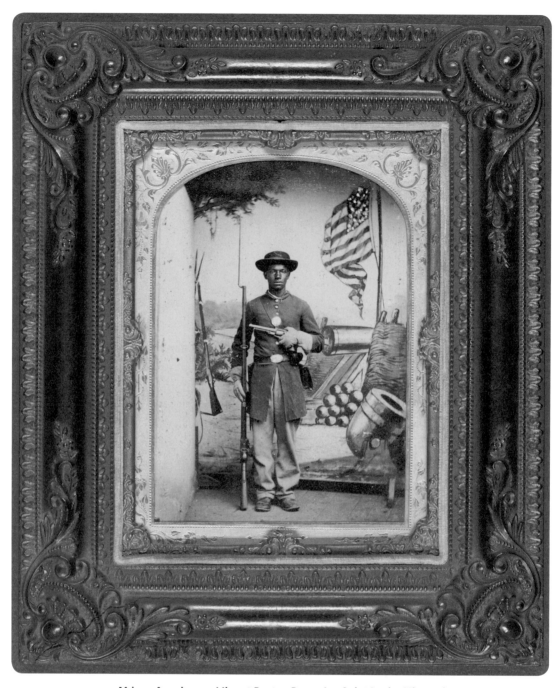

African American soldier at Benton Barracks, Saint Louis, Missouri

Photographer: Enoch Long • c. 1863–1865 • tintype, quarter plate, hand-colored

(Library of Congress, Prints and Photographs Division, LC-DIG-ppmsca-36456)

*Studio portrait with a creative painted backdrop depicting artillery
and a hand-colored American flag waving overhead.*

Martin Robison Delany (1812–1885)

Photographer unknown • c. 1865 • photograph

(Charles L. Blockson Afro-American Collection, Temple University Libraries)

Martin Delany, abolitionist, journalist, writer, physician, and activist, recruited black men to join the Massachusetts Fifty-Fourth and regiments in other states. In 1865 he was commissioned as the first black line field officer in the U.S. army.

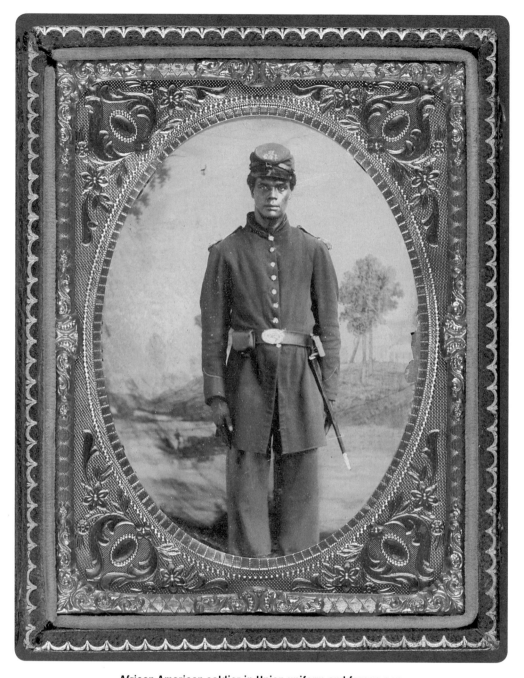

African American soldier in Union uniform and forage cap

Photographer unknown • 1863–1865 • tintype, quarter plate, hand-colored

(Library of Congress, Prints and Photographs Division, LC-DIG-ppmsca-36988)

This soldier's Company B, 103rd Regiment, forage cap designates either the U.S. Colored Troops or the U.S. Volunteers Service. He stands with bayonet and scabbard in front of a painted backdrop showing a landscape with river.

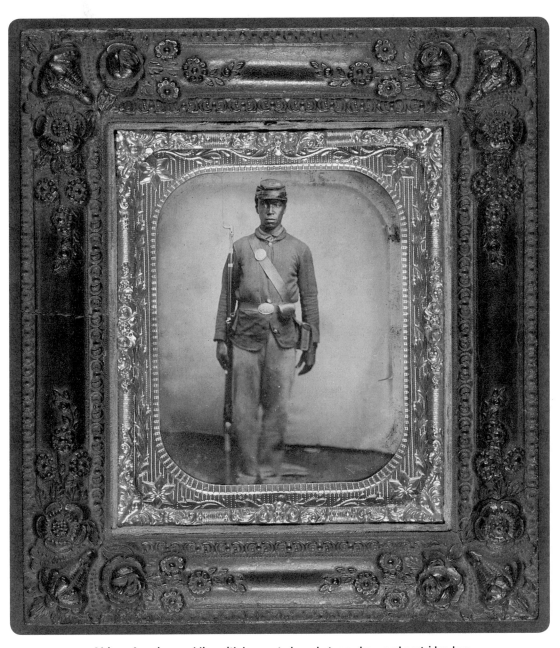

African American soldier with bayoneted musket, cap box, and cartridge box

Photographer unknown • 1863–1865 • tintype, sixth plate, hand-colored

(Library of Congress, Prints and Photographs Division, LC-DIG-ppmsca-37520)

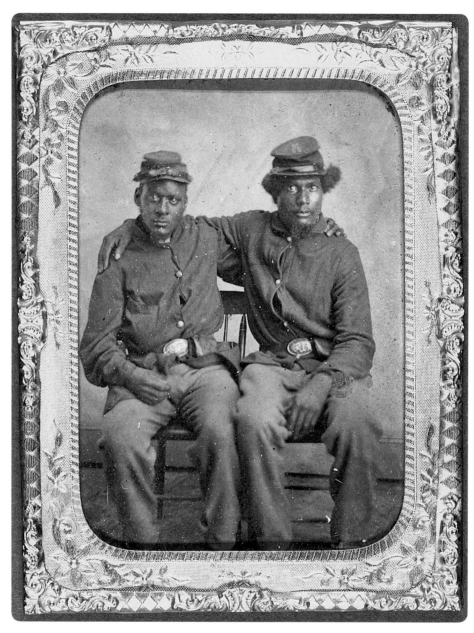

Two brothers-in-arms

Photographer unknown • 1860–1870 • tintype, quarter plate, hand-colored

(Library of Congress, Prints and Photographs Division, LC-DIG-ppmsca-13484)

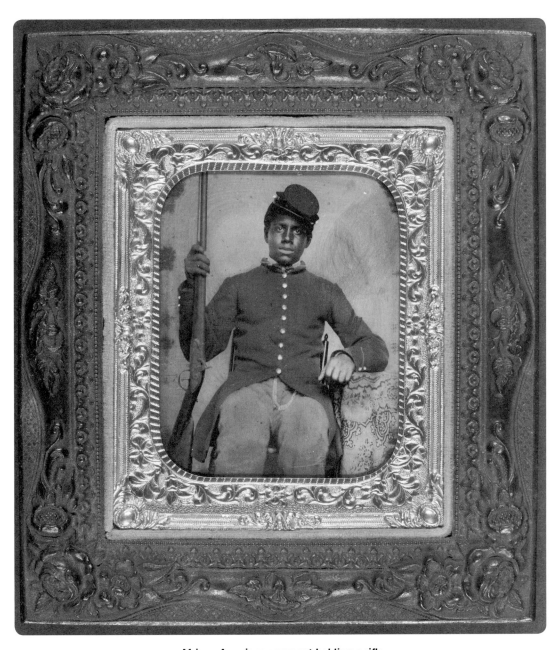

African American sergeant holding a rifle

Photographer unknown • 1863–1865 • tintype, sixth plate, hand-colored

(Library of Congress, Prints and Photographs Division, LC-DIG-ppmsca-37058)

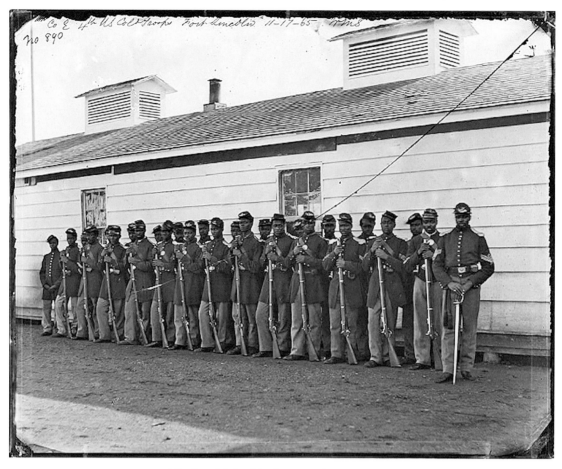

District of Columbia, Company E, Fourth U.S.
Colored Infantry, at Fort Lincoln

Photographer: William Morris Smith • 1862–1865 • photograph

(Library of Congress, Prints and Photographs Division, LC-DIG-cwpb-04294)

Black recruits were initially confined to support roles. After the heroic attack on Fort Wagner by the Fifty-Fourth Massachusetts Regiment, black troops won a share in the fighting, but they were rarely promoted to officer rank. Black soldiers were also paid lower wages than whites until a protest by the Fifty-Fourth Massachusetts prompted Congress in 1864 to equalize salaries and issue back pay.

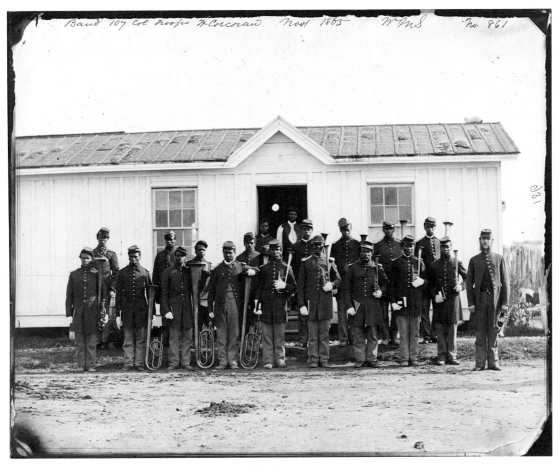

**Band of the 107th U.S. Colored Infantry,
Fort Corcoran, Arlington, Virginia**

Photographer: William Morris Smith • 1865 • photograph

(Library of Congress, Prints and Photographs Division, LC-DIG-ppmsc-02781)

**Execution of Private William Johnson,
Twenty-Third Regiment, U.S.C.T.**

Photographer: Charles Taber & Co.; manufacturers: after Brady Studio
1864 • carte-de-visite

(Library of Congress, Prints and Photographs Division, LC-DIG-ppmsca-11172)

─────────

William Henry Johnson, a private in Company E, Twenty-Third Regiment, U.S. Colored Troops, was hanged for desertion outside the Union trenches encircling Petersburg. The troops called a short truce with nearby Confederates in order to build a gallows and carry out the execution. Union officers invited photographers from the competing firms of Alexander Gardner and Mathew Brady to record the event.

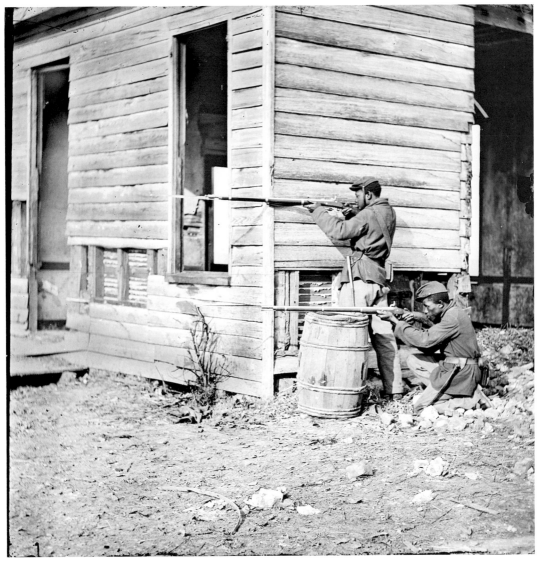

**Dutch Gap, Virginia: picket station of Colored Troops
near Dutch Gap Canal**

Photographer unknown • November 1864 • photograph

(Library of Congress, Prints and Photographs Division, LC-DIG-cwpb-01930)

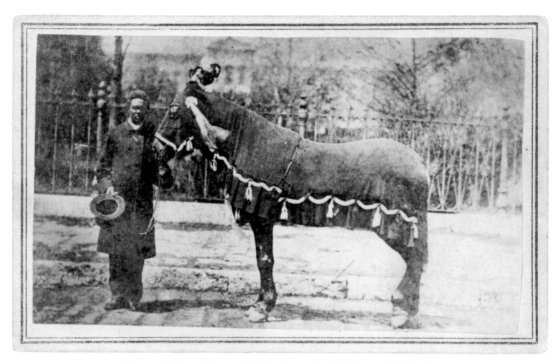

**Reverend Henry Brown with Abraham Lincoln's horse, Old Robin,
on the day of Lincoln's funeral**

Photographer: F. W. Ingmire • 1865 • carte-de-visite

(Library of Congress, Prints and Photographs Division, LC-DIG-ppmsca-10880)

City Point, Virginia: African American army cook at work

Photographer unknown • 1864–1865 • photograph

(Library of Congress, Prints and Photographs Division, LC-DIG-cwpb-02010)

Building, possibly freedmen's quarters

Photographer: J. D. Heywood • 1864–1866 • carte-de-visite

(Library of Congress, Prints and Photographs Division, LC-DIG-ppmsca-10972)

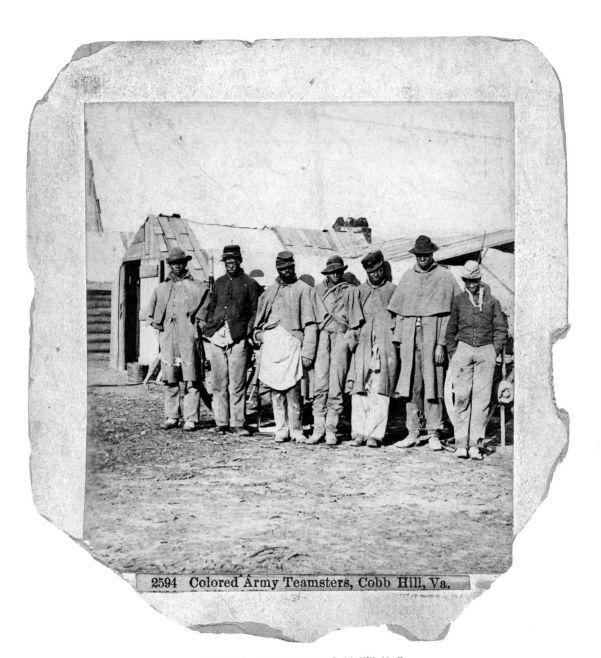

2594 Colored Army Teamsters, Cobb Hill, Va.

"Colored army teamsters, Cobb Hill, Va."

Photographer: John C. Taylor • 1864 • from stereograph

(Library of Congress, Prints and Photographs Division, LC-DIG-ppmsca-11338)

Seven African American men, "contrabands" dressed in worn Union uniforms, stand in front of a wagon and an old barracks in Cobb's Hill, one site of the Bermuda Hundred Campaign.

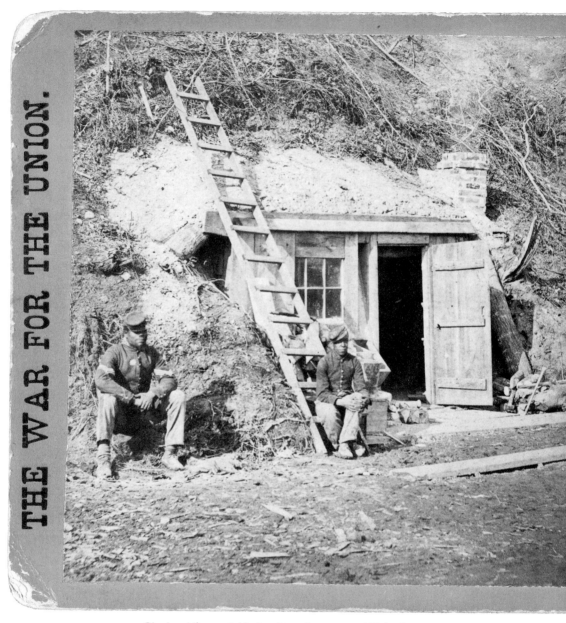

Black soldiers outside bombproof quarters of Major Strong, Sixteenth New York Artillery, at Dutch Gap, Virginia

Photographer: E. & H. T. Anthony & Co.

c. 1864 • photograph (stereographic format)

(Library of Congress, Prints and Photographs Division, LC-DIG-ppmsca-1118)

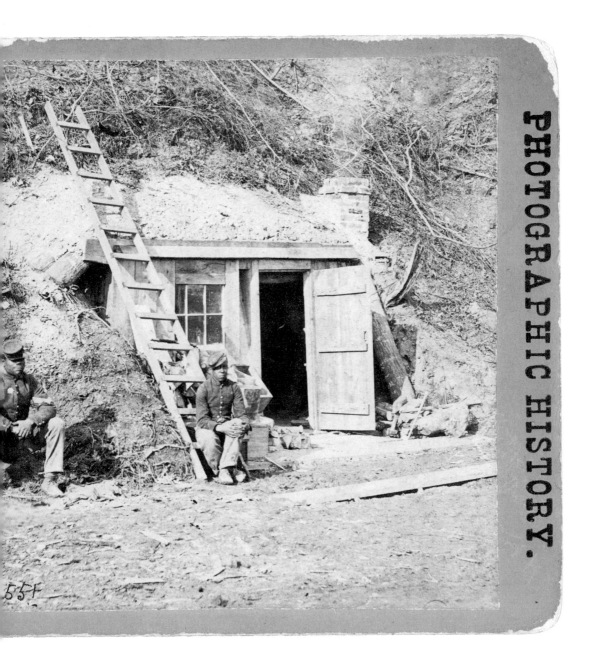

55F

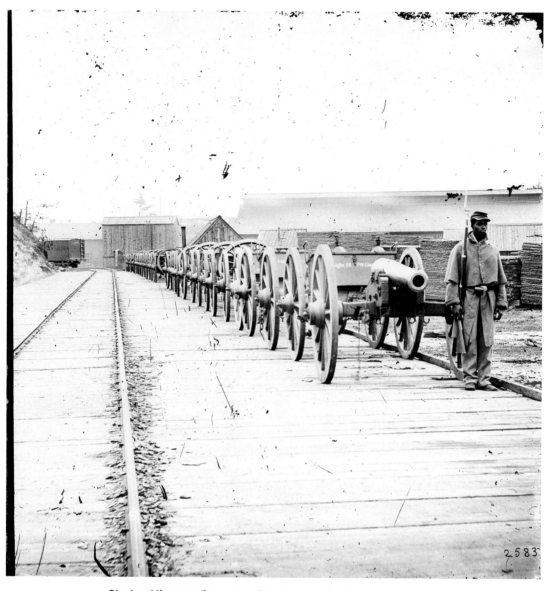

Black soldier guarding a row of twelve-pounder Napoleon cannons, City Point, Virginia

Photographer unknown • 1865 • photograph

(Library of Congress, Prints and Photographs Division, LC-DIG-cwpb-01982)

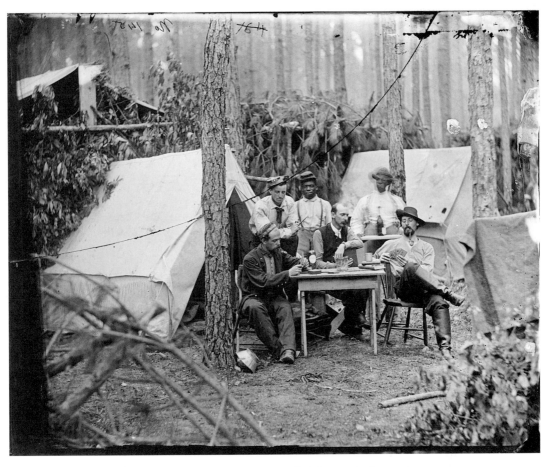

**Officers of the 114th Pennsylvania Infantry playing cards
in front of tents, Petersburg, Virginia**

Photographer unknown • 1864 • photograph

(Library of Congress, Prints and Photographs Division, LC-DIG-cwpb-03882)

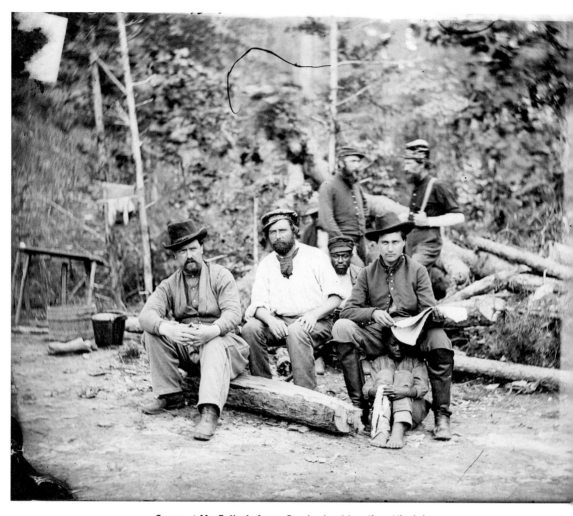

Group at Mr. Foller's farm, Cumberland Landing, Virginia

Photographer: James F. Gibson

1862 • photograph (stereographic format)

(Library of Congress, Prints and Photographs Division, LC-DIG-cwpb-00288)

THE WAR FOR THE UNION.

Slave pen, Alexandria, Virginia

Photographer: Brady & Co.
1861–1865 • photograph (stereographic format)
(Library of Congress, Prints and Photographs Division, LC-DIG-stereo-1s02947)

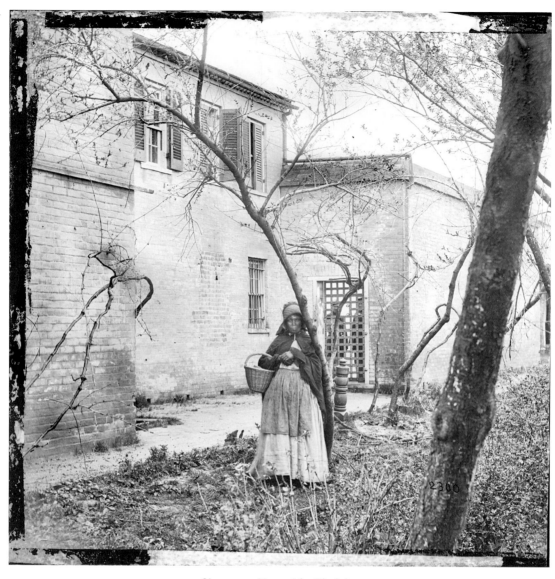

Slave pen, Alexandria, Virginia

Photographer unknown • 1861–1864 • photograph

(Library of Congress, Prints and Photographs Division, 2A06F7F8)

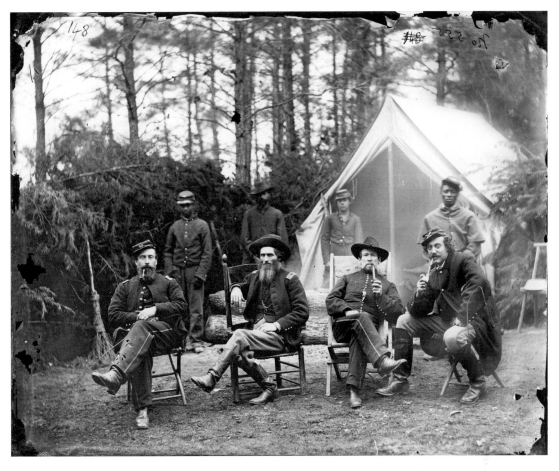

Captain James M. Robertson and staff, First Brigade, Horse Artillery, at Brandy Station, Virginia

Photographer unknown • 1864 • photograph

(Library of Congress, Prints and Photographs Division, LC-DIG-cwpb-04044, AZW10032011)

Washerwoman for the Union army in Richmond, Virginia

Photographer unknown • 1862–1865 • ambrotype, hand-colored

(Courtesy of Smithsonian Institution, National Museum of American History, Photographic History Collection,
Division of Information Technology and Communications)

———

The American flag is hand-colored in the original; she also wears a brass "U.S.,"
signifying her respect for the Union army. Her gaze is straightforward and direct,
and her pose reveals a sense of pride.

———

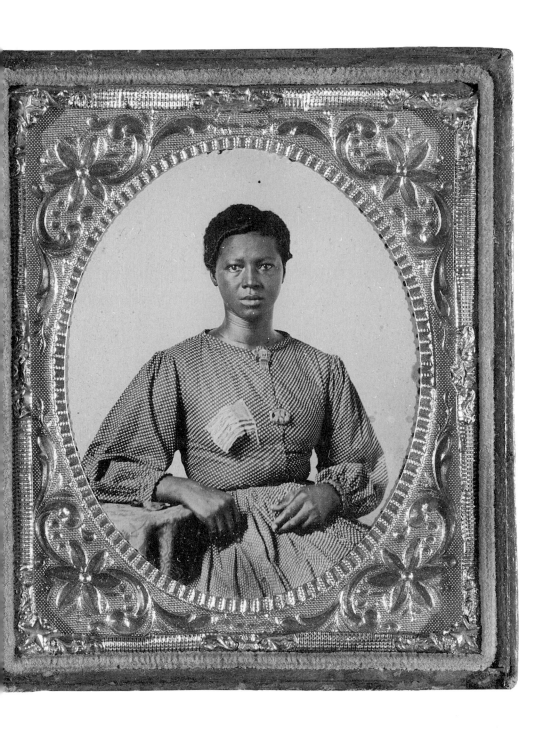

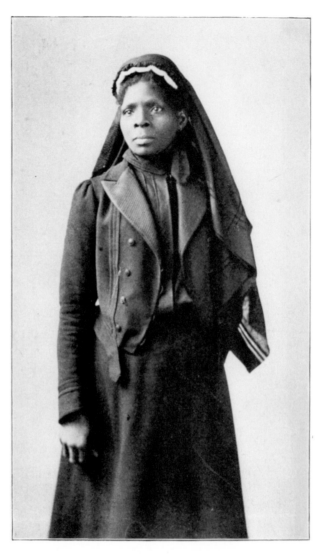

Susie King Taylor

Susie King Taylor

Photographer unknown • 1902 • photograph

(Library of Congress, Prints and Photographs Division, LC-USZ61-1863)

*Susie King Taylor nursed wounded Union soldiers for four years
and three months without pay.*

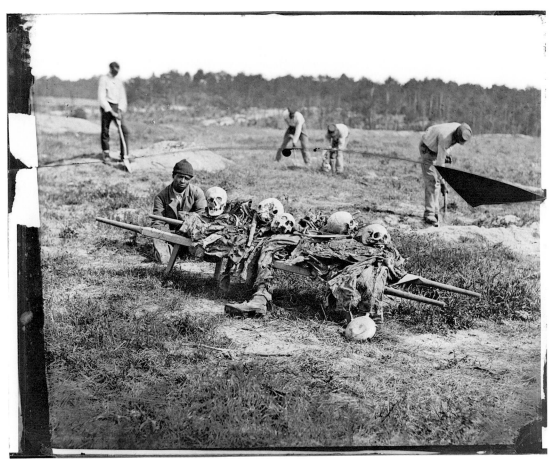

**Collecting the bones of soldiers killed in battle,
Cold Harbor, Virginia**

Photographer: John Reekie • 1865 • photograph

(Library of Congress, Prints and Photographs Division, LC-DIG-cwpb-04324)

**Camp of the Thirteenth New York Cavalry,
Prospect Hill, near Washington, D.C.,
July 1865: Union officers and two black men
in front of barracks**

Photographer unknown • 1865 • photograph

(Library of Congress, Prints and Photographs Division,
LC-B817-7722)

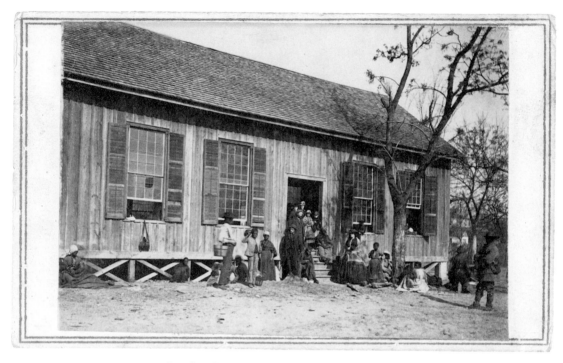

Freedmen's school, possibly in South Carolina

Photographer: Sam A. Cooley • 1865–1870 • photograph

(Library of Congress, Prints and Photographs Division, LC-DIG-ppmsca-10984)

Freedmen's school, Edisto Island, South Carolina

Photographer: Sam A. Cooley • 1865–1870 • photograph

(Library of Congress, Prints and Photographs Division, LC-DIG-ppmsca-11194)

Entered according to Act of Congress, in the year 1862, by M. B. BRADY, in the Clerk's Office of the District Court of the District of Columbia.

**Slave quarters on a plantation,
possibly in Beaufort, South Carolina**

Photographer: Mathew B. Brady • c. 1862 • carte-de-visite

(Library of Congress, Prints and Photographs Division, LC-DIG-ppmsca-10964)

Slave church at Rockville, South Carolina

Photographer: Osborn and Durbec • 1860 • from stereograph

(South Carolina Historical Society, Columbia)

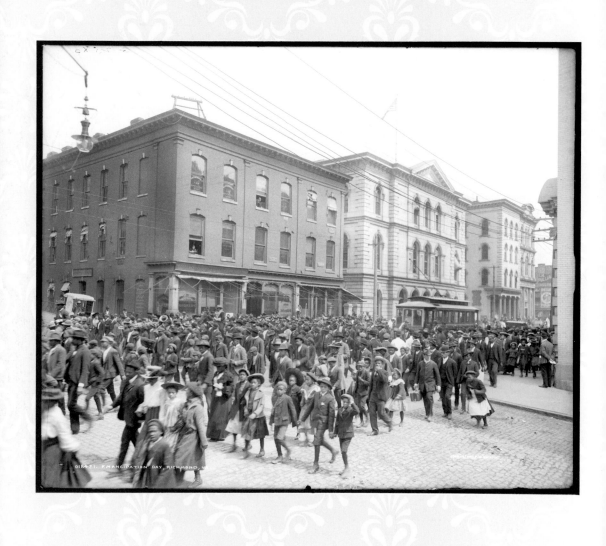

0184-21. EMANCIPATION DAY, RICHMOND, VA.

3

Legacies of Emancipation

We were delighted when we heard that the Constitution set us all free, but
God help us, our condition is bettered little; free ourselves, but deprived of
our children. . . . It was on their account we desired to be free.

Maryland freedwoman whose child was bound
as an apprentice over her objections, c. 1865

Can any colored man, or any white man friendly to the freedom of all men,
ever forget the night which followed the first day of January, 1863, when the
world was to see if Abraham Lincoln would prove to be as good as his word?
I shall never forget that memorable night, when in a distant city I waited and
watched at a public meeting, with three thousand others not less anxious
than myself, for the word of deliverance which we have heard read today.

Frederick Douglass,
speech delivered at the unveiling of the *Freedmen's Memorial*,
Washington, D.C., 1876

We now turn our attention to the legacies of slavery and
emancipation. Though the end of the Civil War in April 1865
effectively ended slavery in the southern states, the institution was
formally abolished with the December 1865 ratification of the Thirteenth
Amendment.[1] Photographs of Emancipation Day celebrations, social and
religious gatherings, portraits of former slaves and their freeborn descendants,
pictures of convict laborers, and images of public monuments remind us that
only the formal institution of slavery died in 1865. The history and memory
of slavery and emancipation endured in the bodies and lived experiences of

both former slaves and the generations of black Americans born in slavery's wake. The extent and meanings of black people's freedom, in their daily lives and on the national stage, took shape unevenly, haltingly, and often incompletely.

From 1866 until 1877—the era known as Reconstruction—Congress worked to clarify and defend black people's freedom and citizenship, most notably with the passage of the Fourteenth and Fifteenth amendments to the Constitution. Congress retreated from this position toward the end of the century. The rise of legalized segregation and discrimination as well as widespread campaigns of terror and violence led many to refer to the late nineteenth and early twentieth centuries as the nadir for black people in America.

During this period, black Americans devised numerous strategies to combat and circumvent repressive social, economic, and political conditions. They built thriving and dynamic communities; they established churches, schools, and banks, formed political organizations, and created cultural outlets, such as literary societies, newspapers, and theaters. Countless black women and men embraced photography as a means of documenting their own existence and celebrating their freedom. The photographic record from this period includes portraits of elderly former slaves, fashionable younger women and men, middle-class families, and such prominent political and social leaders as Booker T. Washington, W. E. B. Du Bois, Mary McLeod Bethune, and the first black legislators.

Images of Emancipation Day celebrations and "slave reunions" stand out, both for the ways in which they directly engage the history of slavery and freedom and for the ways in which they veil or obscure elements of that history. Photographs of schools, teachers, and students on flagship campuses like Tuskegee and Bethune-Cookman exemplify black people's commitment to the promise of the future. Images created during the 1930s by photographers working for the federal WPA engage the history and legacies of slavery and emancipation in other ways, by portraying both the entrenched and oppressive conditions of rural southern poverty and black people's humanity in the face of material and social circumstances that appeared to mirror slavery.

Together, these wide-ranging photographs can be seen as the embodiment of the history and memories of slavery, emancipation, and freedom. They constitute an archive of black people's seen and unseen lives, their spoken and unspoken experiences. These images testify to black Americans' survival and resiliency in the wake of slavery and in the face of late nineteenth- and early twentieth-century segregation and violence. They offer powerful evidence of how black women, men, and children saw themselves and each other: as dignified, beautiful, creative, intellectual, energetic, diligent, steadfast, powerful, and free.

This chapter includes a pair of photographs that illustrate an emotional response to emancipation: "Before the Proclamation" (sad face) and "After the Proclamation" (smiling face). For photography curator Brian Wallis, "these pictures were intended to be derogatory and mildly humorous, and were no doubt issued for a white audience not at all sympathetic to Emancipation. They show a young African American boy obligingly performing the appropriate responses for the intended Southern audience. In the 'Before' image, the boy is slack-jawed and listless; in the 'After' image, he is grinning madly. These photographs deliberately avoid the complexities—political or psychological—of Lincoln's proclamation, but they do suggest some of the practical complications that resulted."[2] The dual images are simply posed and constructed, allowing the viewer to freely interpret them and insert his or her own memory and history.

In the years immediately following the Civil War, recalcitrant slaveholders and southern state lawmakers aimed to recreate slavery's social and economic conditions through restrictive legislation known as Black Codes. Coeval with the codes was a new category of stereotypical imagery. Many former slaveholders refused to relinquish freed black children to their parents but instead insisted upon their continued rights to the children's labor. In some instances the Black Codes reinforced this position with laws that forced black adults to work for white employers and coerced black parents to apprentice their children to white masters. Even after 1868, when Congress required the southern state governments to rewrite their constitutions, ratify the Fourteenth Amendment, and do away with the Black Codes, federal relief efforts endorsed apprenticeship as a means of training young black workers. Apprenticed children and their parents had few rights. They could not control the terms of their labor, received low or no wages, and often found themselves indebted to employers who charged for food and clothing. Apprenticeships were intended mainly to train house servants and agricultural workers, but some children became theatrical performers and musicians.[3] The latter included "Blind Tom" Bethune and the conjoined-twin performers Millie and Christine McKoy (sometimes spelled "McCoy").

"Blind Tom"—Thomas Greene Wiggins (1849–1908)—was one of the most celebrated African American musicians of the nineteenth century. Born blind and enslaved, Tom was four when he began playing the piano for his owner, Colonel James Bethune. In 1857 the eight-year-old Tom performed professionally for the first time, earning a substantial amount of money for Bethune and his family. Colonel Bethune eventually became the musician's legal guardian, a maneuver that made it impossible for Tom to obtain his freedom. Tom traveled throughout the South, and during the Civil War his concerts raised money for the Confederate

army. After the war he continued to perform in America and Europe both as a musician and as a freak-show attraction. His 1882 portrait, taken less than twenty years after emancipation, conveys his sincerity and dignity.

Like Blind Tom, Millie and Christine McCoy were exhibited as a curiosity in theaters as well as in popular freak shows and circuses. Joined at the base of the spine, they were born enslaved in 1851 on the plantation of Alexander McCoy. After performing in theaters around the world, reciting poetry and singing a wide range of tunes, they returned to North Carolina and lived on a farm they had inherited from their father. The twins died in 1912. In their photographs they are fashionably dressed in satin, lace, silk, and woolens.

From the earliest years of the Republic, free and enslaved black people commemorated milestones in their quest for freedom. In 1808 minister and former slave Absalom Jones offered a sermon in Philadelphia on the occasion of the closing of the trans-Atlantic slave trade with the United States: "Let the first of January, the day of the abolition of the slave trade in our country, be set apart in every year, as a day of publick thanksgiving for that mercy. Let the history of the sufferings of our brethren, and of their deliverance, descend by this means to our children, to the remotest generations."[4]

Through the antebellum period, free black people observed not only that date but also the abolition of slavery in the northern states (as occurred in New York in 1827) and in the British West Indies (1834). By the 1850s black people from California to Minnesota to New York, in Canada, and in the West Indies had organized emancipation celebrations in August, the month of West Indian emancipation. In 1857 Frederick Douglass commented upon this established tradition: "I hold it to be eminently fit that we keep up those celebrations from year to year, at least until we shall have an American celebration to take its place."[5]

As soon as the Civil War began, free and enslaved black people opened new avenues for demonstrating their commitment to destroying slavery and establishing unequivocal freedom for black Americans. Not long after Congress officially sanctioned Union officers' policy of extending refuge to self-liberated "contrabands," it moved to abolish slavery in the nation's capital. Enslaved people in Washington were emancipated on April 16, 1862, and received the news of their liberation with a passionate if restrained joy. "Church leaders had issued public messages urging calm and deliberation," historian Kate Masur writes, "and people rejoiced inside their homes, not sure that public displays of ebullience would be well received."[6] The following year, however, free and enslaved people openly heralded January 1, 1863, with shouts, tears, songs, prayers, exuberance,

and jubilation. Bishop Henry McNeal Turner recalled the scene in Washington outside the Israel Church after a reading of the Emancipation Proclamation: "Men squealed, women fainted, dogs barked, white and colored people shook hands, songs were sung"—and cannons were fired in salute.[7] In South Carolina, Charlotte Forten participated in Emancipation Day festivities with freed slaves, black soldiers, and white Union officers:

> New Year's Day—Emancipation Day—was a glorious one to us. The morning was quite cold, the coldest we had experienced; but we were determined to go to the celebration at Camp Saxton,—the camp of the [all-black] First Regiment South Carolina Volunteers,—whither the General and Colonel Higginson had bidden us, on this, "the greatest day in the nation's history." We enjoyed perfectly the exciting scene on board the Flora. There was an eager, wondering crowd of the freed people in their holiday-attire, with the gayest of head-handkerchiefs, the whitest of aprons, and the happiest of faces. The band was playing, the flags streaming, everybody talking merrily and feeling strangely happy. The sun shone brightly, the very waves seemed to partake of the universal gayety, and danced and sparkled more joyously than ever before. . . .
>
> The celebration took place in the beautiful grove of live-oaks adjoining the camp. It was the largest grove we had seen. I wish it were possible to describe fitly the scene which met our eyes as we sat upon the stand, and looked down on the crowd before us. There were the black soldiers in their blue coats and scarlet pantaloons, the officers of this and other regiments in their handsome uniforms, and crowds of lookers-on, —men, women, and children, of every complexion, grouped in various attitudes under the moss-hung trees. The faces of all wore a happy, interested look. . . .
>
> Our hearts were filled with an exceeding great gladness; for, although the Government had left much undone, we knew that Freedom was surely born in our land that day. It seemed too glorious a good to realize,—this beginning of the great work we had so longed and prayed for.[8]

Even in those parts of the Confederacy that remained beyond the scope of the Emancipation Proclamation, such as the areas already under Union control, free and enslaved black people nonetheless celebrated January 1 as a day of deliverance. In Norfolk, Virginia, New Orleans, and Key West, Florida, black people whose legal status remained unchanged organized large celebrations that included white Union forces, northern missionaries, and free black people. They feasted, gave speeches, and took to the streets, marching, waving flags, parading with fifes and drums.[9] In

December 1865, with the war finally over, a Charleston, South Carolina, newspaper announced plans for a celebration: "The Jubilee. Extensive arrangements are being made for the celebration of Emancipation day, which must hereafter be one of the few national Holidays."[10]

After the war ended, Emancipation Day celebrations took place on a variety of dates that held local and national meaning for the participants: January 1, "Juneteenth" (June 19, the day when word of the war's end reached Texas), April 16 (celebrated by black Washingtonians as the anniversary of emancipation in the District), and April 9 (chosen by some black Virginians as the date of General Lee's surrender in Appomattox). In Hudson, New York, a small city on the Hudson River some two hundred miles north of Manhattan, approximately five thousand people gathered on September 3, 1867, for "a grand 'demonstration in remembrance of the people's deliverance from bondage.'" Reverend Henry Highland Garnet and William Howard Day addressed the crowd, which marched from City Hall to the town square.[11] (This event may have been originally planned for August, in keeping with the antebellum custom of marking West Indian Emancipation Day.) In 1879 former slaves in Austin, Texas, celebrated on June 19. One white observer noted, "This is Emancipation Day. The colored are all dressed up. They marched up the Ave. going out to the barbecue."[12]

Photographs of Emancipation Day celebrations capture the jubilation and sense of deliverance that accompanied liberation and also allow us to see the various ways in which people memorialized the enslaved and celebrated freedom. An 1888 image from Richmond, Virginia, for example, presents a group of four adults (three men and one woman) and four children, standing in front of a storefront, likely a business owned by a member of the group. In the center, hanging between two pillars, is a banner featuring a painted bust of Abraham Lincoln, with his name below in block letters. A garland is strung across the entire length of the front of the store, and American flags are affixed to each pillar. The garland and flags are blowing in the wind, as is the flag held by one of the young boys. The blurred images of the decorations coupled with the blurred figure of a moving child on the picture's left side add a sense of movement and vitality to the picture's stationary elements—the adults and the building. Indeed, the three men in the foreground and the woman holding a child in the doorway seem more attentive to the photographer than the children are; the children may be more engaged with a nearby procession or some other public action. The image captures not only the immediate activity of an Emancipation Day celebration but also the symbolic history—the Lincoln banner and American flags—as well as the embodied history in the figures of two men who appear old enough to have experienced emancipation

first-hand. They stand in contrast to the younger generations, but the implicit family or community bond between the older and younger people evokes free black people's living ties to slavery and emancipation.

The history of Emancipation Day celebrations is also rooted in the incorporated black towns that were organized around the country after the Civil War. Eatonville, Florida, incorporated on August 15, 1887, was one of the first: all of its officials and residents were African American. More than fifty black towns were established in the United States in this era. Grounded in community pride and self-governance, they provided opportunities for economic advancement and social uplift, and they offered residents a safe haven. In black towns people and communities could live and flourish apart from the oppressive, violent, and often deadly oversight of white employers, neighbors, and local officials. Many of these towns were, and remain, unknown to the larger society, but others have achieved distinction: Boley, Oklahoma; Institute, West Virginia; Mound Bayou, Mississippi; Grambling, Louisiana; Nicodemus, Kansas; and Allensworth, California. Each town's beginning was unique. For example, Allen Allensworth, who was born a slave, founded the first all-black town in California. Lawnside, New Jersey, became the first African American incorporated municipality in that state in 1926. Originally known as Snowhill, it had been established in the latter part of the eighteenth century and was a station on the Underground Railroad.

Images from the early twentieth century depict large crowds in modern, urban settings. In a 1905 picture of an Emancipation Day parade in Richmond, a large crowd of well-dressed adults and children fills the street, possibly walking along a parade route. A group of men carrying brass instruments as well as a uniformed man on horseback—an army veteran, possibly—are visible in the middle of the crowd. Perhaps the band is bringing up the rear of the formal procession, which is now accompanied by spectators on their way to hear the day's orators and sample the food and music provided at the end of the official events. Spectators, visible in the windows of the brick building, watch the all-black crowd as it moves through the streets. A streetcar and streetlamp provide visual clues to the city's modernization.

The three images of a Saint Augustine, Florida, celebration were likely created on January 1, 1923, the sixtieth anniversary of the Emancipation Proclamation. Historian Mitch Kachun explains that this parade set out from Saint Benedict's Catholic Church in Lincolnville, the city's black neighborhood, and marched past the Saint Augustine National Cemetery, the resting place of many black Civil War soldiers. In one image we can see a car decorated with American flags and a Grand Army of the Republic pennant, adornments that signaled the participants'

patriotism, pride in black men's military service, and continued exaltation of the Union victory. A contingent of men dressed in crisp uniforms and carrying swords in a salute position marches behind the car. The Saint Augustine National Cemetery cannot be seen in the image but is located on the other side of the wall pictured along the left edge of the photograph. In another image, veterans of the First World War march behind a group of musicians, who are also accompanied by spectators, including a man on a bicycle. The parade ended at a baseball field, where people gathered during the day for speeches and barbecue; the festivities continued into the evening with musical performances.[13] In a third image, young women from St. Benedict Catholic School are posed on their parade float. Like the other floats and vehicles, this car is decorated with the American flag. Standing in front of the float is James Welters, a member of the Knights of St. John, a Catholic fraternal association. The images reveal the vibrancy of Lincolnville's community institutions and highlight people's sense of connection to a broader African American community and the nation's history of the Civil War and emancipation.

In the late nineteenth century, Washington, D.C., stood out as a hub of black intellectual life, which centered on Howard University and an array of literary societies and social organizations dedicated to advancing black cultural, political, and intellectual life in America. Emancipation celebrations in that city routinely garnered national attention. In the spring of 1883, a black newspaper in Alabama reminded its readers that on April 16 "the colored people of Washington will celebrate 'Emancipation Day.'" That year's commemoration included an address by Frederick Douglass.[14] By the end of the century, many black Washingtonians debated the propriety of continuing the tradition of emancipation celebrations, concerned about how the large public events and the attendees were perceived by white Americans. In 1885, for example, black people in Washington and nearby communities in Virginia disagreed over the planning and financial management of that year's April 16 celebration.[15] Still, local clergy and civic leaders continued to organize Emancipation Day celebrations through the early decades of the twentieth century.

Photographs of a 1916 gathering in Washington present another aspect of these public tributes to those who had survived slavery. On December 16, 1916, the Cosmopolitan Baptist Church, under the direction of Dr. Simon P. W. Drew, hosted the fifty-fourth convention of former slaves. Noting that the date marked the fifty-first anniversary of the Thirteenth Amendment, the *Washington Bee* stated that the event's purpose was to honor "these old people who were the sinew and backbone of the American republic and the civilized world, whose ancestors had toiled and worked for over 250 years in slavery." Another goal was

to raise $100,000 to construct a hall with memorial windows honoring "Abraham Lincoln, Emancipator," along with a lengthy and odd list of other public figures, including George Washington, Robert E. Lee and Stonewall Jackson, Harriet Beecher Stowe, Frederick Douglass, Queen Victoria, William Tecumseh Sherman, Booker T. Washington, and Mrs. John D. Rockefeller. Dr. Drew enjoyed a national reputation as an evangelical preacher and an advocate for former slaves, black soldiers and veterans, and poor black women and children. Newspaper accounts of the 1916 event stated that 7,000 tickets for free dinners were distributed "to the old folks, poor mothers, fathers and children," and that supporters donated the use of carriages and automobiles to transport the elderly and infirm. The event was especially noteworthy because so many centenarians attended.[16]

Elizabeth Berkeley (aged 125) and Sadie Thompson were featured in a photograph. Both wear fancy winter coats and nicely decorated hats. Standing arm in arm, the women look away from the camera, and each seems to cast her gaze toward the distance. Though they are not looking at each other, their bodies and faces convey an intimacy between them. Did they know each other in slavery? Were they related? Did they meet in a "contraband" camp during the war? Did they meet and become friends, co-workers, or neighbors after the war? Theirs remains an unwritten history. Their faces are creased with age, and despite their proud bearing, the two women have a weary air about them.

This photograph, more than the other images of emancipation celebrations, evokes slavery's brutal past even as it pays tribute to black people's endurance and survival. It brings to mind the ways in which slavery enacted and justified the sexual exploitation and abuse of black women. It is difficult to look at these women standing in front of a Washington church without remembering the Virginia slave traders who happily imagined the profits they could earn from selling the Edmonson sisters as concubines or breeders in the New Orleans slave market. The *Washington Bee* noted that the 1916 convention was called "the Great Queens' Rally," presumably to laud the women who had survived slavery. Seen in this light, Elizabeth Berkeley and Sadie Thompson do not appear simply or singularly as brutalized or victimized but as strong, resourceful, and determined women who have experienced and witnessed much more than they might say or we might imagine. Their picture is striking precisely because of the way it simultaneously summons and banishes memories of sexual exploitation and violence.

By the turn of the century, the size and frequency of Emancipation Day celebrations had declined. Kachun links the fading of this tradition to the rise of legalized segregation—Jim Crow—and the concomitant restriction of access to public spaces like streets, parade grounds, and parks. The threat of white vigilantes

and violence, including lynching, directed against black people in public spaces also worked to squelch emancipation festivities, especially in the South. Influential men and women, educational, political, and civic leaders in the black community, voiced the sentiment that the time had come to look to the future rather than the past, to focus on positive achievements and the social and economic advancement of the race. Increasingly, these leaders eschewed talking at length or in detail about slavery because the topic was so closely associated with black people's degradation rather than elevation. Finally, black men and women participated in the nationwide rise in leisure activities such as ball games, bicycling, and ragtime music. Younger people found new outlets for congregating and socializing that supplanted older celebrations.[17]

A few images from the twentieth century point to a different type of gathering that involved former slaves. A photograph taken in Southern Pines, North Carolina, presents a group of men who had come together at a reunion organized by former slaveholders and their descendants. The titles given to these images, such as "Old Slave Day" or the more generic "slave reunion," strike a discordant note, hinting at the prevalent trend in the dominant early twentieth-century national culture of romanticizing slavery and sentimentalizing the relationship between masters and slaves. Yet the sitters in the pictures included here do not appear to be complicit in the "moonlight and magnolias" fantasy. In the Southern Pines picture, for example, the men wear formal attire: suits, ties, and overcoats. They appear dignified; some look toward the camera, but others look away. Like Elizabeth Berkeley and Sadie Thompson, these men stand as living proof of their capacity for survival. One can imagine that the women and men who gathered at such events felt profound connections with each other based on experiences of love, friendship, and support as well as pain, loss, and despair. Their expressions—indulgent, bemused, skeptical, and fatigued—betray a deeper and far more complicated understanding of their own lives and the larger history of slavery and emancipation than the label "Old Slave Day" would suggest.

This type of sentimental revisionist history was not unique to the twentieth century. The history of Thomas Ball's *Freedmen's Memorial* reveals some of the ways in which black people's efforts to commemorate Abraham Lincoln and emancipation were co-opted and redirected by white patrons. In the wake of Lincoln's assassination, a former slave named Charlotte Scott gave her former master five dollars with the understanding that he would work for the creation of a monument in Lincoln's honor. Newspapers quickly picked up the story. Other black people followed Scott's lead, and the movement soon gained national attention. Shortly thereafter a volunteer war relief agency—the Western Sanitary

Commission of Saint Louis—took charge of the project. Under the leadership of its white sponsors, the commission framed Scott's initial donation not as a civic or even political gesture but as the act of a humble and grateful subordinate. Scott's story was further sentimentalized because she gave her money to her former master. Indeed, the commission's first broadside referred to Charlotte Scott simply as an "old negro woman" who wanted "to build a monument to good Massa Lincoln," erasing Scott as a thoughtful, determined, and named actor.[18] Ultimately, donations from black soldiers constituted a large percentage of the funds raised for the desired memorial, though the white directors remained in charge of the money and decision making.

Thomas Ball's sculpture depicts Lincoln standing above a kneeling, semi-clad black man, who reaches out with one hand that is shackled, with a broken chain. Historian Kirk Savage writes of the monument's rendering of freedom: "Ball's emancipated man is the very archetype of slavery: he is stripped, literally and figuratively, bereft of personal agency, social position, and accouterments of culture. Juxtaposed against the fully dressed, commanding figure of Lincoln, the black figure's nudity loses its heroic aspect and works instead as negation—most drastically a negation of the conventional markers of masculinity now monopolized by the white man above."[19] The monument thus failed to embody Reconstruction's ideals concerning black people's social and civic equality, just as it effaced the accomplishments and aspirations of the black women and men who had paid for it. Ironically, Ball used the image of a self-liberated man named Archer Alexander as the model for the freed slave in the sculpture. Compounding this irony is the fact that Alexander was enslaved in Missouri, a slave state that remained loyal to the Union during the war and was thus exempt from the provisions of the Emancipation Proclamation.

Frederick Douglass spoke at the 1876 unveiling of the monument and, notably, gave virtually no attention to the sculpture in his speech. Rather, he focused on Lincoln's complexities and contradictions. While he described Lincoln as "pre-eminently the white man's President, entirely devoted to the welfare of white men," he also proclaimed that "we, the colored people, newly emancipated and rejoicing in our blood-bought freedom, near the close of the first century in the life of this Republic, have now and here unveiled, set apart, and dedicated a monument of enduring granite and bronze, in every line, feature, and figure of which the men of this generation may read, and those of after-coming generations may read, something of the exalted character and great works of Abraham Lincoln, the first martyr President of the United States."[20] It is hardly surprising that Douglass chose to highlight the glorious outcome of emancipation rather than simply lauding

Lincoln as the Great Emancipator. Of the statue, Douglass was overheard saying critically that "it showed the negro on his knee when a more manly attitude would have been indicative of freedom."[21]

Turn-of-the-century photographic portraits of women and men convey the sentiment expressed in Douglass's critique of the *Freedmen's Memorial*. These portraits, much like their antebellum counterparts, emphasize the subjects' refinement, economic success, skill, and achievement. Occupational portraits, for example, depict craftsmen and -women as skilled artisans, posed with the tools of their trade. Images of young adults, the sons and daughters of those who had been freed from slavery, reflect the forward-looking ethos of the period. They do not serve to commemorate or memorialize emancipation but instead firmly anchor their subjects as free people and American citizens. In the early twentieth century, W. E. B. Du Bois embraced photography as a means of challenging racist repression and arguments about black criminality and degeneracy. Du Bois, like so many before him, used photography to represent black people's humanity, beauty, and respectability.[22] So too did the individual men and women who sat for portraits and displayed photographs of family members, friends, and prominent public figures in their homes.

An 1885 photograph of a young woman in Hannibal, Missouri, is an important visual document. In this studio portrait a young woman is posed in front of a painted screen depicting a romantic garden setting. She wears a formal dress and hat with tasteful embellishments, and she holds an umbrella. The limited available information about the picture indicates that she worked as a house servant. Her clothing and pose, however, convey her respectability and refinement and do not associate her with labor or subjugation. This image stands in stark contrast to the nineteenth- and twentieth-century images of women servants commissioned by their owners and employers, and specifically images of black women holding white babies. Here the woman appears on her own terms, defined only by her elegant clothing and comportment.

Photographs of large gatherings, such as picnics and baptisms, reflect freedom's physical qualities. During the antebellum period, law and custom carefully regulated black people's movements, dictating where and when they could go and prohibiting large gatherings. Freedom thus offered the possibility, if not always the reality, of unrestricted movement and the opportunity for communities to come together when and where they desired. Images of a church picnic in Bon Air, Virginia (a town west of Richmond), convey the different ways in which black people could occupy and claim space for their own social and recreational purposes. The image of a large crowd assembled in front of the Wilkes County courthouse in Washington, Georgia, is especially noteworthy because it suggests

local residents' determination to exercise their rights as free people and citizens even in the face of repressive and deadly violence. During the period when this picture was made, white mobs whipped and lynched black men and women who openly challenged racist employers or otherwise refused to submit to segregation and white supremacy.[23]

Images of convict laborers in Florida add another dimension to our understanding of emancipation's legacies by highlighting the ways in which racist repression was not simply carried over from slavery but was continually remade to accommodate new conditions. Cultural historian Paul Ortiz reports that in the early decades of the twentieth century, commercial entities and a few state governments often coerced free black people into labor relations that resembled the conditions of slavery. Florida lawmakers imposed laws designed to confine African Americans to an economically and socially subordinate position. Laws constrained laborers' mobility, depressed wages, and aimed to keep sharecroppers and workers in debt to white employers. Vagrancy laws allowed for the arrest of unemployed black men, who were then forced to work in local industries under grueling conditions modeled on the days of slavery.[24] Black men and women laid tracks for the railroads, built state roads, and worked in turpentine and logging camps. "The convict lease was profitable to the state, county sheriffs, and northern-based firms alike," writes Ortiz. "By 1910, Florida had the highest incarceration rate of prisoners and juveniles in the Deep South. The state administered one of the most notorious penal systems in the world."[25]

Free black workers, too, were subjected to conditions that paralleled those of slavery. Workers were recruited by Florida's lumber and turpentine companies with promises of decent wages, then trapped in debt and effectively imprisoned by their employers. Armed guards monitored free workers, as well as convicts, and threatened workers who protested or attempted to escape.[26]

These photographs offer a powerful reminder of how black people's freedom has been constrained, undermined, and revoked, and how deeply engrained in legal structures and labor relations was slavery's fundamental ideology of black servitude and white supremacy. Though the people pictured in these photographs did not live in the antebellum period, their experiences of forced labor, violence, and exploitation perpetuated slavery's legacies.

Twentieth-century photographs of former slaves offer another avenue for considering the legacies of slavery and emancipation. In the 1920s and 1930s, black photographers Richard S. Roberts, Elise Forest Harleston, and P. H. Polk photographed formerly enslaved residents in their own communities: respectively

Columbia, Charleston, and Tuskegee. Polk's portraits reveal both sensitivity and clarity toward the past. His intent was to capture the character of these elders, and he titled his portraits "Old Characters."

During the 1930s and 1940s, various federal agencies hired photographers to interview and photograph Americans across the country. The Federal Writers' Project of the WPA interviewed many former slaves in the southern states. Some of the subjects also sat for photographs, creating a visual archive to accompany the oral testimony. Photographers working for the federal Farm Security Administration (FSA) took pictures of impoverished sharecroppers and tenant farmers. The goal of the FSA was to provide services to poor farmers and farmworkers; projects included providing medical care as well as nutrition and health education. Most services were directed toward white recipients, though the FSA gave limited attention to the needs of black people. Interestingly, one measure entailed paying poll taxes for southern black voters. In 1935 the FSA established a photography project to promote its efforts. A contingent of white photographers created images of farmers and farmworkers across the country, illustrating both the hardships of rural poverty and the humanity of those who labored under grueling conditions.[27]

The image of three women—Lucy Mooney and her granddaughters Bertha (the younger child) and Lucy Pettway—seated on a bed in their cabin in Gee's Bend, Alabama, is especially compelling for many reasons. It suggests a twentieth-century history of black poverty rooted in sharecropping and other legacies of slavery and postemancipation social and economic conditions. Beyond this, however, it reveals enduring African American cultural traditions, such as women's textile work. Black women's artistry as quilt-makers has been documented by the eminent scholar Gladys-Marie Fry. Lucy Mooney and her granddaughters sit on a handmade quilt that evokes memories of the ones enslaved women pieced together to keep their families warm at night, and the ones made and sold by free black women to support their families. The photographer simply identified the women as "descendants of slaves of the Pettway plantation." Lucy Mooney was born around 1880, was raised by her grandmother after her mother passed away, and lived until 1969. Yet their connection to slavery and enslaved ancestors is not simply a record of grinding poverty, deprivation, and hardship. Rather, the image can be seen as reflecting the strength and durability of women's knowledge and skills—and also of their aesthetic sensibility and ability to merge artistry with functional objects. Indeed, from 2002 to 2006 quilts made by Lucy Mooney, her granddaughters, and other women of Gee's Bend were displayed in major art museums across the United States. This photograph, like the other

images of multigenerational families, allows us to contemplate the ways in which memories were recalled, preserved, and shared among family members. How did grandmothers, mothers, aunts, daughters, and sisters shape the stories they told and passed on to each other? What did quilt making mean to these women and to the generations that followed?[28]

Lucy Pettway, who passed away in 2003, recalled her early life:

My lifestyle centered around going to school, bringing water from a spring, the wood stove, fireplace, outhouse, kerosene lamps, washboard, washpot, and two tin tubs used for washing and taking a bath. Smoothing irons were placed to the fireplace to press my clothes. . . .

I earned a degree from ASU–Montgomery, Alabama. Taught school for many years.

Now that I've retired, my mind reflects back to the past, comparing the past with the future. Life wasn't easy but I made it by God's grace. I've come this far by faith.[29]

The photograph of Lucy Mooney and Lucy and Bertha Pettway thus offers much more than an image of hardscrabble life in rural Alabama. With Lucy Pettway's memory as a guide, the photograph can be seen as a reflection of the loving and dedicated relationships that sustained families, supported children's education, and created emotional worlds that far exceeded the material conditions of sharecropping on former plantations.

Dorothea Lange's 1937 photograph of the Pharr plantation house near Social Circle, Georgia, offers another opportunity to consider how history and memory shaped the landscape.[30] According to Lange's notes, enslaved people built the plantation house in 1840 with bricks imported from England to Savannah, Georgia, and then transported to the plantation by ox cart. By the time Lange photographed the house, it had been abandoned, though renters worked the surrounding land. The image of the empty house is striking because it can be seen as a monument to the sweat, blood, and tears of those who were forced to labor on the plantation. Like the plaque in the Capitol Building that acknowledges the enslaved laborers who constructed that edifice, the very existence of the Pharr house testifies that enslaved people's lives remain present in the physical world even though they also remain unnamed and unwritten. Together, the image of the abandoned plantation house and the image of Lucy Mooney and her granddaughters suggest that places as well as people can preserve, recall, and narrate memories of slavery and freedom.

The work of contemporary photographers Wendel White, William Williams, and David "Oggi" Ogburn offers yet another opportunity to consider the legacies of nineteenth-century black activism and patriotism. White's photographs of the burial sites of black veterans of the Civil War memorialize these forgotten soldiers. The photograph in this volume symbolizes the experiences of the black soldiers who committed their lives to the fight for black people's freedom. Williams's photographs of battle sites and monuments to black solders also remind viewers of the historical meanings and historic consequences of the Civil War. Williams made a distinctive photograph of a statue of a Civil War soldier, the *Sergeant Carney Monument*, in Norfolk, Virginia. The monument serves as a grave marker (the statue's face is a portrait of Carney) and also as a memorial to all U.S. soldiers of color up to the Spanish-American War. Last, Ogburn's photograph of a Civil War monument located in Washington is a reminder of the archival research and record keeping by contemporary community leaders dedicated to preserving regional African American history. Sculptor Ed Hamilton was commissioned to create the African American Civil War Memorial and Museum in 1998, a tribute to the U.S. Colored Troops who served during the Civil War.

Perhaps more than any other image, Richard Avedon's portrait of William Casby invites consideration and debate about what freedom looks like. William Casby was born into slavery in Louisiana in 1863 or 1864. Avedon photographed him in the spring of 1963 during a trip that included appointments to photograph Martin Luther King Jr. (who posed with his father and son) and also Freedom Riders from the Student Nonviolent Coordinating Committee.[31] There is no clear indication of how Avedon and Casby found each other; most likely one of Avedon's friends or colleagues introduced them. American Studies scholar Sara Blair explains that Avedon "conducted a photographic tour of the South" and photographed key figures in the Civil Rights movement as part of a collaborative project with James Baldwin.[32]

In 1964 Baldwin and Avedon published *Nothing Personal*, a volume of photographs and texts that addressed issues of cultural politics and the power of visual and textual representation. The two men, friends since high school, intended their project to stand as a provocative meditation on the current social and political climate, the power of racism, and the possibilities of redemption through art, writing, and experience. The book proved too controversial for most reviewers at the time, and it has long been out of print.[33]

Casby's image has been displayed in the world's leading museums and galleries in the half-century since its creation. Scholars have noted that Avedon's portrait of Casby deliberately engages but also challenges the history of photography as a

documentary or evidentiary mode of representation. Although the format recalls a mug shot, perhaps, Avedon's image aims instead to convey Casby's lived experience and humanity. Sara Blair notes that the image "render[s] with auratic precision the impress on its subject's face of an unimaginable past."[34] This is, of course, Avedon's rendering of Casby rather than Casby's depiction of himself, his life, and his views on the history of black people's enslavement and freedom.

The portrait is especially challenging in that it offers few visual clues other than what the viewer brings to a reading of Casby's face. In many respects the image is anchored in a history of generalizations and assumptions about black men, slavery, and liberation. Yet by including it in our collaborative project on the photographic history of emancipation, we seek to offer a new set of referents for this image. How might a reading of Casby's image change if it is considered alongside the images of Frederick Douglass, Urias McGill, Harriet Tubman, and Susie King Taylor? What can one "see" in Casby's face if one contemplates his knowledge not just of slavery but also of emancipation? In this image Casby is isolated from family, friends, and community, just as the viewer is cut off from Casby's voice. One might look at the image and pause to consider the knowledge he brought to his meeting and photo session with Avedon. What did Casby recall of his parents and their enslavement? Who helped form his memories of his own enslavement and emancipation? What did he tell his own family about the past, and did they create their own photographic narratives and memories?

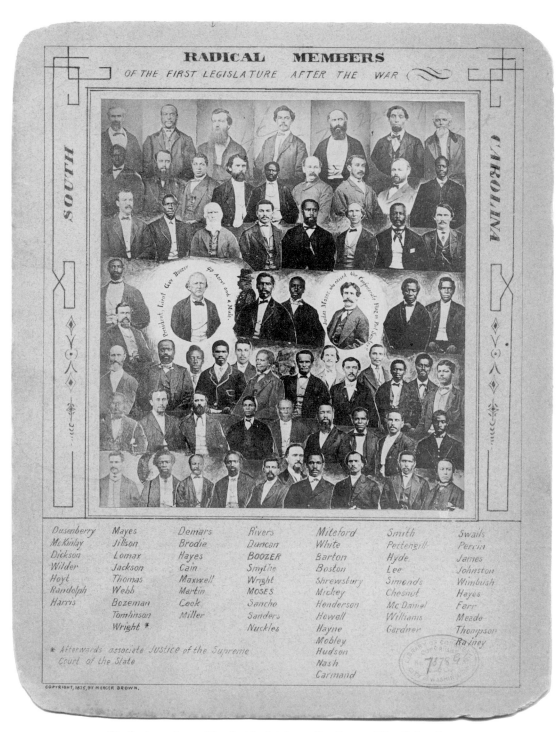

"Radical members of the first legislature after the war," South Carolina

Photographer: William F. Shorey

c. 1876 • photo collage of portraits

(Library of Congress, Prints and Photographs Division, LC-DIG-ppmsca-30572)

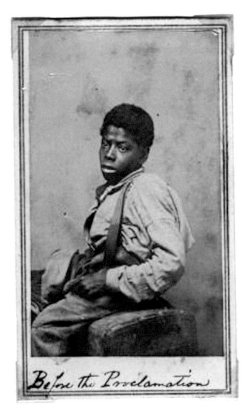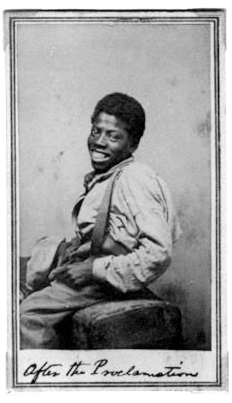

"Before the Proclamation" and "After the Proclamation"

Photographer: Algenon S. Morse and William A. Peaslee

c. 1863 • cartes-de-visite

(International Center of Photography, gift of Daniel Cowin, 1990, 893.1990)

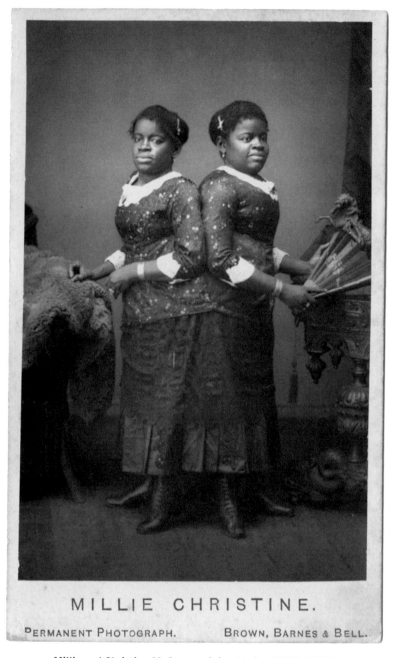

MILLIE CHRISTINE.

PERMANENT PHOTOGRAPH. BROWN, BARNES & BELL.

Millie and Christine McCoy, conjoined twins (1851–1912)

Photographer: Brown, Barnes & Bell • c. 1860 • carte-de-visite

(Charles L. Blockson Afro-American Collection, Temple University Libraries)

The conjoined twins Millie and Christine McCoy were born into slavery and sold at birth to a showman named Joseph Pearson Smith. Smith and his wife worked closely with the children, teaching them foreign languages, dance, and music. The twins appeared frequently with P. T. Barnum's circus and traveled internationally. They were always fashionably dressed in their photographs.

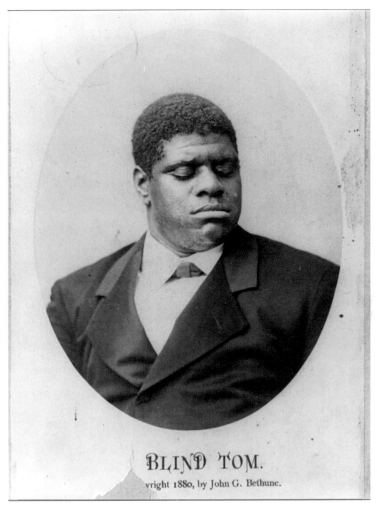

BLIND TOM.

...vright 1880, by John G. Bethune.

"Blind Tom": Thomas Greene Wiggins (1849–1908)

Photographer unknown • c. 1882 • carte-de-visite

(Charles L. Blockson Afro-American Collection, Temple University Libraries)

Blind at birth, Tom was a musical prodigy who, as reported, effortlessly performed songs he heard played on the piano of his owner, Colonel James Bethune. At an early age he composed music, performed in concerts, and toured the country. During the Civil War Tom played benefit concerts to raise money for the Confederate army. Colonel Bethune became his legal guardian when he was a teenager, and even after the war and slavery ended, Tom continued to perform at Bethune's, and later his heir's, direction.

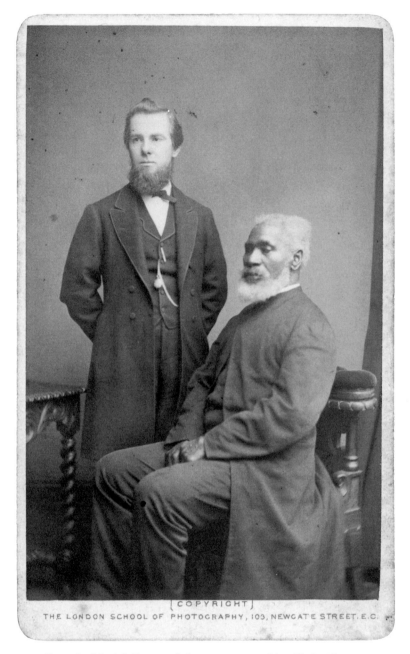

Portrait of Josiah Henson sitting next to an unidentified white man

Photographer: Bradshaw and Godart • c. 1876 • albumen print

(Charles L. Blockson Afro-American Collection, Temple University Libraries)

Josiah Henson, author, abolitionist, and minister, was born into slavery in Maryland but escaped to freedom in Ontario, Canada, in 1830. There he founded a school for other fugitive slaves. His life story, published in 1849, is believed to have inspired the character George Harris, the fugitive slave in Harriet Beecher Stowe's Uncle Tom's Cabin.

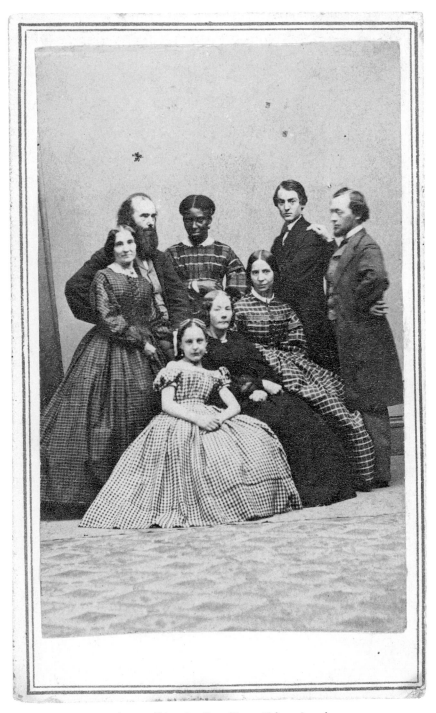

Group portrait, possibly a family, with an African American woman

Photographer: Seth C. Landon • 1860–1870 • carte-de-visite

(Library of Congress, Prints and Photographs Division, LC-DIG-ppmsca-11016)

Emancipation Day in Richmond, Virginia

Photographer: George Cook

1888 • photograph

(Cook Collection, Valentine Richmond History Center, Richmond, VA)

A storeowner stands outside his shop on East Main Street near 21st Street with his family and patrons. A banner with the likeness of Abraham Lincoln hangs high over the door frame.

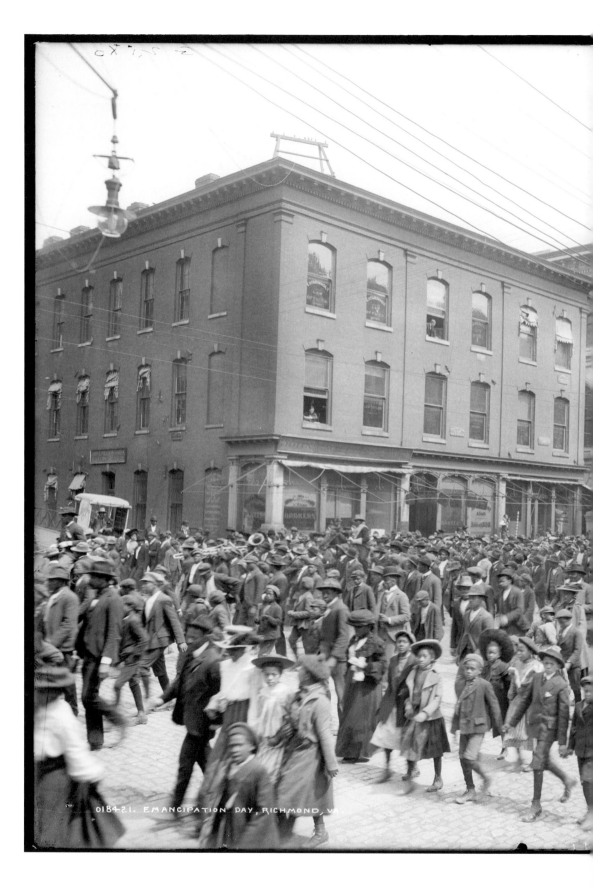

018421. EMANCIPATION DAY, RICHMOND, VA.

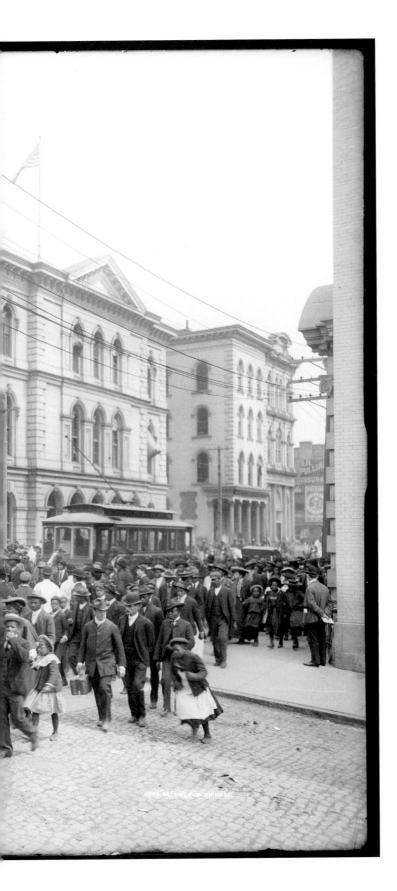

**Emancipation Day, April 3,
Richmond, Virginia**

Printed by Detroit Publishing Company
1905 • photograph

(Library of Congress Prints and Photographs
Division, LC-D401-18421)

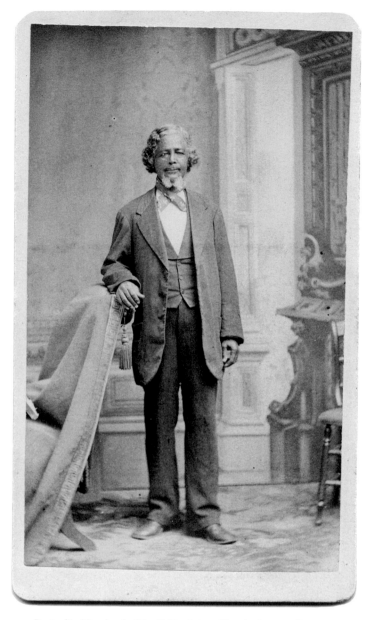

Portrait of Benjamin "Pap" Singleton, Morris County, Kansas

Photographer unknown

c. 1880s • albumen print

(Kansas State Historical Society, Topeka, 6643)

———

Originally from Tennessee, Singleton was active in encouraging black families to move to Kansas, gaining the title "Father of the Exodus."

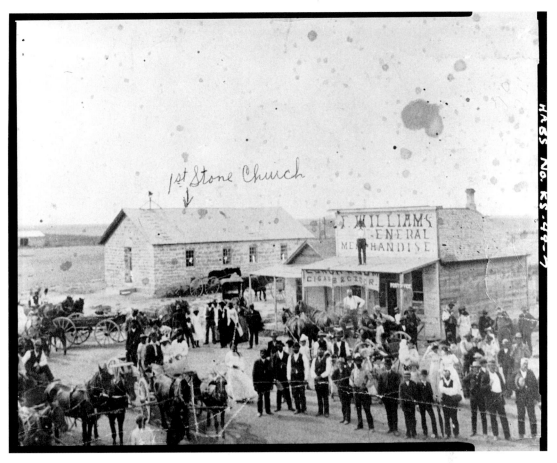

Townspeople in Nicodemus, Kansas

Photographer unknown

c. 1885 • photograph

(Library of Congress, Prints and Photographs Division,
HABS KANS,33-NICO,1—7)

A view of Washington Street in the all-black town of Nicodemus,
showing the church and general store.

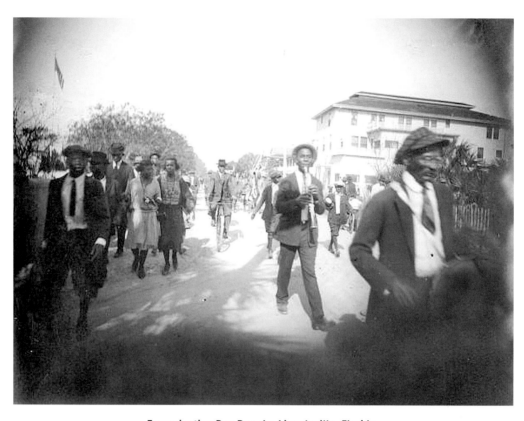

Emancipation Day Parade, Lincolnville, Florida

Photographer: Richard Aloysius Twine • 1922–1927 • photographs

(Florida Memory, Division of Library and Information Services, Tallahassee, LV025, LV048)

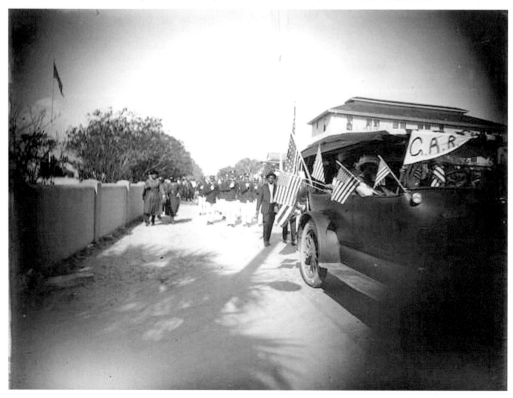

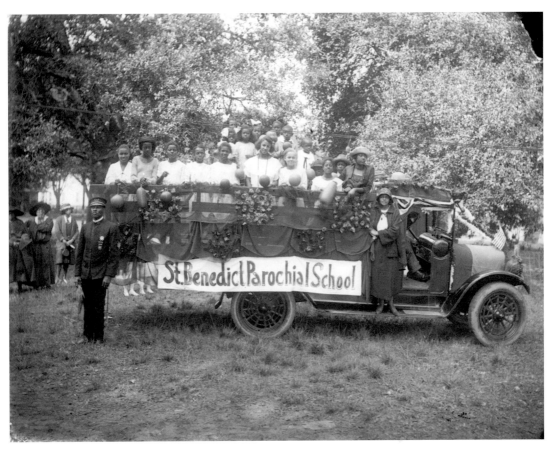

**School float: Emancipation Day Parade,
Lincolnville, Florida**

Photographer: Richard Aloysius Twine
1922–1927 • photograph

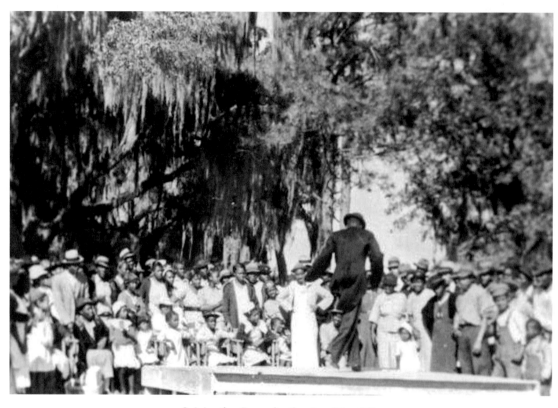

**Celebrating Emancipation Day (May 20)
at Horseshoe Plantation**

Photographer unknown
1922–1927 • photograph

(Florida Memory, Division of Library and Information Services,
Tallahassee, RC11491)

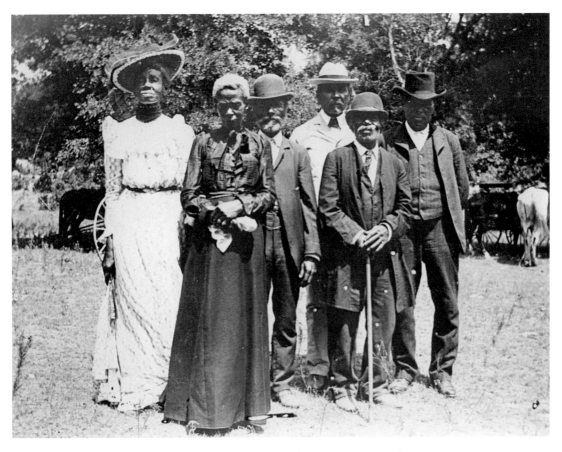

**Emancipation Celebration, Official Juneteenth Committee,
East Woods Park, Austin, Texas, June 19**

Photographer unknown

1900 • photograph

(Courtesy Austin History Center, Austin Public Library, PICA05476)

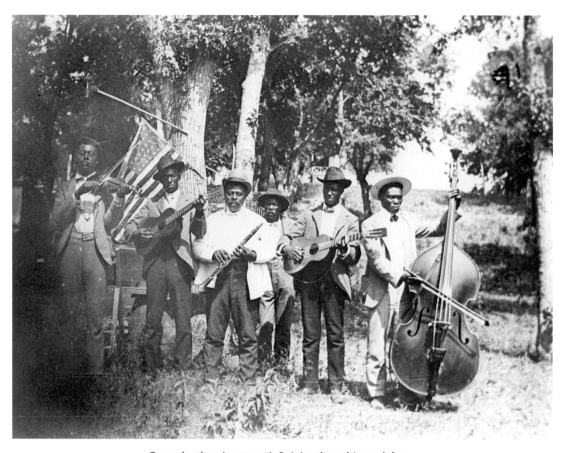

Emancipation–Juneteenth Celebration with musicians

Photographer unknown

1900 • photograph

(Courtesy Austin History Center, Austin Public Library, PICA05481)

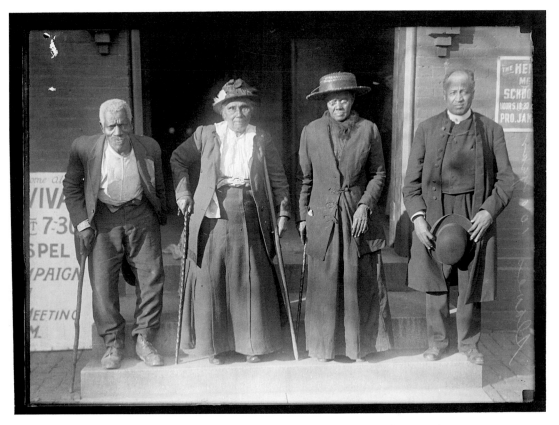

Slave reunion at the Cosmopolitan Baptist Church, Washington, D.C.

Photographer: Harris & Ewing

1916 • photograph

(Library of Congress, Prints and Photographs Division, LC-DIG-hec-0354)

———

Pictured are Lewis Martin, 100; Martha Elizabeth Banks, 104;
Amy Ware, 103; and Reverend Simon P. Drew, born free.

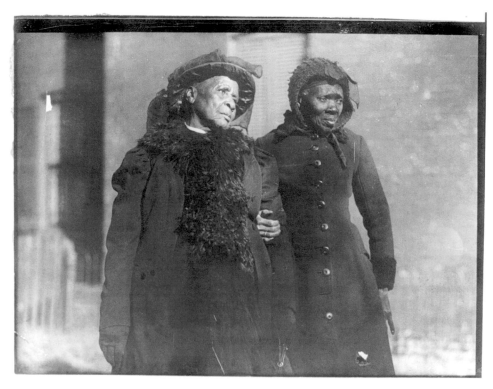

**Elderly women in attendance at convention
for former slaves, Washington, D.C.**

Photographer unknown
1916 • photograph

(Library of Congress, Prints and Photographs Division, LC-USZ62-35649)

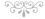

Facing page: **"Old Slave Day," April 8,
Southern Pines, North Carolina**

Photographer unknown
1937 • photograph

(Library of Congress, Prints and Photographs Division, LC-USZ62-125155)

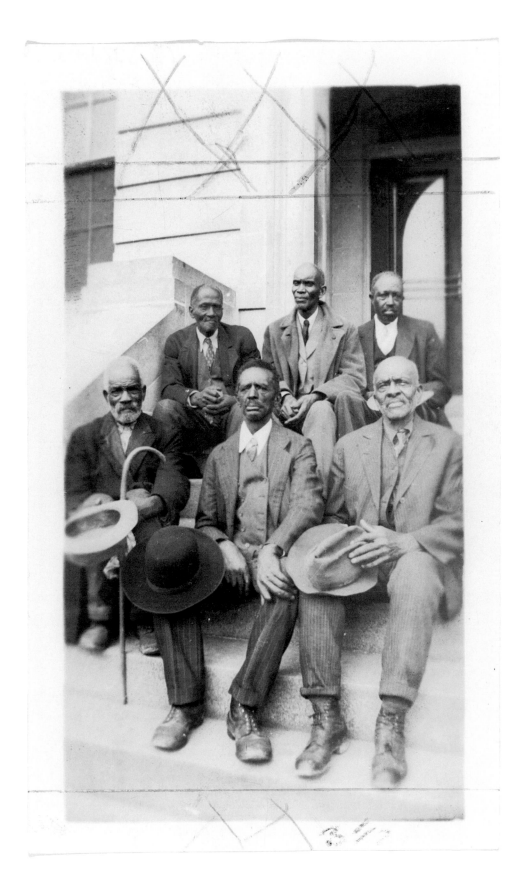

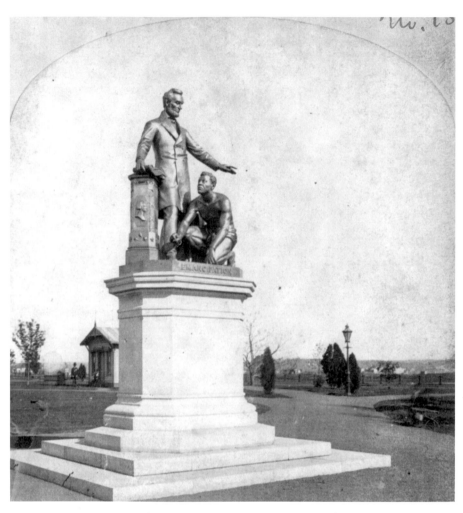

Emancipation Monument *[Freedmen's Memorial]*,
Lincoln Park, Washington, D.C.

Sculptor: Thomas Ball; photographer: J. F. Jarvis

November 13, 1870 • stereograph

(Library of Congress, Prints and Photographs Division, LC-USZ62-53278)

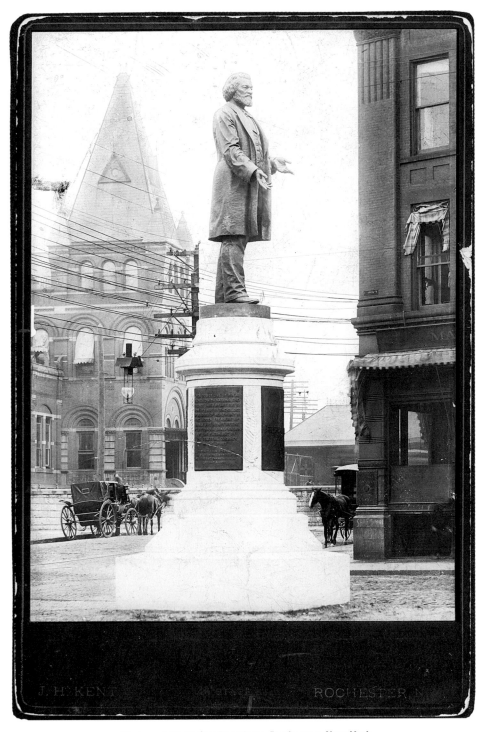

Statue of Frederick Douglass, Rochester, New York

Photographer: J. H. Kent

c. 1890s • cabinet card, albumen print

(Schomburg Center for Research in Black Culture, New York Public Library,
Photographs and Prints Division, 25sccab, 771425)

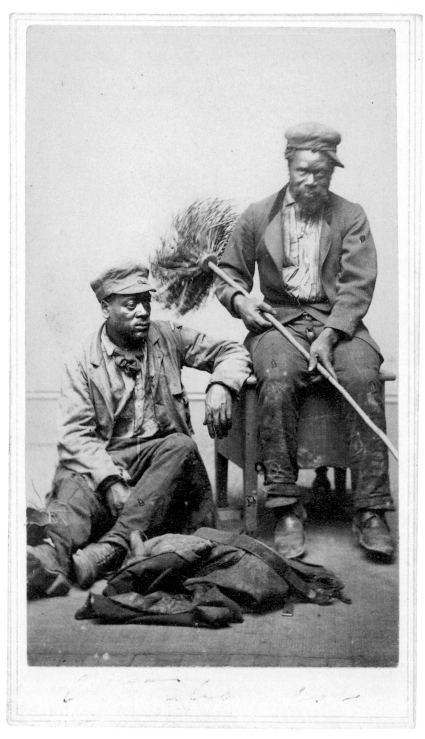

Chimney sweeps

Photographer: Charles D. Fredricks & Co.
1860–1870 • carte-de-visite

(Library of Congress, Prints and Photographs Division, LC-DIG-ppmsca-10990)

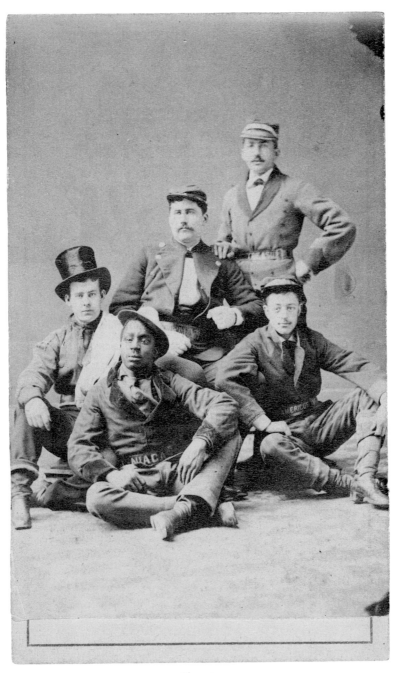

Firemen

Photographer unknown
1865–1870 • carte-de-visite
(Library of Congress, Prints and Photographs Division, LC-DIG-ppmsca-11010)

———

*Group portrait of five men, including one African American,
identified as firemen.*

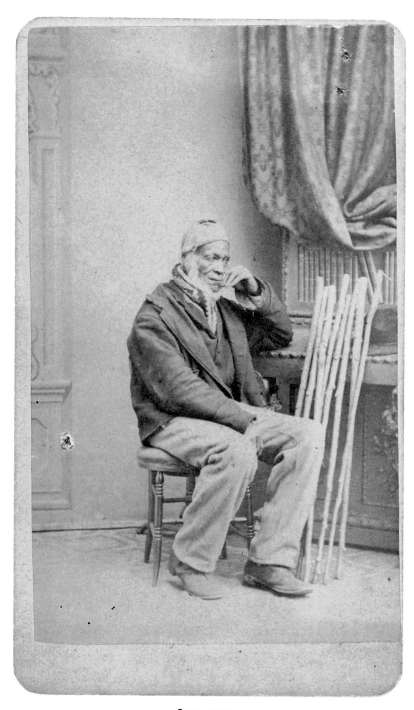

Cane carver

Photographer: Alexander Gardner

1870–1880 • carte-de-visite

(Library of Congress, Prints and Photographs Division, LC-DIG-ppmsca-11044)

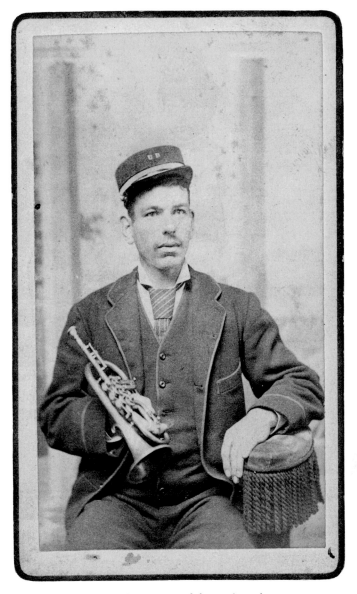

Newton Stevens, musician and teacher

Photographer: J. F. Holley

1870–1880 • carte-de-visite

(Library of Congress, Prints and Photographs Division, LC-DIG-ppmsca-11054)

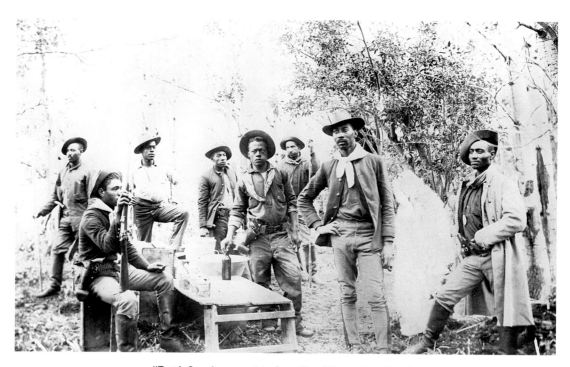

**"Tenth Cavalry escort to Gen. Merritt's party at lunch,
St. Mary's, Montana"**

Photographer: A. B. Coe
1894 • photograph

(Montana Historical Society, Research Center Archives, Helena, 957-993)

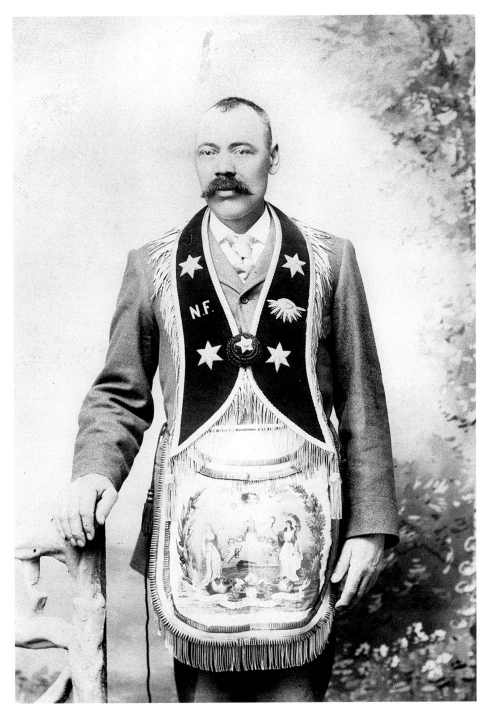

Man in Masonic apron, Helena, Montana

Photographer: J. P. Ball

c. 1890 • cabinet card, albumen print

(Montana Historical Society, Research Center Archives, Helena, 957-605)

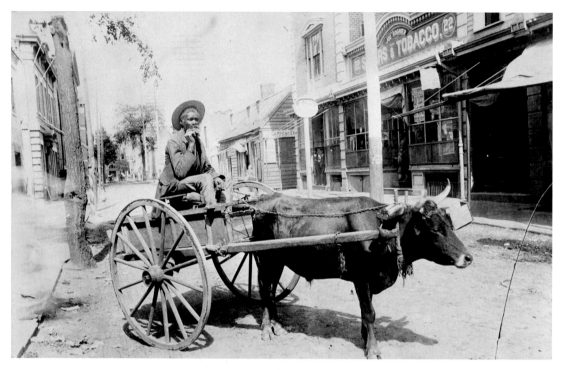

Ox cart and driver, Savannah

Photographer: William O. Wilson
1880s • photograph

(Courtesy Georgia Archives, Vanishing Georgia
Collection, ctm-340-84)

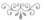

Facing page: **Studio portrait of Aunt Memory Adams,
Tallahassee, Florida**

Photographer unknown
c. 1893 • photograph

(Florida Memory, Division of Library and Information Services,
Tallahassee, 17217, RC00722)

———

*Aunt Memory was born into slavery. She attended the 1893 World's Fair
and sold photographs of herself to pay her expenses. As in other
occupational portraits, she holds her working tools.*

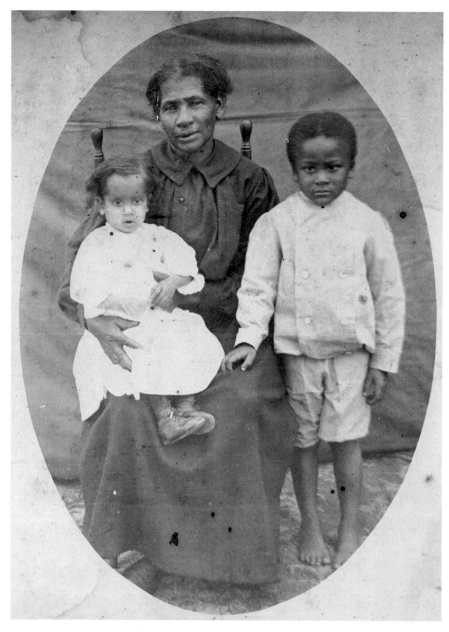

**Mrs. Minerva Greaves Black, formerly enslaved,
with her grandchildren, Wallace and Perry Billingslea**

Photographer unknown
no date • photograph

(Courtesy Georgia Archives, Vanishing Georgia
Collection, jon080)

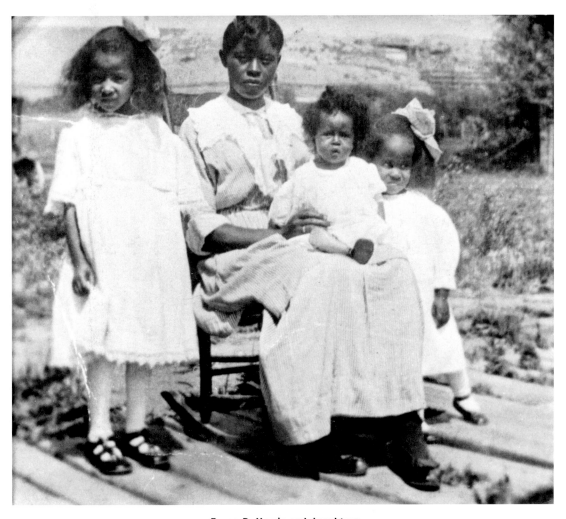

Emma R. Harris and daughters

Photographer unknown

c. 1880s • photograph

(Montana Historical Society, Research Center Archives,
Helena, PAC 96-25.1)

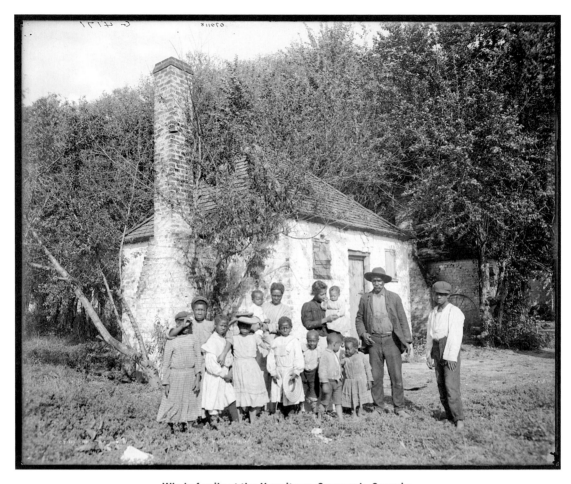

Whole family at the Hermitage, Savannah, Georgia

Photographer unknown; published by Detroit Publishing Co.

1907 • photograph

(Library of Congress, Prints and Photographs Division, LC-D4-70118)

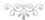

Facing page: **Gill children in their living room**

Photographer unknown

1900 • photograph

(Missouri State Archives, Jefferson City, MS339-0102)

This group portrait includes framed family photographs and a piano.

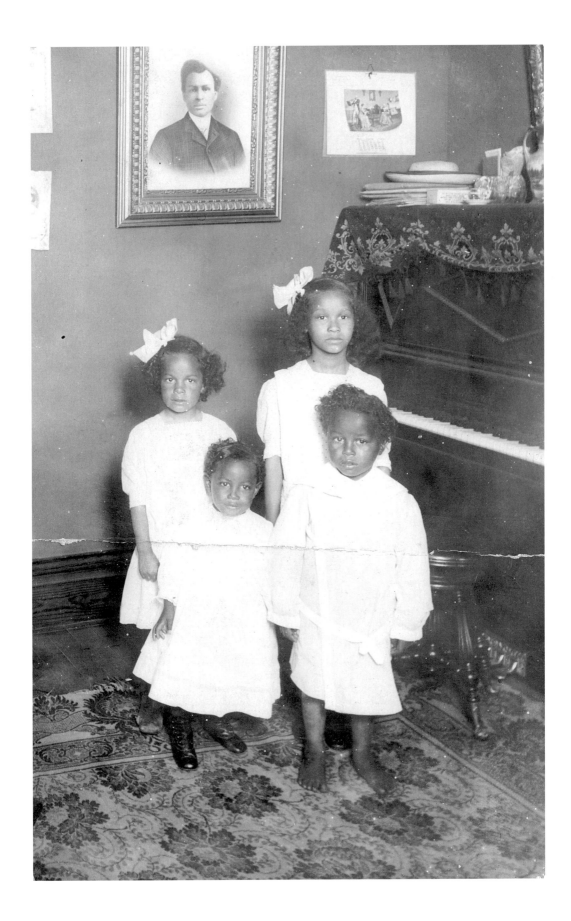

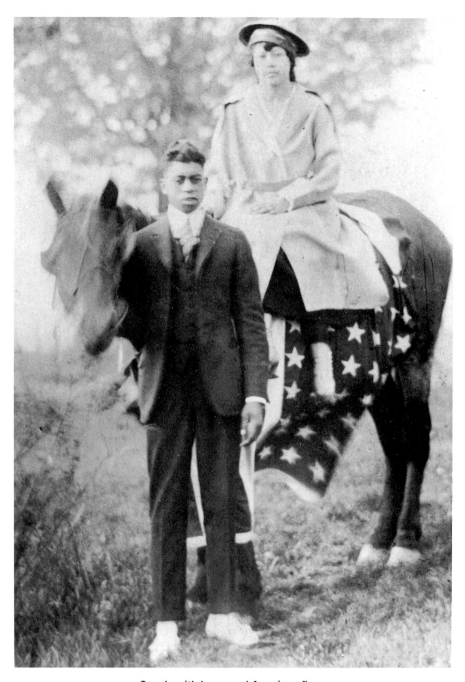

Couple with horse and American flag

Photographer unknown
c. 1920s • photograph

(Missouri State Archives, Jefferson City, MS339-0046)

—————

*Oron E. Clark and an unidentified young woman, who is seated on a horse
draped with an American flag.*

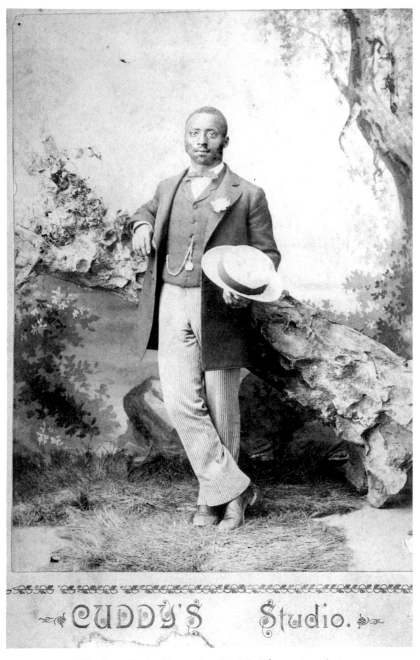

Studio portrait of Jesse Lee Scott holding a straw hat

Photographer: Cuddy Studio

c. 1890s • cabinet card, albumen print

(Missouri State Archives, Jefferson City, MS330-0016)

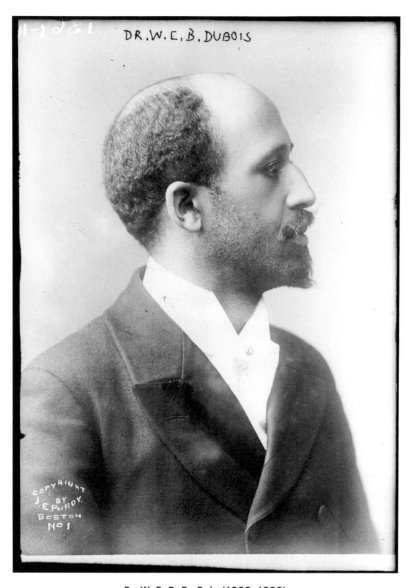

Dr. W. E. B. Du Bois (1868–1963)

Photographer: J. E. Purdy • c. 1900 • photograph

(Library of Congress, Prints and Photographs Division, LC-DIG-ggbain-07435)

———

Scholar and activist W. E. B. Du Bois studied at Harvard and in 1895 became the first black American to earn a doctorate. He used photography to shape understanding about African American visual culture—notably in the exhibit he organized for the 1900 Paris Exposition. In addition to co-founding the National Association for the Advancement of Colored People, Du Bois published the landmark Philadelphia Negro *and* The Souls of Black Folk *and served as editor of the NAACP's monthly magazine,* The Crisis.

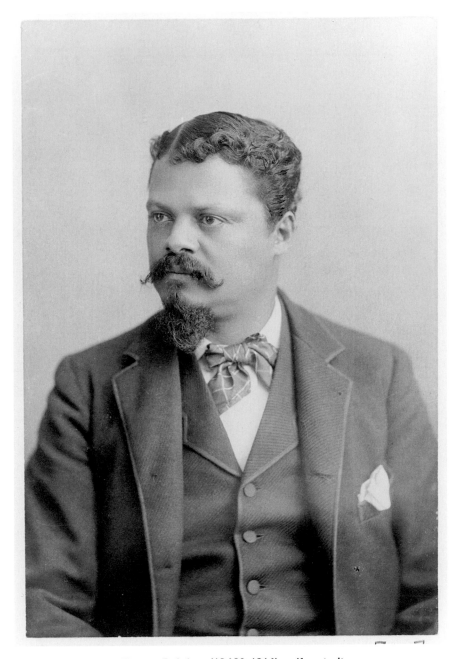

Thomas E. Askew (1848?–1914): self-portrait

Photographer: Thomas E. Askew • c. 1889–1890 • photograph

(Library of Congress, Prints and Photographs Division, LC-USZ62-124795)

———

Askew's striking studio portraits were exhibited by W. E. B. Du Bois at the 1900 Paris Exposition. Askew, one of Atlanta's earliest known black photographers, began his career in the 1880s and eventually opened his own studio in his home. Askew was known as a master of light and composition. A few years after his death, all of his negatives were destroyed in Atlanta's Great Fire of 1917.

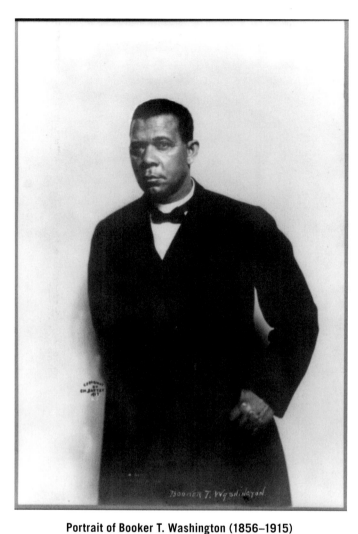

Portrait of Booker T. Washington (1856–1915)

Photographer: C. M. Battey • c. 1915 • photograph

(Library of Congress, Prints and Photographs Division, LC-USZ62-25624)

———

Born enslaved in 1856 on a small farm in Virginia, Booker Taliaferro Washington, educator and orator, was educated at Hampton Institute. He later taught school and in 1881 founded Tuskegee Normal and Industrial Institute in Alabama to educate blacks in agricultural and trade skills. He became a founding member of the National Negro Business League in 1900. His autobiography, Up from Slavery, *was written in 1901.*

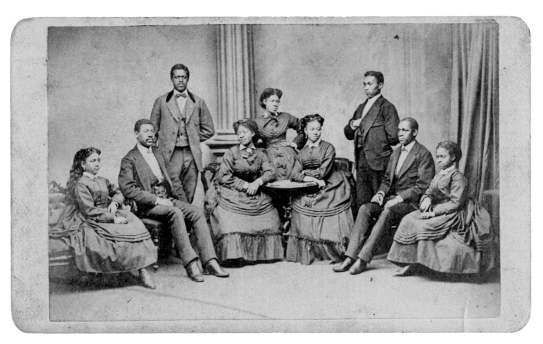

Jubilee Singers, Fisk University, Nashville, Tennessee

Photographer unknown; published by American Missionary Association · 1870–1880 · carte-de-visite

(Library of Congress, Prints and Photographs Division, LC-DIG-ppmsca-11008)

Educator Mary McLeod Bethune
with a line of girls from her school

Photographer unknown · c. 1905 · photograph

(Florida Memory, Division of Library and Information Services, Tallahassee, N041432)

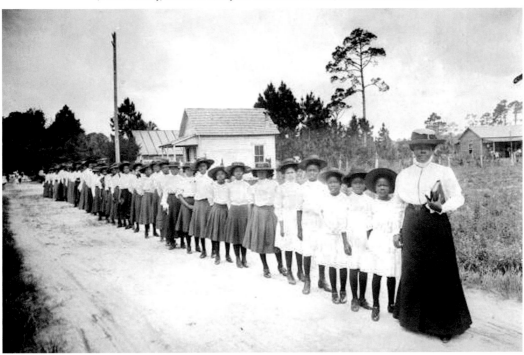

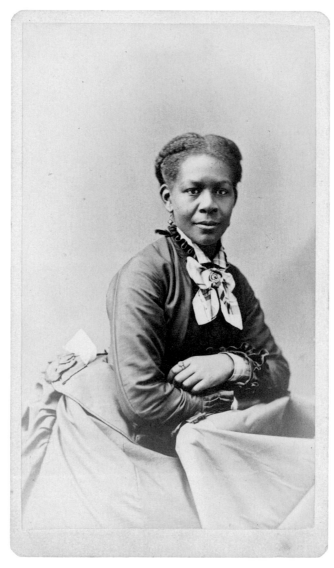

Unidentified woman

Photographer: Frank Forshew
1850–1880 · carte-de-visite

(Library of Congress, Prints and Photographs Division,
LC-DIG-ppmsca-11064)

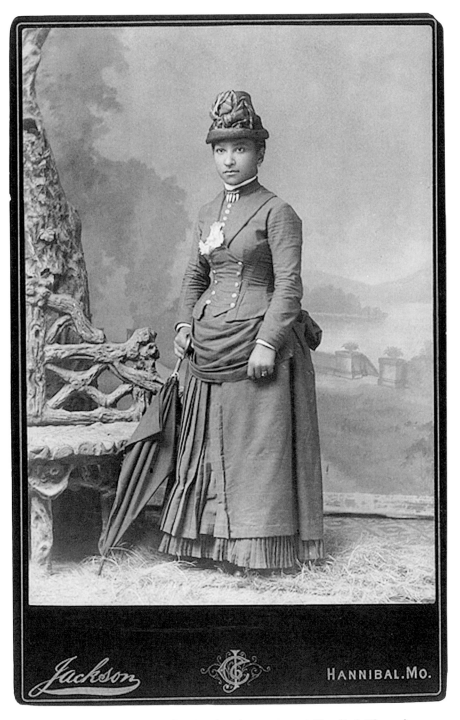

Portrait of a woman believed to be a house servant, Hannibal, Missouri

Photographer: C. Jackson
1885 • cabinet card

(Missouri State Archives, Jefferson City, B7236)

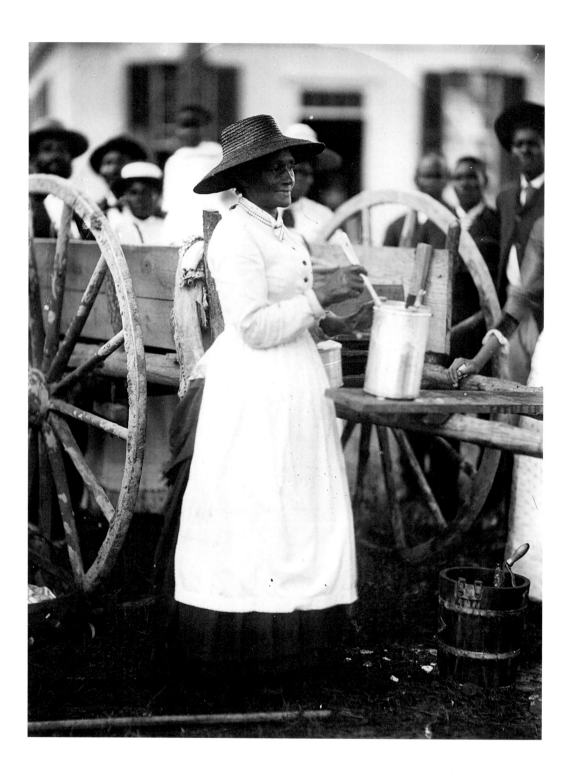

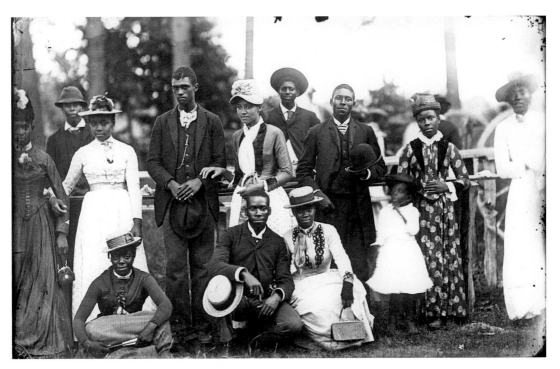

Picnic, Bon Air, Virginia

Photographer: Heustis Cook

c. 1880s • photograph

(Valentine Richmond History Center, Richmond, VA,
Cook Collection, 1384)

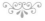

Facing page: **Woman selling ice cream at a picnic,
Bon Air, Virginia**

Photographer: Heustis Cook

c. 1880s • photograph

(Valentine Richmond History Center, Richmond, VA,
Cook Collection, 1496)

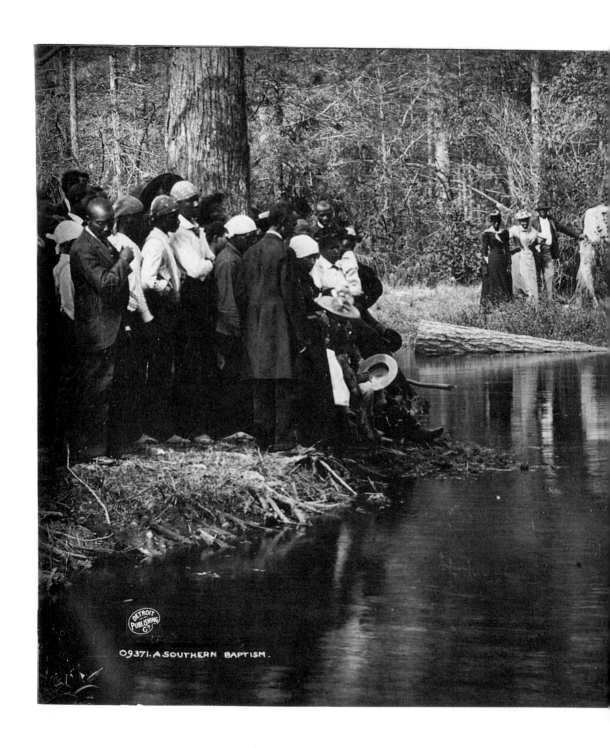

09371. A SOUTHERN BAPTISM.

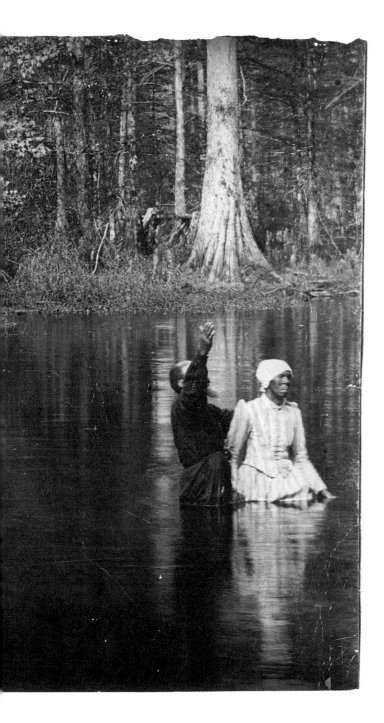

"A southern baptism"

Photographer unknown;
published by Detroit Publishing Co.
1900–1906 • photograph

(Library of Congress, Prints and Photographs
Division, LC-DIG-det-4a31436)

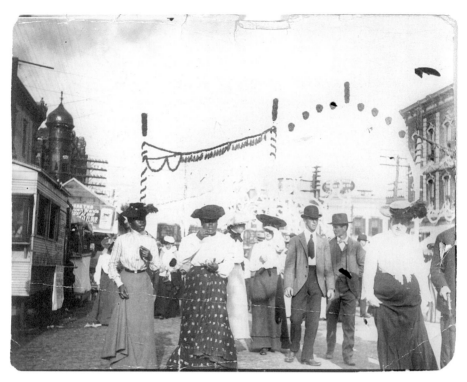

Two women at Fall Festival in Hannibal, Missouri

Photographer unknown • 1899 • photograph

(Missouri State Archives, Hannibal Free Public Library, B0665)

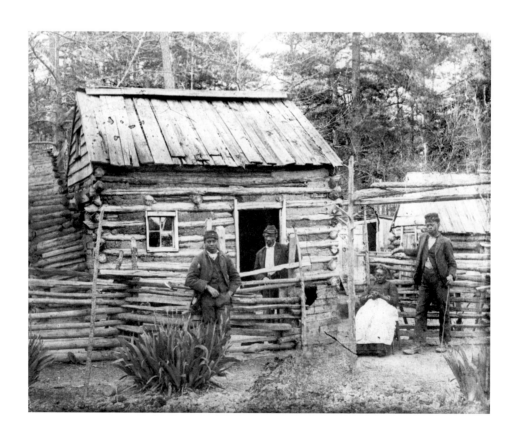

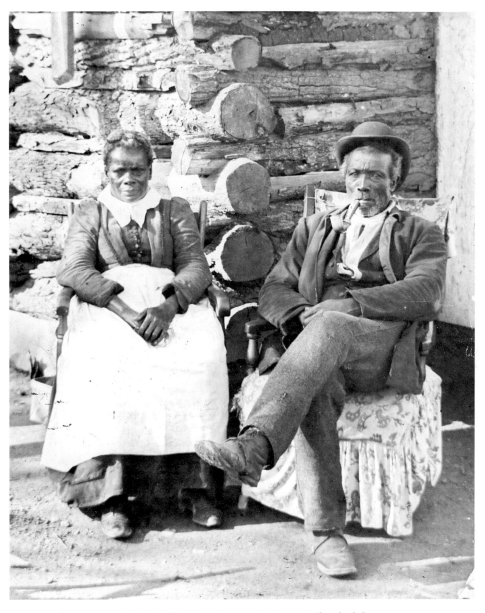

"Uncle Daniel and Aunt Charlotte," Bon Air, Virginia

Photographer: Heustis Cook • c. 1880s • photograph

(Valentine Richmond History Center, Richmond, VA, Cook Collection, 1434)

Facing page: **"Uncle Daniel's cabin," Bon Air, Virginia**

Photographer: Heustis Cook • c. 1880s • photograph

(Valentine Richmond History Center, Richmond, VA, Cook Collection, 1437)

Home of Jeff Kilpatrick, minister and former slave, White Plains, Georgia

Photographer unknown

c. 1900 • photograph

(Courtesy Georgia Archives, Vanishing Georgia Collection, grn043)

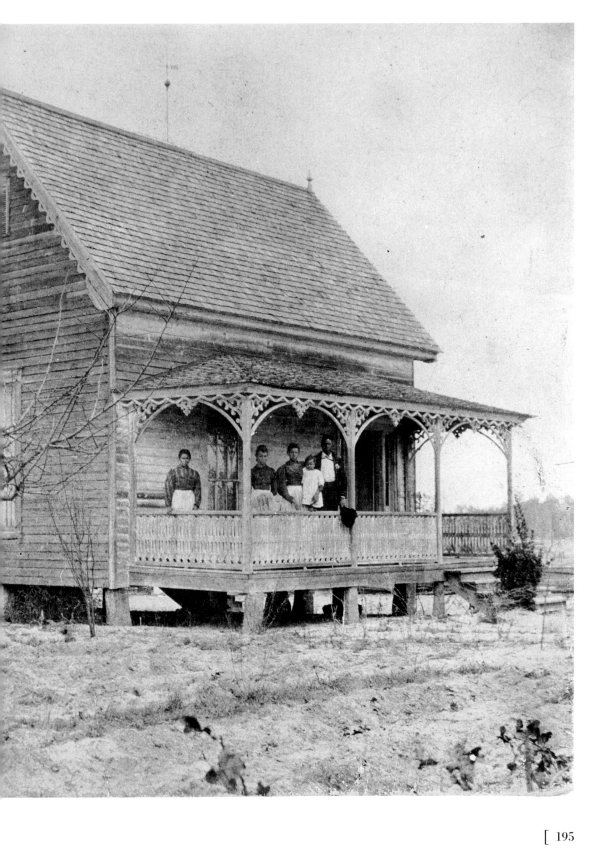

"Proud father and his two daughters in horse-drawn buggy," Hannibal, Missouri

Photographer: Anna Schnizlein • 1907 • photograph

(Missouri State Archives, Hannibal Free Public Library, B7238)

In the background is the bridge over Minnow Creek.

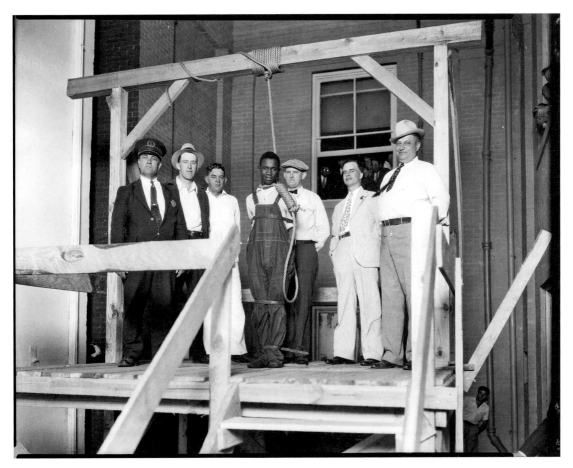

**Moments before the execution of James Keaton,
Columbus, Mississippi**

Photographer: O. N. Pruitt • 1934 • photograph

(Courtesy Wilson Library, University of North Carolina at Chapel Hill,
Pruitt-Shanks Photographic Collection, Southern Historical Collection, 5463)

*Twenty-two-year-old James Keaton is shown just before his execution by hanging at
the Lowndes County Courthouse in Columbus, Mississippi, at 2 a.m. on Friday, May 25,
1934. Sheriff Harry West stands on the far right, smiling. Keaton was indicted, tried,
convicted, and sentenced—all within seven days—for the murder of a white service
station owner.*

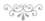

Facing page: **Gathering around county courthouse, Washington, Georgia**

Photographer: Hodson & Goodman • 1885–1904 • photograph

(Courtesy Georgia Archives, Vanishing Georgia Collection, wlk003)

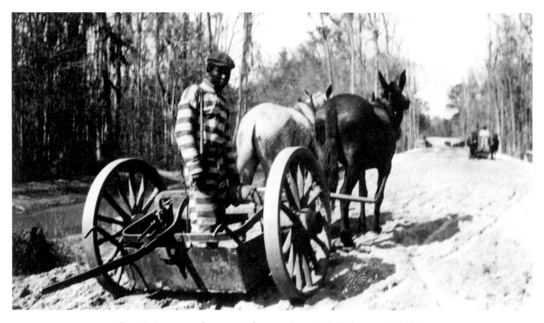

Penal slavery: prisoners doing road work, Tallahassee, Florida

Photographer unknown • 1930 • photograph

(Florida Memory, Division of Library and Information Services, Tallahassee, 06010)

Prisoners working along railroad tracks, Volusia County, Florida

Photographer unknown • c. 1914 • photograph

(Florida Memory, Division of Library and Information Services, Tallahassee, 13879)

Prisoners assigned to harvest timber

Photographer unknown

c. 1920s • photograph

(Florida Memory, Division of Library and Information Services, Tallahassee, 07700)

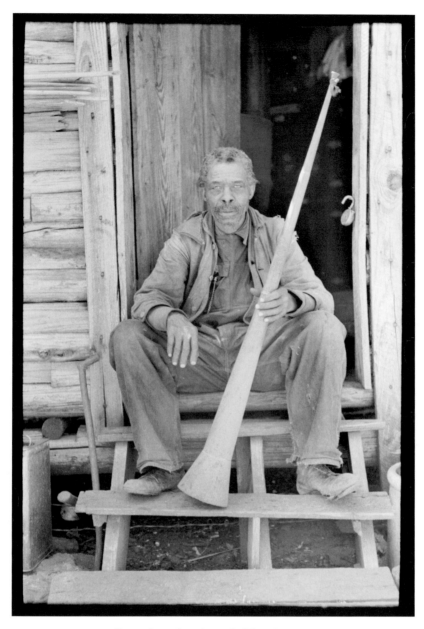

**Formerly enslaved man holding the horn
with which slaves were called, near Marshall, Texas**

Photographer: Russell Lee
1939 • photograph

(Library of Congress, Prints and Photographs Division, LC-USF33-012186-M1)

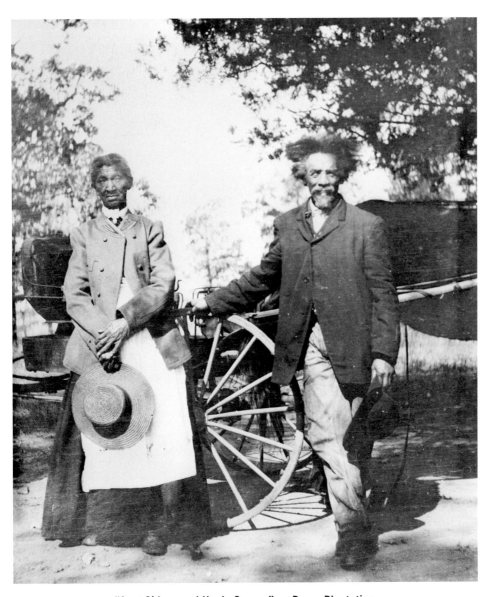

**"Aunt Sidney and Uncle George" on Burge Plantation,
Newton County, Georgia**

Photographer unknown

c. 1910 • photograph

(Courtesy Georgia Archives, Vanishing Georgia Collection, new257-83)

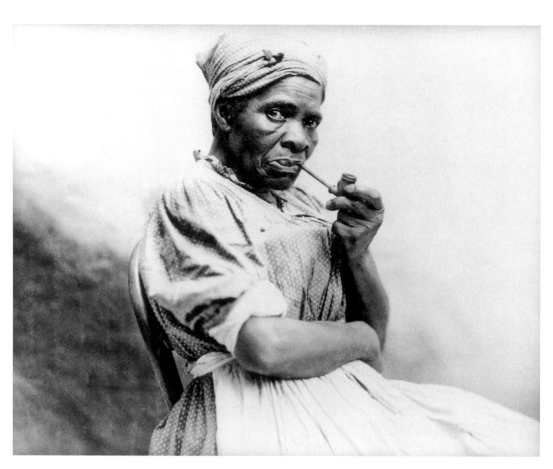

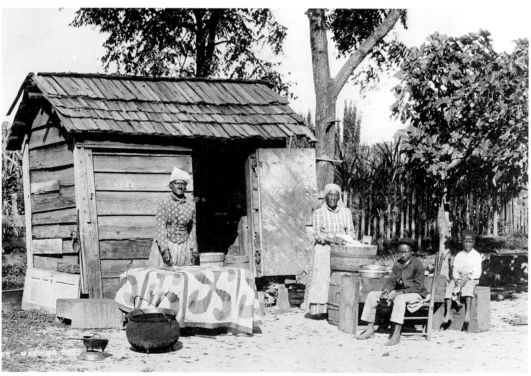

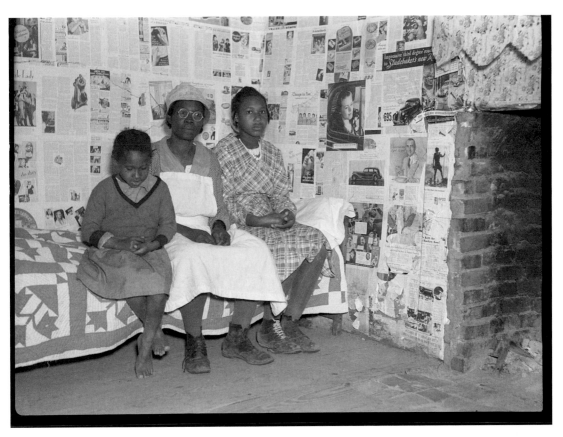

Gee's Bend, Alabama

Photographer: Arthur Rothstein • 1937 • photograph

(Library of Congress, Prints and Photographs Division, LC-DIG-fsa-8b35939)

———

Residents of Gee's Bend are known for their quilting tradition. Lucy Mooney and her granddaughters, Bertha and Lucy Pettway, descendants of slaves of the Pettway plantation, sit on a quilt-covered bed.

Facing page, top: **Portrait of woman holding pipe**

Photographer unknown • 1920–1930 • photograph

(Courtesy Austin History Center, Austin Public Library, Austin, TX, PICB19453)

Facing page, bottom: **Women washing clothes, Thomas County, Georgia**

Photographer: A. W. Moller • 1895 • photograph

(Courtesy Georgia Archives, Vanishing Georgia Collection, tho176)

Pharr plantation house near Social Circle, Georgia

Photographer: Dorothea Lange
1937 • photograph

(Library of Congress, Prints and Photographs Division, LC-USF34-017935-C)

———

The photographer's notes state that this house was built in 1840 by slave labor. The bricks came from England to Savannah; later an ox team transported them to the plantation site. The plantation formerly had 150 slaves. When she photographed it in July 1937, Lange noted that the house had been abandoned by the one remaining member of the family, and the land rented out to small farmers.

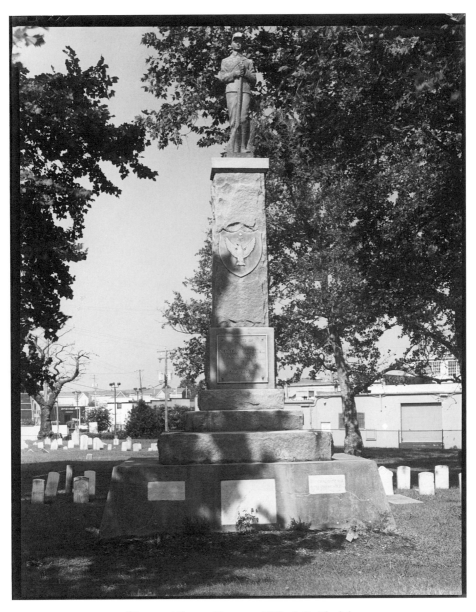

"*Sergeant Carney Monument*," Norfolk, Virginia

Photographer: William Earle Williams

2004 • gelatin silver print

(Courtesy of the photographer)

The statue is both a portrait of Sergeant William Carney
and a memorial to all soldiers of color who served in the Civil War
and the Spanish-American War.

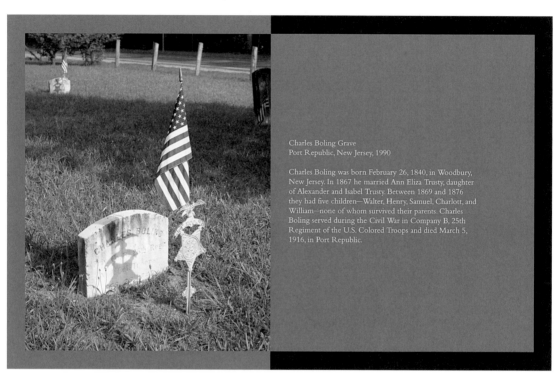

Charles Boling Grave
Port Republic, New Jersey, 1990

Charles Boling was born February 26, 1840, in Woodbury,
New Jersey. In 1867 he married Ann Eliza Trusty, daughter
of Alexander and Isabel Trusty. Between 1869 and 1876
they had five children—Walter, Henry, Samuel, Charlott, and
William—none of whom survived their parents. Charles
Boling served during the Civil War in Company B, 25th
Regiment of the U.S. Colored Troops and died March 5,
1916, in Port Republic.

**Gravesite of Civil War soldier Charles Boling,
Port Republic, New Jersey**

Photographer: Wendel A. White
1990 • gelatin silver print with text

(Courtesy of the photographer)

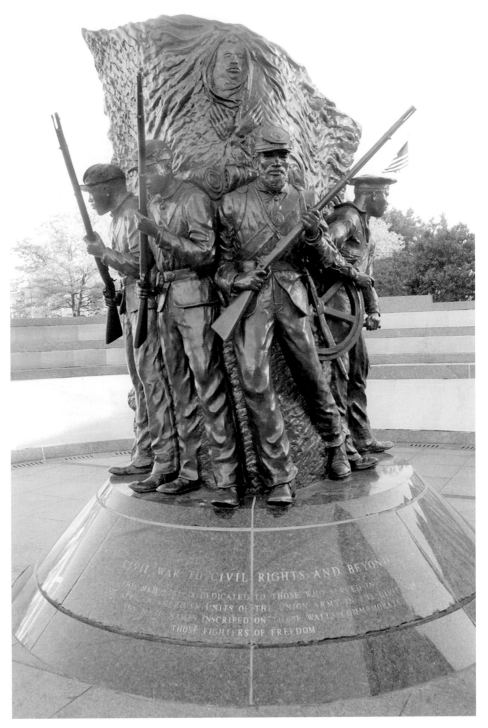

African American Civil War Memorial, Washington, D.C.

Sculptor: Ed Hamilton

Photographer: David "Oggi" Ogburn
2012 • c-print

(Courtesy of the photographer)

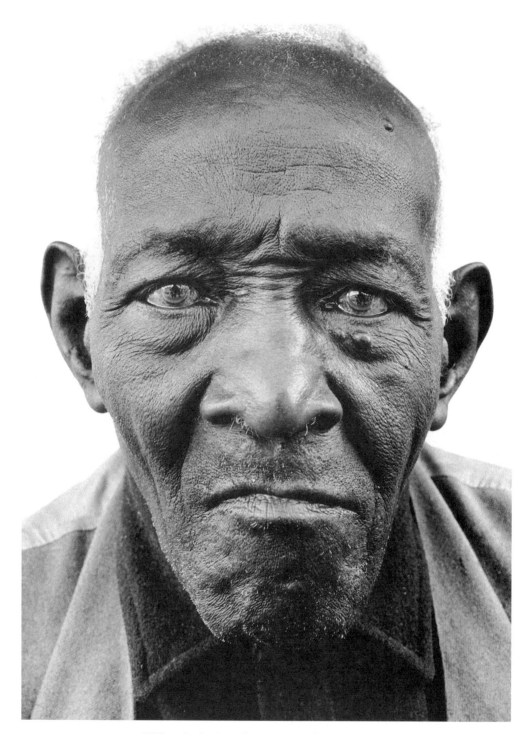

**William Casby, born in slavery, Algiers, Louisiana,
March 24, 1963**

Photographer: Richard Avedon

1963 • silver gelatin print

(©The Richard Avedon Foundation)

Notes

Introduction

1. Shannon Thomas Perich, "A Flag of Freedom?" available online at http://www.npr.org/blogs/pictureshow/2010/07/06/128334240/a-flag-of-freedom.

2. For access to portraiture see Barbara McCandless, "The Portrait Studio and the Celebrity," in *Photography in Nineteenth-Century America,* ed. Martha Sandweiss (New York: Harry N. Abrams and Amon Carter Museum, 1991), 52. The ambrotype process used a collodion wetplate: a sheet of glass was coated with nitrocellulose dissolved in ether and alcohol, sensitized with potassium iodide and silver nitrate, then exposed and developed before the emulsion dried.

3. Frederick Douglass, "What to the Slave Is the Fourth of July?" in *The Oxford Frederick Douglass Reader,* ed. William L. Andrews (New York: Oxford University Press, 1996), 118-119.

4. Alan Trachtenberg, *Reading American Photographs: Images as History, Mathew Brady to Walker Evans* (New York: Hill and Wang, 1989), chap. 1; John Stauffer, *The Black Hearts of Men: Radical Abolitionists and the Transformation of Race* (Cambridge: Harvard University Press, 2001), 49–51; Frederick Douglass, "Pictures and Progress," in *The Frederick Douglass Papers,* ed. John W. Blassingame, ser. 1, vol. 3 (New Haven: Yale University Press, 1985), 452–473; another version of this lecture is available through the Library of Congress website: http://memory.loc.gov/ammem/doughtml/doughome.html.

5. Gibbes is quoted in Molly Rogers, *Delia's Tears: Race, Science, and Photography in Nineteenth-Century America* (New Haven: Yale University Press, 2010), 227. For a brief account of Zealy's career see Harvey S. Teal, *Partners with the Sun: South Carolina Photographers, 1840–1940* (Columbia: South Carolina University Press, 2001), 28–32.

6. Deborah Willis and Carla Williams, *The Black Female Body: A Photographic History* (Philadelphia: Temple University Press, 2002), 21–22. For a history of the slave market see Walter Johnson, *Soul by Soul: Life inside the Antebellum Slave Market* (Cambridge: Harvard University Press, 1999), chap. 5.

7. Lisa Gail Collins, *The Art of History: African American Women Artists Engage the Past* (New Brunswick: Rutgers University Press, 2002), 23; see also Collins, "Historic Retrievals: Confronting Visual Evidence and the Documentation of the Truth," *Chicago Art Journal* 8 (1998): 5–17. In his study of the history of photography, Alan Trachtenberg observes that Delia and Drana stare directly at Zealy, returning the viewer's gaze. He suggests that their eyes "speak directly to ours, in an appeal to a shared humanity," resisting the dehumanizing effects of their staged portraits (*Reading American Photographs*, 56). Molly Rogers addresses Trachtenberg's interpretation in the introduction to her *Delia's Tears,* where she forcefully states, "Looking at a photograph cannot 'free' a person . . . does not magically restore what was taken from her" (xxiii). She goes on to interrogate Trachtenberg's notion of "shared humanity," reminding us that the very notion of humanness is a historical, cultural construct. Rogers cautions against rendering Delia and Drana as passive victims redeemed by the viewers' projection of dignity.

8. Willis and Williams, *The Black Female Body*; Susan Dwyer Amussen, *Caribbean Exchanges: Slavery and the Transformation of English Society* (Chapel Hill: University of North Carolina Press, 2007), 196–217.

9. Willis and Williams, *The Black Female Body*, 129.

10. Alan Sekula, "The Body and the Archive," quoted in Brian Wallis, "Black Bodies, White Science: Louis Agassiz's Slave Daguerreotypes," in *Only Skin Deep: Changing Visions of the American Self,* ed. Coco Fusco and Brian Wallis (New York: Harry N. Abrams, 2003), 178 (emphasis in original).

11. Marianne Hirsch, *Family Frames: Photography, Narrative, and Postmemory* (Cambridge: Harvard University Press, 1997), 51 (quotation), and see chap. 2; Eugene Genovese, *Roll, Jordan, Roll: The World the Slaves Made* (New York: Pantheon, 1974).

12. Jacqueline Goldsby, *A Spectacular Secret: Lynching in American Life and Literature* (Chicago: University of Chicago Press, 2006), 279 (emphasis in original).

13. H. Mattison, *Louisa Picquet the Octoroon; or, Inside Views of Southern Domestic Life* (1861), in *Black Women in Nineteenth-Century American Life: Their Words, Their Thoughts, Their Feelings,* ed. Bert James Loewenberg and Ruth Bogin (University Park: Pennsylvania State University Press, 1976), 63. Elizabeth Ramsey wanted Louisa to send a photograph of herself and her children. Ramsey wrote to Picquet, "I want you to hav your ambrotype taken also your children and send them to me I would giv this world to see you and my sweet little children" (ibid., 66). See also Jeanne Moutoussamy-Ashe, *Viewfinders: Black Women Photographers* (New York: Dodd, Mead, 1986), 4–7.

14. Maria Franklin, personal communication, Austin, TX, October 19, 2011.

15. The carte-de-visite was patented in France by Adolphe Eugene Disderi in 1854 and introduced in the United States in 1859. These small images were usually printed on albumen paper (some used collodion technique) and mounted on cards similar in size to a calling card (4.25" by 2.5"). The photographer's name or that of the studio (or both) was printed on the back of the card. Between 1863 and 1868, American cartes-de-visite were used to raise funds for the Civil War and for the education of formerly enslaved children. The process remained in use through the late 1870s.

16. For further discussion of race and portraiture see Alan Sekula, "The Traffic in Photographs," in Fusco and Wallis, *Only Skin Deep,* 79–110; Nicholas Mirzoeff, "The Shadow and the Substance: Race, Photography, and the Index," ibid., 111–128; Martin

A. Berger, *Seeing through Race: A Reinterpretation of Civil Rights Photography* (Berkeley: University of California Press, 2011), chap. 1, esp. 43–46.

17. Notice for Dolly is available online at http://dc.lib.unc.edu/cdm4/document. php?CISOROOT=/plantation&CISOPTR=795. See p. 179.

18. Ibid.; Louis Manigault to Charles W. Henry, 10 April 1863, Manigault Family Papers, South Caroliniana Library, University of South Carolina, Columbia, SC. Manigault wrote at least two notices. He sent one to the Augusta police and a second to a friend in Charleston.

19. William Capers to Louis Manigault, April 8, 1863; William Capers to Louis Manigault, April 13, 1863; John Bolton Habersham to Louis Manigault, April 13, 1863; Charles W. Henry to Louis Manigault, April 14, 1863; William Capers to Louis Manigault, June 17, 1863; William Capers to Louis Manigault, July 2, 1863; all in Louis Manigault Papers, Special Collections Library, Duke University, Durham, NC.

20. Mary Frances Berry, *Black Resistance, White Law: A History of Constitutional Racism in America* (New York: Prentice-Hall, 1971), 55–57; Jane Rhodes, *Mary Ann Shadd Cary: The Black Press and Protest in the Nineteenth Century* (Bloomington: Indiana University Press, 1998), 27–28.

21. Nell Irvin Painter, *Sojourner Truth: A Life, a Symbol* (New York: W. W. Norton, 1996); Carla Peterson, *"Doers of the Word": African-American Women Speakers and Writers in the North (1830–1880)* (New York: Oxford University Press, 1995); Margaret Washington, *Sojourner Truth's America* (Urbana: University of Illinois Press, 2009).

22. Popularized in America in 1866, the cabinet card image, an albumen print (4" by 5.5"), was mounted on slightly larger card stock (4.25" by 6.5"), often with the name of the photographer or studio. This format was especially popular for the display of family portraits.

23. Painter, *Sojourner Truth,* 197.

24. Ibid., 187.

25. Ibid.

26. Gwendolyn DuBois Shaw, *Portraits of a People: Picturing African Americans in the Nineteenth Century* (Seattle: University of Washington Press, 2006), 48.

27. "A Tribute for the Negro," *North Star*, April 7, 1849, p.2.

28. Stauffer, *The Black Hearts of Men*, 50.

29. See Leslie Harris, *In the Shadow of Slavery: African Americans in New York City, 1626–1863* (Chicago: University of Chicago Press, 2002).

30. Mary Niall Mitchell, *Raising Freedom's Child: Black Children and Visions of the Future after Slavery* (New York: New York University Press, 2008), 4.

31. Fannie Lawrence and Rose Ward's freedom was purchased with the help of funds from Reverend Henry Ward Beecher and Plymouth Church. The slave children from New Orleans—Charley, Rebecca, and Rose—were freed by General Nathaniel Prentice Banks following the Emancipation Proclamation, and a year after the fall of New Orleans to Union army forces. Information comes from Shaw, *Portraits of a People,* 154.

32. Ibid., 3.

33. Paul Finkelman, "Lincoln and the Preconditions for Emancipation," in *Lincoln's Proclamation: Emancipation Reconsidered,* ed. William A. Blair and Karen Fisher Younger (Chapel Hill: University of North Carolina Press, 2009), 13–44.

34. Hirsch, *Family Frames*, xi.

1. Harriet Jacobs, *Incidents in the Life of a Slave Girl Written by Herself* (Boston, 1861; Cambridge: Harvard University Press, 2000),191.

2. *Dred Scott v. Sandford,* 60 U.S. 393 (1857).

3. Michael Bieze, *Booker T. Washington and the Art of Self-Representation* (New York: Peter Lange, 2008), 101.

4. Richard J. Powell, "Sartor Africanus," in *Dandies: Fashion and Finesse in Art and Culture,* ed. Susan Fillin-Yeh (New York: New York University Press, 2001), 224.

5. Martha S. Jones, *All Bound Up Together: The Woman Question in African American Public Culture 1830–1900* (Chapel Hill: University of North Carolina Press, 2007), 175.

6. Charlotte L. Forten, *The Journals of Charlotte Forten Grimké*, ed. Brenda Stevenson (New York: Oxford University Press, 1988), 86. For a study of women's fashion see Joan Severa, *Dressed for the Photographer: Ordinary Americans and Fashion, 1840–1900* (Kent, OH: Kent State University Press, 1995), 87–88.

7. Jones, *All Bound Up Together,* 180.

8. Forten, *Journals*, 235.

9. Margaret Washington, *Sojourner Truth's America* (Urbana: University of Illinois Press, 2009), 309.

10. Ibid., 42–43.

11. *Emancipator and Republican*, August 15, 1850, p. 2.

12. *North Star*, September 5, 1850, p. 2.

13. Ibid.

14. For a detailed account of the escape on the *Pearl* and the subsequent fates of the Edmonson children see Josephine F. Pacheco, *The Pearl: A Failed Slave Escape on the Potomac* (Chapel Hill: University of North Carolina Press, 2005); Henry Ward Beecher quoted in Debby Applegate, *The Most Famous Man in America: The Biography of Henry Ward Beecher* (New York: Doubleday, 2006), 227.

15. Jacobs, *Incidents in the Life of a Slave Girl,* 77.

16. John Stauffer, *The Black Hearts of Men: Radical Abolitionists and the Transformation of Race* (Cambridge: Harvard University Press, 2001), 164.

17. *North Star*, September 5, 1850, p. 2.

18. *Frederick Douglass' Paper*, January 4, 1855, p. 2.

19. Alan Trachtenberg, *Lincoln's Smile and Other Enigmas* (New York: Hill and Wang, 2007), 73.

20. Stauffer, *The Black Hearts of Men*, 170. See also Ann Shumard, *A Durable Memento: Portraits by Augustus Washington, African American Daguerreotypist* (Washington, D.C.: National Portrait Gallery, 1999).

21. Frederick Douglass, "John Brown, Speech Delivered at Storer College, Harper's Ferry, West Virginia, May 30, 1881," in *Frederick Douglass: Selected Speeches and Writings,* ed. Philip S. Foner, abridged and adapted by Yuval Taylor (Chicago: Lawrence Hill Books, 1999), 633–647.

22. "Letters to the American Colonization Society" [Part 5], *Journal of Negro History* 10 (1925): 286–288.

23. Wilson Jeremiah Moses, ed., *Liberian Dreams: Back to Africa Narratives from the 1850s* (University Park, PA: Pennsylvania State University Press, 1998), 181–182.

24. Marie Tyler-McGraw, *An African Republic: Black and White Virginians in the Making of Liberia* (Chapel Hill: University of North Carolina Press, 2007); James Sidbury, *Becoming African in America: Race and Nation in the Early Black Atlantic* (New York: Oxford University Press, 2007); Patrick Rael, *Black Identity and Black Protest in the Antebellum North* (Chapel Hill: University of North Carolina Press, 2002).

25. Winston James, *The Struggles of John Brown Russwurm: The Life and Writings of a Pan-Africanist Pioneer, 1799–1851* (New York: New York University Press, 2010), 77.

26. *Maryland Colonization Journal,* June 15, 1841, p. 274; James, *The Struggles of John Brown Russwurm*, 80.

27. Severa, *Dressed for the Photographer*, 95.

28. Quotation from *Harper's Weekly* in Marcus Wood, *Blind Memory: Visual Representations of Slavery in England and America, 1780–1865* (New York: Routledge, 2000), 268.

29. Quoted in Mary Niall Mitchell, *Raising Freedom's Child: Black Children and Visions of the Future after Slavery* (New York: New York University Press, 2008), 64.

Chapter 2 · A Collective Portrait of the Civil War

1. *North Star*, September 5, 1850, p. 3.

2. Ross J. Kelbaugh, *Introduction to African American Photographs 1840–1950: Identification, Research, Care and Collecting* (Gettysburg, PA: Thomas Publications, 2005), 40.

3. Keith Davis, "'A Terrible Distinctness': Photography of the Civil War Era," in *Photography in Nineteenth-Century America*, ed. Martha A. Sandweiss (New York: Harry N. Abrams and Amon Carter Museum, 1991), 131.

4. W. Jeffrey Bolster and Hilary Anderson, *Soldiers, Sailors, Slaves and Ships: The Civil War Photographs of Henry P. Moore* (Concord: New Hampshire Historical Society, 1999), 17.

5. Quoted ibid., 15.

6. Ibid., 42.

7. Willie Lee Rose, *Rehearsal for Reconstruction: The Port Royal Experiment* (reprint ed., Athens: University of Georgia Press, 1999).

8. Charlotte L. Forten, *The Journals of Charlotte Forten Grimké*, ed. Brenda Stevenson (New York: Oxford University Press, 1988), 39.

9. *South Carolina Leader*, May 12, 1866, p. 3.

10. Judith Ann Carney, *Black Rice: The African Origins of Rice Cultivation in the Americas* (Cambridge: Harvard University Press, 2003), 108.

11. Ibid., 109.

12. Charles Joyner, *Down by the Riverside: A South Carolina Slave Community* (Urbana: University of Illinois Press, 1984), 113.

13. Stephanie Camp, *Closer to Freedom: Enslaved Women and Everyday Resistance in the Plantation South* (Chapel Hill: University of North Carolina Press, 2004), 83–84.

14. Frederick Douglass, "Men of Color, to Arms!" (1863), in *The Oxford Frederick Douglass Reader,* ed. William L. Andrews (New York: Oxford University Press, 1996), 224–225.

15. See http://opinionator.blogs.nytimes.com/2011/04/18/nick-biddle-and-the-first-defenders/.

16. For contemporary sources, see ibid.

17. Gerald Astor, *The Right to Fight: A History of African Americans in the Military* (Cambridge: Da Capo Press, 2001), 36.

18. See http://nationalhumanitiescenter.org/pds/maai/identity/text7/fleetwooddiary.pdf.

19. Pamela Newkirk, ed., *Letters from Black America: Intimate Portraits of the African American Experience* (Boston: Beacon Press, 2009), 231 (emphasis in original).

20. Thomas C. Battle and Donna M. Wells, eds., *Legacy: Treasures of Black History* (Washington, D.C.: Howard University and National Geographic, 2006), 102.

21. Stevenson, introduction to Forten, *Journals,* 43.

22. Newkirk, *Letters from Black America,* 230.

23. Hannah Johnson to Hon. Mr. Lincoln, July 31, 1863, in *Families and Freedom: A Documentary History of African-American Kinship in the Civil War Era,* ed. Ira Berlin and Leslie S. Rowland (New York: New Press, 1997), 81–82.

24. Both quotations from Stephanie McCurry, "War, Gender, and Emancipation," in *Lincoln's Proclamation: Emancipation Reconsidered,* ed. William A. Blair and Karen Fisher Younger (Chapel Hill: University of North Carolina Press, 2009), 129.

25. After the war, King Taylor established a school for freed slaves. Her husband, Sergeant Edward King of the First South Carolina Volunteers, died in 1866, and she was able to collect a widow's pension. In 1879 she married Russell Taylor and continued working as an activist until her death in 1912.

26. Lisa Tendrich Frank, *Women in the American Civil War*, vol. 1 (Santa Barbara, CA: ABC-CLIO, 2008), 12.

27. Susie King Taylor and Patricia W. Romero, *Reminiscences of My Life in Camp: A Black Woman's Civil War Memoirs* (Princeton: Markus Weiner, 1988).

28. Quoted in Davis, "A Terrible Distinctness," 143.

29. Ibid., 138.

30. Bolster and Anderson, *Soldiers, Sailors, Slaves and Ships,* 19.

Chapter 3 · Legacies of Emancipation

1. Michael Vorenberg, *Final Freedom: The Civil War, the Abolition of Slavery, and the Thirteenth Amendment* (New York: Cambridge University Press, 2001).

2. Brian Wallis, *African American Vernacular Photography: Selections from the Daniel Cowin Collection* (New York: ICP/Steidl, 2005), 10.

3. Wilma King, *Stolen Childhood: Slave Youth in Nineteenth-Century America,* 2d ed. (Bloomington: University of Illinois Press, 2011), chap. 8; Mary Niall Mitchell, *Raising Freedom's Child: Black Children and Visions of the Future after Slavery* (New York: New York University Press, 2008), chap. 4, and see p. 154 for the first epigraph to this chapter.

4. Absalom Jones, "A Thanksgiving Sermon," in Philip S. Foner and Robert James Branham, ed., *Lift Every Voice: African American Oratory, 1797–1900* (Tuscaloosa: University of Alabama Press, 1998), 73–79.

5. Douglass quoted in Mitch Kachun, *Festivals of Freedom: Memory and Meaning in African American Emancipation Celebrations, 1808–1915* (Amherst: University of Massachusetts Press, 2003), 96.

6. Kate Masur, *An Example for All the Land: Emancipation and the Struggle over Equality in Washington,* vol. 3 (Chapel Hill: University of North Carolina Press, 2010), 41.

7. Turner quoted ibid.

8. Charlotte Forten, "Life on the Sea Islands," part 2, originally published in *Atlantic Monthly,* June 1864; available online at http://www.theatlantic.com/magazine/archive/1864/06/sea-islands/8759/.

9. For descriptions of wartime celebrations see Kachun, *Festivals of Freedom*, chap. 3; Paul Ortiz, *Emancipation Betrayed: The Hidden History of Black Organizing and White Violence in Florida from Reconstruction to the Bloody Election of 1920* (Berkeley: University of California Press, 2005), 9.

10. *South Carolina Leader*, December 16, 1865, p. 2.

11. "Grand Celebration in Hudson, New York," *The Elevator,* October 18, 1867, p. 2.

12. George A. Brush diary, June 19, 1879, typescript p. 28, Brush Papers, Box 1, folder 1, Austin History Center, Austin, TX.

13. Kachun, *Festivals of Freedom*, n.p. (photo caption).

14. *Huntsville Gazette*, April 7, 1883, p. 2. Douglass speech: *Washington Bee*, April 7, 1883, p. 1; ibid., April 21, 1883, p. 2.

15. *Richmond Planet*, February 21, 1885, p. 3; Kachun, *Festivals of Freedom*, 229.

16. Articles discussing the event appeared in the *Washington Bee:* October 7, October 21, November 15, December 16, 1916; articles discussing Drew's advocacy for black soldiers appeared in the *Washington Bee,* July 22, 1916; *Savannah Tribune,* July 29, 1916; *Kansas Elevator*, August 5, 1916.

17. Kachun, *Festivals of Freedom*, 237, 245.

18. Kirk Savage, *Standing Soldiers, Kneeling Slaves: Race, War, and Monument in Nineteenth-Century America* (Princeton: Princeton University Press, 1997), 91.

19. Ibid., 90.

20. "Oration by Frederick Douglass Delivered on the Occasion of the Unveiling of the Freedmen's Monument in Memory of Abraham Lincoln" (Washington, D.C.: Gibson Brothers, 1876), 4–5; available online at http://memory.loc.gov/ammem/doughtml/doughome.html.

21. Douglass quoted in Savage, *Standing Soldiers, Kneeling Slaves,* 177.

22. Shawn Michelle Smith, *Photography on the Color Line: W. E. B. Du Bois, Race, and Visual Culture* (Durham: Duke University Press, 2004).

23. J. William Harris, *Deep Souths: Delta, Piedmont, and Sea Island Society in the Age of Segregation* (Baltimore: Johns Hopkins University Press, 2001).

24. Ortiz, *Emancipation Betrayed*, 53.

25. Ibid. (unpaginated photo insert).

26. Jerrell Shofner, "Forced Labor in the Florida Forests: 1880–1950," *Journal of Forest*

History 25 (January 1981): 14–25; for more on slavery and forced labor in Florida, see http://www.ciw-online.org/a_brief_history_of_inhumanity.html.

27. Gordon Parks, the only black photographer associated with the FSA project, was not paid by the FSA; his work was supported by a fellowship from the Rosenwald Fund. Parks was the project's only unpaid photographer.

28. Gladys-Marie Fry, *Stitched from the Soul: Slave Quilts from the Antebellum South* (Chapel Hill: University of North Carolina Press, 2001); John Beardsley, William Arnett, Paul Arnett, and Jane Livingston, *Gee's Bend: The Women and Their Quilts* (Atlanta: Tinwood Books, 2002).

29. Lucy Pettway quoted in Beardsley et al., *Gee's Bend*, 356.

30. For Lange's career see Linda Gordon, *Dorothea Lange: A Life beyond Limits* (New York: W. W. Norton, 2009).

31. Richard Avedon, 1963 datebook, Avedon Foundation, New York City.

32. Sara Blair, *Harlem Crossroads: Black Writers and the Photograph in the Twentieth Century* (Princeton: Princeton University Press, 2007), 193.

33. Ibid., chap. 4.

34. Ibid., 188. In his stunningly opaque and brief mention of Avedon's photograph, theorist Roland Barthes writes that "the essence of slavery is here laid bare: the mask is the meaning, insofar as it is absolutely pure (as it was in ancient theater)." Roland Barthes, *Camera Lucida: Reflections on Photography*, trans. Richard Howard (New York: Hill and Wang, 1981), 34.

Index

Page numbers in italics refer to images. Portraits are listed under the name or description of the subject.